THE NORWICH SCHOOL OF ARTISTS

Andrew Moore

Norfolk Museums Service

LONDON: HMSO

Second impression 1995

ISBN 0 11 701587 3 (paperback)
ISBN 0 11 701589 X (cased edition)

Design by Richard Malt

Cover design by Guy Myles Warren, HMSO Graphic Design

British Library Cataloguing in Publication Data
A CIP catalogue record for this book is
available from the British Library

Norfolk Museums Service is a joint service
provided by the County and District Councils

HMSO

Published by HMSO and available from:

HMSO Publications Centre
(Mail, fax and telephone orders only)
PO Box 276, London SW8 5DT
Telephone orders 0171 873 9090
General enquiries 0171 873 0011
(queuing system in operation for both numbers)
Fax orders 0171 873 8200

HMSO Bookshops
49 High Holborn, London WC1V 6HB
(counter service only)
0171 873 0011 Fax 0171 831 1326
68-69 Bull Street, Birmingham B4 6AD
0121 236 9696 Fax 0121 236 9699
33 Wine Street, Bristol BS1 2BQ
0117 9264306 Fax 0117 9294515
9-21 Princess Street, Manchester M60 8AS
0161 834 7201 Fax 0161 833 0634
16 Arthur Street, Belfast BT1 4GD
01232 238451 Fax 01232 235401
71 Lothian Road, Edinburgh EH3 9AZ
0131 228 4181 Fax 0131 229 2734

HMSO's Accredited Agents
(see Yellow Pages)

and through good booksellers

Printed in the Republic of Singapore for HMSO
Dd 299908 C20 3/95

HALF TITLE PAGE
Catalogue title page of the first exhibition
organised by the Norwich Society of Artists, 1805

FRONTISPIECE
Henry Ninham *Sir Benjamin Wrenche's Court, Norwich*

pencil, watercolour and brown ink
(20.2 × 15.7 cms)
exhibited: ?Norwich Society 1831 (38)
as *Sir Benjamin Wrenche's Court*
etched: *Picturesque Antiquities of the City of Norwich* 1842
Presented by Lord Harvey of Tasburgh
1929 (42.89.929)

FRONT AND BACK COVER ILLUSTRATION
John Crome 1768–1821 *Norwich River: Afternoon c.* 1819

oil on canvas
(71.1 × 100.3 cm)
In 1994 Norwich Castle Museum acquired the most important
work by John Crome to come on to the market for many years.
It shows a scene on the River Wensum, probably near the New
Mills at St Martin's at Oak, not far from where Crome lived in
St George's Colegate.

In this magnificent painting Crome has captured the stillness
of a hot summer day on the river. The area around New Mills
was a favourite subject with Crome and he exhibited several
views of it with the Norwich Society of Artists. His exhibit of
1819, *A Scene on the Norwich River – Afternoon*, could well be
this painting. See also pages 26–7 for New Mills subjects.

CONTENTS

FOREWORD

I am pleased to introduce this book which fills an important gap in the literature on the history of nineteenth century British art. Andrew Moore provides a general survey of that celebrated group of painters, all with close ties to Norwich and Norfolk, who made a significant contribution to the development of this important regional school. A total of one hundred paintings is featured, while many more, including portraits of the artists, are added as related material. All the illustrations are of paintings in the collections at Norwich Castle Museum and the book therefore acts as a summary guide to a collection of national significance in the care of Norfolk Museums Service. The paintings, individually discussed, are arranged in a broadly chronological order within nine chapters. Each chapter also contains a biographical outline of the leading artists. The introduction traces the artistic background of eighteenth century Norwich and discusses the unique phenomenon of the Norwich Society of Artists within the social, economic and political context of the city at the beginning of the nineteenth century.

The author provides a factual account of the leading personalities and their work which greatly enhances the reader's enjoyment of the paintings. Appreciation of the Norwich artists, including John Crome and John Sell Cotman, has often been clouded by problems of attribution but the illustrations in this book have been selected as undisputed examples of their work. Sincere thanks are due to the Chairman and Trustees of the Norwich Town Close Estate Charity for their generous grants to enable a third of the featured paintings to be reproduced in full colour. We are grateful to HMSO for undertaking to reprint this work which was first published in 1985.

Catherine Wilson
Director, Norfolk Museums Service

Addenda

Since this book was first published in 1985 research by Gillian McKenna in the St Stephen's Church register of baptisms has revealed that the true date of birth of Henry Ninham (see pp 118-119, 122-123) was 15 October 1796.

ACKNOWLEDGEMENTS

I wish to acknowledge my debt to the work of James Reeve, Curator of the Norwich Museum from 1851-1910, whose fruitful researches into the Norwich artists have remained of especial importance to writers on the School. It is to his records and also those of Horace Bolingbroke that I am indebted for many of the extracts from the local Norwich press which have proved extremely informative. Horace Bolingbroke's manuscript catalogue (at Norwich Castle Museum) of the etchings of the Norwich School has yet to be superseded by a much-needed more complete publication. I am also indebted to the work of my predecessor at Norwich, Miklos Rajnai, not only for the record systems established by him at the Castle Museum, but also for his published work, in particular *The Norwich Society of Artists 1805-1833 A dictionary of contributors and their work*, meticulously compiled with the assistance of Mary Stevens and published for the Paul Mellon Centre for Studies in British Art by the Norfolk Museums Service, 1976.

The authors whose publications I have found most helpful are listed in the Select Bibliography on page 146. However I wish to take this opportunity to thank in particular Trevor Fawcett who, in addition to his various publications on eighteenth and nineteenth century Norwich, has provided me with most helpful information. Similarly, I wish to record my thanks to Charlotte Crawley (née Miller) a copy of whose unpublished dissertation, 'Captain Manby and the Joy Brothers', she kindly deposited with Norwich Castle Museum.

I also wish to record my appreciation of the help I have received from a number of people in the preparation of the text. During the early stages of collating material I was greatly assisted by Adrian Annabel, Sarah Blandy, Gerald Chapman, Patricia Lennon and Michael Simpson who all gave of their time freely as volunteers within the Art Department of Norwich Castle Museum. I am grateful also for the invariable courtesy and help of the staffs of the Print Rooms of the British Museum and the Victoria and Albert Museum, as well as of the Norfolk Record Office and the Norwich Reference and Local Studies Libraries.

I welcome the opportunity to express my gratitude to colleagues who have helped at various stages in the preparation of the text for publication, including Damian Eaton, Robin Emmerson, June Santo and, in particular, Norma Watt for her painstaking help on countless occasions. Norma Watt, with the assistance of Michael Simpson, arranged the comprehensive photographing of the works for illustration, undertaken by G G.S. Photography, and also compiled the list of artists' portraits, the family trees and the index. My thanks are also due to Richard Malt for the design and supervision of the production of the project. I reserve my final thanks for my wife, Judith Moore, for her unstinting help and advice concerning the manuscript and for her informed discussions of many aspects of a subject that has frequently related to her own research interests.

Andrew W. Moore

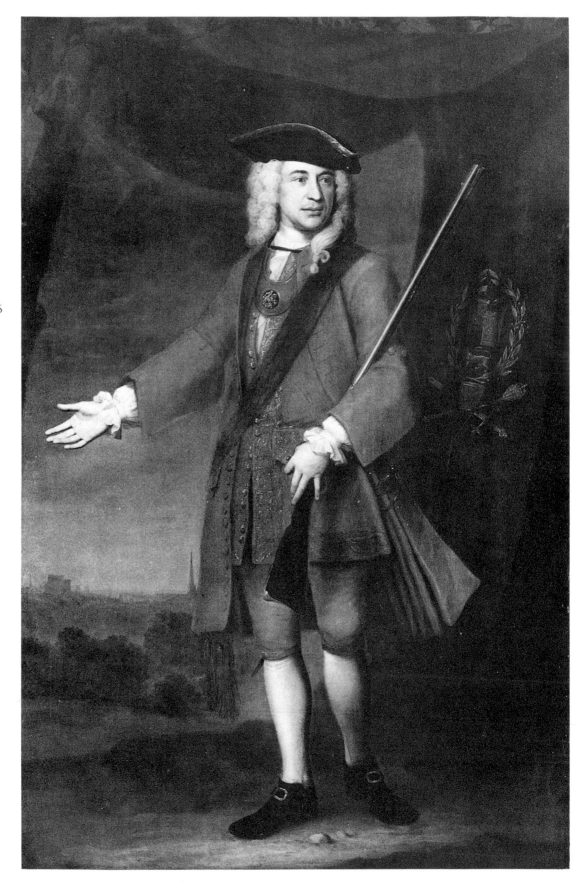

John Theodore Heins
*Timothy Balderstone,
Mayor of Norwich* 1736

oil on canvas
(236.3 × 147.4 cms)
signed, bottom right:
Heins, Fec:

Civic Portrait C 51

INTRODUCTION

The Norwich School of Artists has long been recognised as a unique phenomenon in the history of nineteenth century British Art. The 'School' is mainly represented by landscape paintings which portray tranquil rural scenes, usually of the landscape of Norfolk. The paintings of John Crome and John Sell Cotman are the finest work of the Norwich School. In their own lifetimes both masters received a degree of public recognition which fluctuated according to contemporary fashion, although Crome's acclaim was more Norfolk-bound than that of Cotman, whose publications, particularly the *Architectural Antiquities of Normandy* (1822), brought him wider praise. Nevertheless, their reputations since their deaths, like those of their lesser-known contemporaries, have become obscured by both mis-attributions and factual inaccuracies.

Thomas Bardwell
*Portrait of
William Crowe*
1746
oil on canvas
(228.6 × 147.3 cms)
signed, bottom right,
with monogram
Civic Portrait C40

It is the aim of this book to illustrate some of the best work of the painters of the Norwich School, taken exclusively from the most representative collection of their work, that of Norwich Castle Museum. The book is divided into ten chapters, which identify the leading artists, but also define their immediate circles and spheres of influence. Each chapter includes biographical material in order to define the amateur, professional and also family contacts which help to characterize the School. The present introduction aims to provide the eighteenth and nineteenth century context to an artistic phenomenon which is not exclusively artistic in its origins.

It quickly becomes apparent that the history of the School is effectively the history of that group of artists most closely associated not only with Crome and Cotman, but also with the Norwich Society of Artists, founded in 1803. The Society survived until 1833 and, viewed in the context of the contemporary economic and social climate of the period, this was in itself a significant achievement. Artistic activity in Norwich did not come to a dead stop in 1833, however, as the continuing work of the younger artists demonstrates. But the character of the City's art did gradually become a part of the national pattern and the Norwich context ceases to be especially significant for pictures produced there in the second half of the nineteenth century.

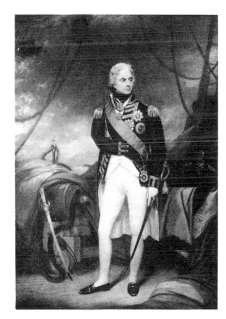

William Beechey
Horatio, Viscount Nelson
1801
oil on canvas
(261.4 × 182.6 cms)
Civic Portrait C 17

Just as artistic endeavour did not cease in Norwich in 1833, neither did it spontaneously erupt in 1803. The foundation of the Norwich Society must be seen within the context of a growing artistic autonomy in Norwich throughout the second half of the eighteenth century, which was itself closely allied to the economic, social and political worlds of both the city and the county at that time. The City of Norwich boasts a fine collection of portraits of civic dignitaries, which was begun in the seventeenth century. Men either from the landed gentry who distinguished themselves in Parliament or from the increasingly prosperous mercantile classes achieved the double honour of civic reponsibility and of having their full-length portraits painted by the local portraitists of the the day, notably John Theodore Heins (1697-1756) and Thomas Bardwell. Heins, a German emigré who had settled in Norwich, received his first commission from the citizens in 1732. Thomas Bardwell (1704-67) interrupted Heins' monopoly of civic portraiture when commissioned to portray William Crowe, Mayor in 1747. Between them Heins and Bardwell contributed at least twenty-five portraits to be hung in St. Andrew's Hall in Norwich, which effectively became one of

the first publicly owned picture galleries in provincial England. Other artists who added to the stock of civic portraiture during the late eighteenth and into the early nineteenth centuries included Herbert Stoppelaer who painted portraits of two mayors, Peter Colombine and Jeremiah Ives, around 1755-56; J.A. Adolph, who held an exhibition in the winter of 1764 (*Norwich Mercury*, 1 December 1764); and later William Beechey (1753-1839), whose commissioned portrait of Nelson represents the crowning achievement of the City's active patronage in portraiture.

During the latter half of the eighteenth century Norwich became an increasingly attractive centre for visiting artists. Artists such as Thomas Rowlandson (1756-1827) and Edward Dayes (1763-1804)

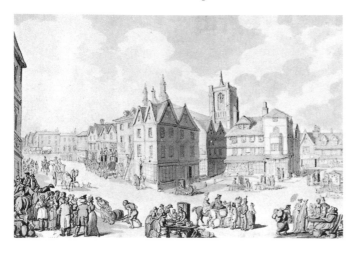

made brief visits, more to record aspects of the city than for any real sense of Norwich as an artistic centre. Joseph Farington (1747-1821) meanwhile included Norwich as just one stop on a wider itinerary, although he visited Norwich on more than one occasion as he had relatives in the City. Not all visiting artists simply passed through, however. One of the earliest artists to settle in Norwich was another German emigré artist, Lewis Hubner (1694-1769) who, according to his obituary in the *Norwich Mercury*, '...had resided near 30 Years in this City. His chief Excellence as a Painter, was in Still Life: in most of his Pieces, are Marks of intense Application, perspicuous and bold Expression, and Elegance in Colouring ...' (27 May 1769). Hubner was one of the first artists to hold auction sales of his paintings in Norwich—at the Union Coffee House—and may have been the earliest example of that breed of artist-dealer which flourished in Norwich and the county during the late eighteenth and into the following century. The most notable of these was Henry Walton (1746-1813), the son of a farmer at Dickleburgh who, after studying in London under Zoffany, established a high degree of connoisseurship and later acted as adviser and buyer for a number of East Anglian collectors, including Dawson Turner of Yarmouth and Thomas Harvey of Catton, Norwich. Another artist to settle in Norwich for a brief period (*c.* 1777-81) was John Sanders who on his arrival advertised his services as a portraitist, hoping 'this City will not consider him as an itinerant Painter, being desirous of gaining the Esteem and Respect of those on

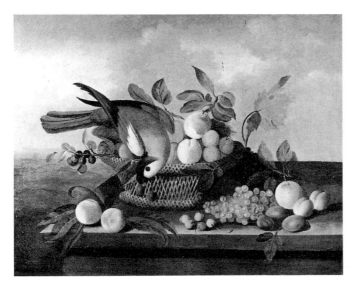

whom he will be happy to rely' (*Norwich Mercury*, 2 August 1777). He too was happy to diversify his talents, painting scenery for the Yarmouth and Norwich theatres, and advertising that he would also 'clean or repair the Collection of Pictures of any Nobleman or Gentleman, being acquainted with a Method of preserving them, known to but very few Persons who undertake that Employment' (*Norwich Mercury*, 1 January 1780). It is in the light of this established pattern of diversification that John Crome's activities as a buyer and seller, and also restorer of paintings may be seen.

Towards the end of the century there was an increasing number of dealers' exhibitions in Norwich and in October 1788 an exhibition was held at Cobb's large room in Rampant Horse Street to which local artists were allowed to submit pictures for a fee of one shilling a time (*Norfolk Chronicle*, 11 October 1788). An exhibition of Old Master paintings was opening at Sir Benjamin Wrenche's Court on 14 March 1796 which also included works by English artists and some Norwich painters (*Norwich Mercury*, 12 March 1796). The time was undoubtedly ripe for the establishing of a new artistic confraternity to act as a focus for the sporadic but increasing artistic activity within the City.

While the growth of artistic activity in Norwich during the eighteenth century is a key element in explaining the subsequent foundation and relative longevity of the Norwich Society of Artists, this context should not be divorced from the social, economic and political background of Norwich and Norfolk during the same period. Trevor Fawcett, in his paper, 'Measuring the Provincial Enlightenment: The Case of Norwich' (*Eighteenth Century Life*, vol. VIII, n.s., 1, October 1982) has summarised the inter-

relation between the industrial, commercial, intellectual, religious and political forces that drove Norwich actively to pursue a radical and progressive course during the eighteenth century. Daniel Defoe, in recording his impressions of Norfolk whilst on his tour of Eastern England in 1723, found 'a Face of Diligence spread over the whole Country; the vast Manufactures carry'd on (in chief) by the *Norwich* weavers, employs all the Country round in spinning Yarn for them ... An Eminent Weaver of *Norwich* ... made it appear very plain, that there were 120000 People employ'd in the Woollen and Silk and Wool Manufactures of that City only; not that the People all lived in the City, tho' *Norwich* is a very large and populous City too ...' (D. Defoe, *A Tour through England and Wales*). Until the 1730s Norwich was the most densely populated city in England outside London and thereafter rivalled only by Bristol in terms of its population well into the middle of the century. Norwich remained a regional capital, with a social mixture of prosperous merchant-manufacturers on the one hand and the Norwich and Norfolk squirearchy on the other. Apart from the example of the Cathedral and the parish churches there was a long tradition of Dissent in the City, originating partly from the religious refugees or 'Strangers' from abroad who had settled in Norwich. The radical nature of the City was compounded in the 1790s when its reputation was one of fervent Jacobinism. On 11 July 1789 an article in the *Norwich Mercury* asserted that: 'The apprehensions of some of certain bad consequences to be feared if the French should become a free people, are too ridiculous to be seriously answered.' The fall of the Bastille was celebrated for months after the event. The Guild Day entertainments at William Quantrell's Rural Gardens in June 1790 were proudly announced in the local press: 'The evening's amusements to conclude with "Paris in an Uproar, or Assault on the bastille" in which will be exhibited the Governor, Mayor, Gardes Criminelles and Gardes Francoises, Emblems of Liberty &c taken on the spot. The Scenery and Machinery painted and executed by Mr. Ninham of this City' (C.B. Jewson, *The Jacobin City...*, 1975, p. 16). Even by the end of 1791, when the Reign of Terror had caused a backlash of unfavourable opinion in the country, the *Norwich Mercury* still considered events with qualified optimism: 'from partial evil, general good may arise' (10 December 1791).

Fanny Burney's appraisal of Norfolk in 1792 is illuminating in the context of the political climate of the period: 'I am truly amazed, & half alarmed to find this County filled with little Revolution Societies, which transmit their *notions of things* to the Reformists of London' (27 November 1792). It was not only the purely political groups who formed societies, usually in the coffee-houses or taverns of the City, but also groups with intellectual, educational or social aims. The coffee-house and tavern society of Norwich had been commented upon as early as 1737 for its 'good fellow-ship, [which] perhaps not one city in England can match' (B. Mackerell: T. Fawcett, *op. cit.* p. 15). 'Good fellow-ship' became a tradition in Norwich, to the extent that freemasonry was quickly established, with the first Provincial Grand Lodge in the country instituted in 1759. Groups promoting natural history and the sciences flourished, including the Norwich Botanical Society and another progressive circle who formed around the Norwich bookseller, Abraham Brooke. Another notable group to form in Norwich was the Society of United Friars, a benevolent institution founded in 1785. Its alternative title, Society for the Participation of Useful Knowledge, gives an indication of its philanthropic aims, the printed text of which stated: 'From the Exercise of their mental Faculties, this Fraternity expect to derive *Information* and *Improvement;* to make their Meetings subservient to *rational* Purposes; and, at the same time, by the Indulgence of *cheerful Sentiments*, to enjoy a vivacious and innocent suspension from the Cares of Life' (Fawcett, *ibid*, p. 19). The *Norfolk Chronicle* recorded in 1788 that 'a certain degree of proficiency, either in literature, or the arts, or in some species of elegant and useful knowledge is a necessary candidate for admission into the Society' (24 May 1788). Artists who joined the Society included William Beechey and William Stevenson (1750-1821) and later John Sell Cotman, but the main cast of the Society was scientific in character. Another group to flourish in the 1790s was the Speculative Society (formed 1790), whose members included the radical intellectual William Taylor and his friend, the poet and antiquary, Frank Sayers.

It is in the light of this tradition of specialised-interest societies in Norwich that the foundation of the Norwich Society of Artists may be seen as a natural progression. Although the new radicalism in politics and non-conformity in religion was to initiate cultural or philanthropic societies elsewhere than in Norwich, the foundation of the Norwich Society of Artists on 19 February 1803 gave it the distinction of being the first provincial group of its kind to follow the example of the Royal Academy in London, founded in 1768. The *Norwich Mercury* announced the arrival of the new society on 26 March 1803: 'An Academy has lately been established in this city by a society of gentlemen for the purpose of

opposite

Thomas Rowlandson
Norwich Market Place
1788

pencil, watercolour
and brown ink
(26.8 × 39.9 cms)
inscribed, bottom left:
Norwich
Presented by the
Friends of the Norwich Museums
1963 (254.963)

opposite

Lewis Hübner
*A Parakeet perched on
a Basket of Mixed Fruit*

oil on canvas
(70.7 × 88.6 cms)
signed, bottom left:
L. Hubner Pinxit
Purchased with the aid
of a grant from the
Victoria and Albert Museum
1973 (383.973)

investigating the rise, progress, decline, and revival of the fine arts.' Other societies were to be founded along similar lines in Edinburgh and Bath (both in 1808), in Leeds (the Northern Society, 1809) and in Liverpool (1810), but none was to achieve the longevity of the Norwich Society or give rise to an autonomous school of painting as happened in Norwich.

The Society held its first annual exhibition in 1805, and the exhibitions were to continue without a break until 1825. A two year gap during 1826-27 was caused by the demolition of Sir Benjamin Wrenche's Court where the Society held its exhibitions. Their new gallery formed part of the new Corn Exchange which was completed in time for the Society to resume its exhibition sequence in 1828. The new gallery was a considerable improvement upon the exhibition room at Sir Benjamin Wrenche's Court which in 1826 was 'surveyed by a professional person, who reports it to be unsafe for the society's purpose ... many watercolour drawings were last year materially affected by the bad state of the walls' (*Norfolk Chronicle*, 8 July 1826). By contrast, the new exhibition room, designed by W. Mear, was, among other improvements, 'lighted from skylights of ground glass, continued round the room upon an inclination most adapted to throw light upon paintings' (*Norfolk Tour*, 1829, p. 1110). In 1828, with the fillip of a new gallery and in an apparent effort to broaden its scope and appeal, the Society changed its name to the Norfolk and Suffolk Institution for the Promotion of the Fine Arts. The way forward for the Society was, however, beset with problems, the chief of which was a lack of continuing local patronage and real financial support, with the result that the Society held its last exhibition, the twenty-seventh, in 1833. Before charting the demise of the Society, however, it is appropriate to consider the extent of its success.

Although the exhibiting artists were unhappy with the limited purchase of their pictures on exhibition throughout the 1820s, it was not until 1825 that the catalogue actually specified items were 'For Exhibition and Sale'. In 1805 only nineteen pictures were asterisked as for sale out of two hundred and twenty three items. The original articles of the Society make no mention of the sale of works, expecting instead to raise funds through fines for absenteeism or 'from admissions, subscriptions, benefactions &c.', any profits to be 'appropriated to the purchase of books, &c.' (article 10). The 1803 articles of the Society are in unison with the intellectual and educational aims of its Norwich forebears, 'with a view to discover and point out the Best Methods of Study, to attain to greater Perfection in these Arts [of Painting, Architecture and Sculpture].' A measure of the Society's success may be seen in the remarks made by the Duke of Sussex when he visited the Society's exhibition in 1819: 'His Royal Highness considered it most satisfactory to those gentlemen who are the supporters of the Institution, that Norwich as a provincial City, was first to be emulous of distinction in the fine arts, that Norwich was the first to follow the example of the Metropolis in concentrating the productions of her native artists in the form of an exhibition, and that it still survives the societies which have sunk into oblivion, either from individual cabal, or the laxity of public encouragement ... "I like", said his Royal Highness "the plan of pitting county against county, and have at all times considered Norfolk as the first in talent ..."' (*The Norwich, Yarmouth and Lynn Courier*, 28 August 1819). The Society had indeed survived a split within its own membership. In 1816 three of its leading members, Robert Ladbrooke, James Sillett and John Thirtle seceded and formed a new group, the Norfolk and Norwich Society of Artists.

The precise reasons for the split are unclear. Henry Ladbrooke, in his *Dottings*, reduced the history of the dispute to an unlikely clash between his father and John Crome over the expense and frippery of the Society's regular suppers: 'Crome being the more popular man carried the day in favour of the night suppers. My father and some others withdrew and exhibited on Theatre Plain' (*Eastern Daily Press*, 22 April 1921). The local press at the time made no clear analysis of the split, preferring to continue to review both the rival exhibitions, 'whom we still can but describe as pupils of the same school ... We shall also take the tone of the public wishes, at least in classing them together, rather than considering them as separate establishments' (*Norwich Mercury*, 1 August 1818). The seceding group held annual exhibitions for three consecutive years, 1816-18, after which the group disbanded, having failed to claim precedence as the establishment rather than the seceders. Ladbrooke and Thirtle resolutely refused to return to the fold of the Norwich Society, although Sillett had no such qualms. 'A Friend and Lover of the Arts' wrote to R.M. Bacon, editor of the *Norwich Mercury*, in August 1823 decrying the fact that amateurs still possessed voting powers in the Norwich Society, who 'cannot be supposed to have the interests of the Society so much at heart as the artists themselves' (*Norwich Mercury*, 16 August 1823). The editor, himself a member, denied the correspondent's fears, but it was John Berney Crome, the President that year, who gave the official reason in a reply printed in the following issue: 'Some few years

since the [seceders] made several attempts at innovation upon the rules and regulations of the Society, which were supported by no other members than themselves, and upon the final decision of the Society against their propositions (as likely to endanger the institution) they seceded ... Such are the facts' (*Norwich Mercury*, 23 August 1823). The articles of the Norwich Society had been revised by 1818 and the only significant change apart from matters of procedure was that the seventh article now read: 'All political and theological discussions are not to be admitted.' These are precisely the issues upon which passions were most likely to have been raised, particularly in the turbulent political climate that reigned in England during the post-Napoleonic war years. They are also an indication of an attempt to throw off

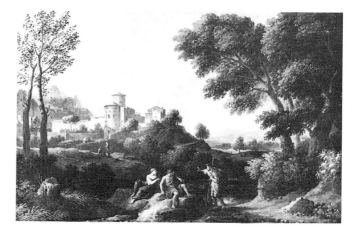

any overt radicalism at a time when practical matters such as fund-raising and the need for patronage from amongst the establishment were beginning to bite.

Since its inception the Norwich Society of Artists had been pursuing artistic endeavour despite an increasingly unstable social, economic and political climate. In the early years of the century the Society faced a possibly hostile political climate, as one more potentially radical local society attempting to establish itself within the context of an increasingly entrenched conservatism amongst the local squirearchy. The taste of the landed gentry was equally conservative, formed almost entirely by the tradition of collecting old master paintings. They were not likely to be attracted by the appearance of a new artistic confraternity and the opportunity to purchase contemporary art. Collections such as those at Holkham and Houghton, Felbrigg and Narford established a hierarchy of values, seemingly impervious to change. The example of French and Italian landscape paintings in the classical idiom, such as the celebrated Claudes at Holkham, represented locally the summit of endeavour within that particular tradition. The classical tradition was upheld in Norwich by Joseph Browne (?1720-1800), a copyist whose landscapes earned him the posthumous epithet, 'the Norwich Claude'.

Local collections did not exclusively represent the classical tradition, however, and the work of the Dutch masters of the seventeenth century was a more immediately attractive precedent for John Crome and his followers. The landscapes of Meindert Hobbema (1638-1709), van Goyen (1596-1656) and Ruiysdael (1628/9-82) contained images often close to familiar Norfolk countryside. It was perhaps

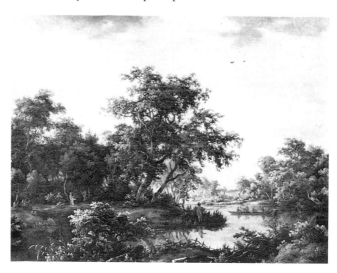

because of their tacit reference to this particular landscape tradition that the early Norwich landscapists met with a degree of success with their contemporaries. A considerable part of their appeal must also derive from the fact that they celebrated the quiet tranquillity of the English countryside at a time when England was at war. A similar appeal may be found in the landscape paintings of John Constable (1776-1837) and also in the early novels of Jane Austen and Walter Scott. These writers affirmed the virtues of order and conservatism through the more explicit medium of words; yet visual depictions of the beauty and tranquillity of the countryside may also be seen as reassuring celebrations of national harmony. Underlying the innovatory localised landscapes of the Norwich School is a profound reflection of the conservative values that characterized the early nineteenth century English cultural retreat from the turbulence of war and revolution.

The emergence of the new mercantile class during the later years of the eighteenth century and thereafter heralded the appearance of enlightened collectors such as Thomas Harvey of Catton. Harvey purchased old master paintings through dealers in Rotterdam and Antwerp as well as his agent Jacob More in Rome, but equally responded to the work of his contemporaries. Similarly, the squirearchy were not universally impervious to modern art, and local collectors included the Marquis of Stafford, whose Norfolk seat was at Costessey Park. Lower on the social scale were local tradesmen who collected modern works. Joseph Farington was impressed, on his visit to Norwich in August 1812, to meet two artisan collectors, 'Mr. Coppinge ... a House-painter and Glazier' (see p. 96) and 'Mr. Sprat ... a Coachmaker at

Norwich, and very much a lover of the arts. He showed me several pictures which He had collected, the works of modern artists' (J. Greig, *The Farington Diary*, VII, p. 100).

Joseph Farington also recorded his impressions of Norwich on that same trip, and his comments provide a touchstone to the social and economic situation of the City during this period: 'I do not recollect any town that exhibits a greater show of prosperity, more that of a place inhabited by people in good circumstances. Yet Norwich is said to have suffered more from the decay of its manufactures owing to the want of exportation in these difficult times than any other town in the Kingdom, and it has been lately proved that in consequence of the want of trade the population has lessened considerably within the last

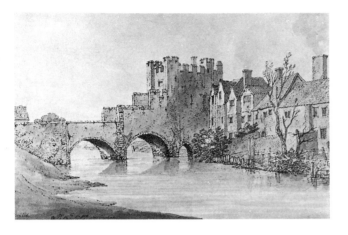

Joseph Farington
*The Bishop's Bridge,
Norwich* 1787

pencil, pen and ink with
blue and grey wash
(22.2 × 33.6 cms)
inscribed and signed,
bottom left:
*Norwich Octr. 12th 1787
Jos: Farington*
Presented by the
Friends of the Norwich Museums
1962 (576.962)

ten years' (*ibid*, p. 102). It is in the light of the knife-edge upon which the City's economy was placed during the first quarter of the nineteenth century that the successful survival of the Norwich Society of Artists should be viewed. In the early 1820s there was a sense of optimism and a strengthening economy, but the delicate balance upon which the success of the amusements of August Assizes week depended may be seen in the following report in the *Norwich Mercury* of 18 August 1821: 'The Harvest, which so frequently operates to thin the attendance during this week of gaiety, is this year so backward as not at all to interfere with the calls of business or the desires of pleasure. But perhaps the depressed state of the Country has a more powerful effect in stopping the flux of company to the City. The increase of our numbers, and the prosperity which attends the manufactories,

in some measure compensated the absence of the County population, and thus by these countervailing effects the city has exhibited pretty nearly the same phaenomena of a bustling time as usual.'

Towards the middle of the 1820s Britain suffered severe economic depression and Norfolk was amongst the first areas to be affected. On 22 June 1826, the Yarmouth banker Dawson Turner wrote to John Sell Cotman: 'the times are wretchedly bad: they are unfavourable to everything, but particularly to the luxuries of life, with which retrenchment naturally first begins' (S.D. Kitson, *The Life of John Sell Cotman*, 1937, p. 264). The first signs that the Norwich artists were falling foul of that attitude whereby art should be an area in which 'retrenchment naturally first begins' was in the *Norwich Mercury* review of the Society's exhibition in 1823. The reviewer commented that the establishment of the Society had been 'highly creditable; its support is even more so, because experience has taught our artists that the meaning of the word patronage, the foster mother of genius, is totally and entirely unknown in Norwich. The late Mr. Crome once said at the close of one of his most successful exhibitions, that he had not been applied to even for the price of a picture. Even the door-money paid during the three public weeks is insufficient, we understand, to defray the expences, and the artists themselves actually incur an annual charge ... It may, perhaps, create some remorse to those who ought to feel differently towards the arts, that at Newcastle, where a similar society has been formed only two years, a fine exhibition room has been built by subscription, and all the pictures there exhibited were sold. Some of our Norwich artists find there a merit, which is denied them at home. At Leeds, too, similar encouragement is afforded' (2 August 1823). This was the beginning of a concerted campaign on behalf of all those interested in the well-being and livelihood of art and artists in Norwich. The cancellation at the last minute of the annual exhibition in 1826, albeit due to the exhibition room being 'unsafe for the Society's purpose', occasioned an outspoken denunciation of the sad state of patronage in the City, which mentioned by invidious comparison not only Newcastle and Leeds, but Carlisle and Lancaster as well (*Norfolk Chronicle* 8 July 1826). The following year James Stark added his voice to the critics of those who appeared indifferent to the financial difficulties of the Society and the aspirations of its members. He marshalled his evidence in an impressive essay entitled 'On the moral and political influence of the Fine Arts', the content of which was duly published by the *Norwich Mercury* (26 May 1827). As far as Stark was concerned 'patronage [was] and ever has been *unknown*' in Norwich since the inception of the Society. In detailing the average receipts at the door and annual sales at Edinburgh, Newcastle, Carlisle and Leeds, whilst also taking comparative populations into account, he could not bring himself to record the lamentably low receipts and sales at Norwich, preferring 'to pass over facts so disgraceful to the residents of the district'. In the hope of encouraging patronage in the future Stark chose not to lay the blame upon the citizens of Norwich: 'The prosperity of Norwich, though an old manufacturing place, had decayed during the war,

and has sprung up again during peace. It is therefore of recent origin. The generation which rears opulence is seldom the generation which uses it with the liberal discretion, especially in the encouragement of the fine arts, that gives to wealth its best title to respect. It is to the educated offspring of the first gainers of riches that we must look for the patronage of art, and this race is hardly yet arisen, though it is rising amongst us.' In reality, however, the fast-growing industrialised cities to which the Norwich artists consistently referred and sent their work (and where they invariably found a buyer), were quickly to overtake Norwich as manufacturing and industrial centres, and also as centres of artistic patronage founded upon new money.

Despite its new gallery and name, and an assertive policy of holding two loan exhibitions of Works of Ancient and Modern Masters to attract the attention of the local collectors, in 1828-29, the Norwich Society was short-lived thereafter. The Society did not meet with complete indifference, being given in 1829 a grant of one hundred pounds by the Norwich Corporation to establish 'a gallery of antique statues' (*Norwich Mercury*, 27 June 1829). The tide had, however, turned against them, and the nature of this piece of civic patronage was simply a prelude to the subsequent fractured debate over the institutionalising of artistic activity in Norwich along the lines of the Government Schools of Design (see p. 129). One of the major talents to emerge from the Norwich School of Design (founded 1845) was the artist Frederick Sandys (1829-1904), and his removal to London by 1851 represents the break with tradition that was finally the most creative stance a Norwich artist could make by the middle

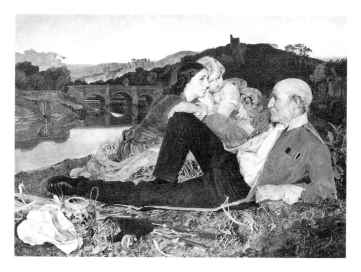

Frederick Sandys
Autumn 1860

oil on canvas
(79.6 × 108.7 cms)
R.J. Colman Bequest
1946 (1209.235.951)

of the century. Sandys' oil *Autumn*, painted in the Pre-Raphaelite style, owes more to the example of Millais than to Sandys' Norwich forebears. With its depiction of an old soldier reclining on the banks of the river Wensum, with Bishop's Bridge in the background, *Autumn* forms a coda to the tradition of the Norwich School.

The achievement of the Norwich School of Artists lies in many directions, not least in its survival for thirty years at a time when similar societies were short-lived. Its autonomy as a School and its status as the first exhibiting society to be founded upon the example of the Royal Academy are both marks of success. Although not exclusively a School of landscape painting, the Norwich artists were among the innovators at the beginning of the nineteenth century to reject the old hierarchy of classical values in the depiction of landscape. Their portrayal of the tranquillity of the English countryside during a period of war allied the School with those conservative values which regarded celebrations of the rural landscape almost as symbols of national harmony. The Norwich painters succeeded in attracting both local and national patronage, failing locally only in the 1820s when recession took hold of the agrarian economy upon which their County traditionally relied. The Norwich Society's longevity must in great measure be due to the increasing professionalism of its organisation, in which both professional drawing masters and amateurs took part. The solidarity of its members enabled the Society to survive the potentially hazardous rift of the Secession in 1816, and also encouraged a spirit of artistic experimentation and the creative interchange of ideas. One of the most significant fruits of that interchange was the development of a new intimacy of focus upon the localised landscape, expressed not only in oils, drawings and watercolours, but also in etching. The etchings of the Norwich School remain the most unrecognised aspect of the quiet revolution that the Norwich artists achieved, establishing that tradition of etching in Britain which was to reach its climax with the works of Whistler. Crowning all these achievements is the work of Crome and Cotman, two of the most original talents in the history of early nineteenth century British art, whose only contemporary rivals in the field were Thomas Girtin, J.M.W. Turner and John Constable.

CROME & LADBROOKE

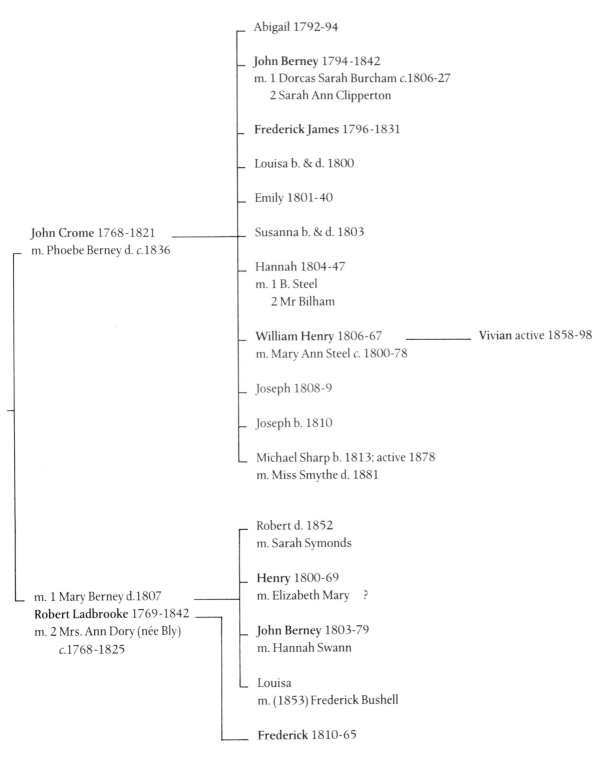

Abigail 1792-94

John Berney 1794-1842
m. 1 Dorcas Sarah Burcham *c.*1806-27
 2 Sarah Ann Clipperton

Frederick James 1796-1831

Louisa b. & d. 1800

Emily 1801-40

Susanna b. & d. 1803

Hannah 1804-47
m. 1 B. Steel
 2 Mr Bilham

William Henry 1806-67 **Vivian** active 1858-98
m. Mary Ann Steel *c.* 1800-78

Joseph 1808-9

Joseph b. 1810

Michael Sharp b. 1813; active 1878
m. Miss Smythe d. 1881

John Crome 1768-1821
m. Phoebe Berney d. *c.*1836

m. 1 Mary Berney d.1807
Robert Ladbrooke 1769-1842
m. 2 Mrs. Ann Dory (née Bly)
 *c.*1768-1825

Robert d. 1852
m. Sarah Symonds

Henry 1800-69
m. Elizabeth Mary ?

John Berney 1803-79
m. Hannah Swann

Louisa
m. (1853) Frederick Bushell

Frederick 1810-65

COTMAN & THIRTLE

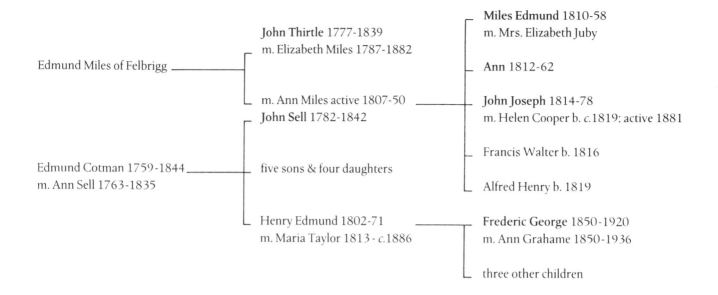

Edmund Miles of Felbrigg

John Thirtle 1777-1839
m. Elizabeth Miles 1787-1882

m. Ann Miles active 1807-50

John Sell 1782-1842

Edmund Cotman 1759-1844
m. Ann Sell 1763-1835

five sons & four daughters

Henry Edmund 1802-71
m. Maria Taylor 1813 - c.1886

Miles Edmund 1810-58
m. Mrs. Elizabeth Juby

Ann 1812-62

John Joseph 1814-78
m. Helen Cooper b. c.1819; active 1881

Francis Walter b. 1816

Alfred Henry b. 1819

Frederic George 1850-1920
m. Ann Grahame 1850-1936

three other children

STANNARD & HODGSON

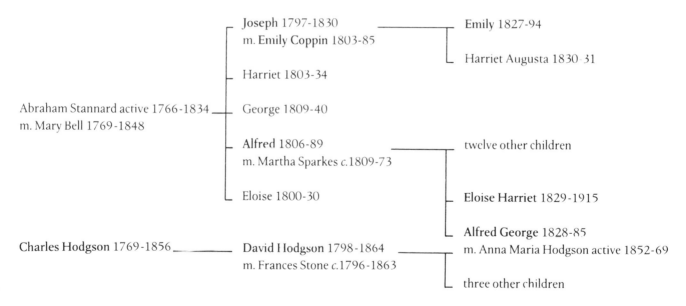

Abraham Stannard active 1766-1834
m. Mary Bell 1769-1848

Joseph 1797-1830
m. Emily Coppin 1803-85

Harriet 1803-34

George 1809-40

Alfred 1806-89
m. Martha Sparkes c.1809-73

Eloise 1800-30

Charles Hodgson 1769-1856

David Hodgson 1798-1864
m. Frances Stone c.1796-1863

Emily 1827-94

Harriet Augusta 1830-31

twelve other children

Eloise Harriet 1829-1915

Alfred George 1828-85
m. Anna Maria Hodgson active 1852-69

three other children

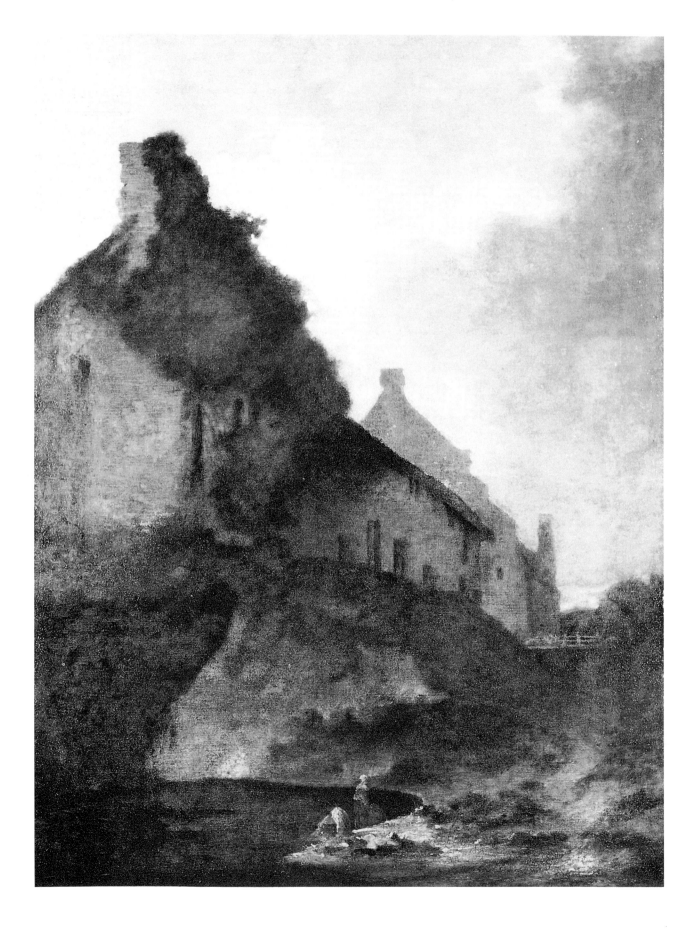

JOHN CROME

On 4 May 1821, within a fortnight of John Crome's funeral, the Rev. William Gunn wrote from his home at Smallburgh near Norwich to his friend, the Royal Academician John Flaxman: 'The fine arts are not forgotten at Norwich; we too have an annual exhibition. We are now deploring the loss of one of its first ornaments Crome who died a fortnight ago. He was a poor lad who laid the foundation of his celebrity in cleaning brushes for Beechey. He never after lost sight of the art and when he returned to his native city pursued one branch of it as a journeyman house painter and at length aspired to the higher department of landscape and some of his works have been in the royal exhibition. People are now crazy for his pictures which are bought with avidity and sell high...' (Trinity College Library, Cambridge). This adds credence to Henry Ladbrooke's later comment in 1861 that at the close of the Norwich Society exhibitions 'there was not a picture of his that had not the word "sold" upon it' (Reeve Collection, BM). R.M. Bacon, in his obituary of John Crome, tells of Crome's increasing success as a drawing master on the one hand and as a frequently-commissioned artist on the other. 'His pictures were beginning to be known and valued in London, the great mart of talent; and those last exhibited in the British Gallery have been highly praised by excellent judges' (*Norwich Mercury*, 28 April 1821). Bacon further observed that his funeral was attended 'by a numerous attendance of artists and other gentlemen. Mr. Sharp, Mr. Vincent, came from town on purpose, and Mr. Stark was also present. An immense concourse of people' attended the funeral. Crome had achieved, in his own lifetime, considerable local esteem and a growing metropolitan reputation with an oeuvre of paintings and etchings which remain a signal contribution to the history of British landscape painting.

John Crome

John Crome, the son of a journeyman weaver, was born in Norwich on 22 December 1768, and was baptised on Christmas Day in the Church of St. George, Tombland. The skeletal history of his early years has often been fleshed out with anecdote and tradition but a few facts do emerge. In 1783 Crome was apprenticed to a coach and sign painter, Francis Whisler. His indentures, although dated 15 October 1783, actually operated from 1 August that year (NCM). In this respect his career may be allied to those of his contemporaries John Ninham and James Sillett, both of whose beginnings lay in the field of heraldic painting (see pp. 47-48). His apprenticeship ended in 1790, when he presumably continued in the trade. In the Reeve Collection (BM) there is an autograph receipt for 'Painting Lame Dog writing and Gilding Board for ye Lamb and gilding name of ye Maids Head', dated 22 May 1803, the year of the foundation of the Norwich Society of Artists. Crome appears to have had a cool head for business and was not averse to undertaking any profitable exercise related to his artistic training. He was the first amongst his Norwich contemporaries to undertake picture restoration, being paid forty pounds for cleaning and repairing the civic portraits hanging in St. Andrew's Hall, for which he received an extra seven guineas towards the expenses involved in undertaking the work (Reeve Collection, BM). In 1820 he was again called upon to clean the pictures in St. Andrew's Hall, for which he received twelve guineas.

On 2 October 1792 John Crome was married to Phoebe Berney in the church of St. Mary Coslany by the Rev. S. Forster. Witnesses included Robert Ladbrooke and the bride's sister, Mary Berney, who were themselves to marry exactly a year later. On 30 October 1792 Phoebe Crome gave birth to their first child, Abigail, but she did not survive infancy (see chart, p. 16). 1793 was a year of illness for Crome, as he suffered from hydrocele for which he was admitted to Norwich Hospital twice within six months. The 1790s saw Crome consolidate his artistic training. Although he was not specifically enrolled as a pupil to a master, it is a misconstruction of his development to infer that he was self-taught or received only rudimentary tips from the painters he met. The Rev. William Gunn in his letter to John Flaxman refers to the young artist's early contact with William Beechey. The evidence of Crome's oils suggests a true study of Beechey's work, as well as a knowledge of Beechey's milieu. Beechey was a fellow Academician of Richard Wilson, an artist whose work also proved an early influence upon Crome. Similarly John Opie was another Academician whom Crome met at this time. Opie visited Norwich in 1797 where he met Amelia Alderson. They married the following year, and it is likely that this is the year in which Crome sat for Opie's portrait of him (NCM 15.4.99).

Perhaps the most significant influence upon Crome during the last decade of the eighteenth century was Thomas Harvey, a patron, collector and amateur artist in his own right. By profession Harvey was a

opposite

John Crome
*View of Carrow Abbey,
near Norwich* 1805

oil on canvas
(133.7 × 99 cms)
R.J. Colman Bequest
1946 (705.235.951)

master weaver and also property owner. His wife was the daughter of a merchant of Rotterdam, a connection which greatly facilitated his acquisition of a number of continental pictures, most notably Dutch seventeenth-century masters. Harvey's collection was later sold in two parts: his sale of 1819 included 'original Pictures by Wilson, Cuyp, Teniers, Salvator, Jordaens, Fyt, Hondikooter, Ruysdael, etc., etc.' (*Norfolk Chronicle*, 5 June 1819), while the sale of 12 & 13 January 1821 contained drawings by artists who included Gainsborough, Cuyp, Berghem and 'Van de Velde' as well as landscapes by Harvey himself. The friendship of Harvey was a formative experience for Crome on a number of levels. According to Dawson Turner, Crome had copied Harvey's Gainsborough oil *The Cottage Door* (see p. 23) while Harvey's own sketching and etching style, despite its amateur quality, very much espouses that of Gainsborough. Crome was to be equally attracted to Harvey's Dutch pictures such as Hobbema's *Landscape* (Buhrle Collection, Zürich), which Dawson Turner later claimed was copied by Crome (D. Turner, *Outlines in Lithography*, 1840). Another important early influence upon Crome was the work of Richard Wilson, examples of which were not only in Harvey's collection, but later also in the collections of Daniel Coppin, a house painter and glazier by trade (see p. 96), as well as Dawson Turner at Yarmouth. Crome's Memorial Exhibition organised by the Norwich Society in the autumn following his death contained two oils ascribed to 1796 and 1798, both entitled *Composition, in the Style of Wilson*. Of his surviving early work *Norwich from Mousehold Gravel Pits* (T. Colman Collection) is the earliest known example of a Wilson influence, while a number of later works reveal a continued debt to Wilson's technique throughout the remainder of Crome's career (see, for example, p. 26).

Crome's early acquaintance with Harvey and his collection almost certainly encouraged Crome himself to take up collecting. His accounts with the Gurneys reveal that in 1812 Crome was in their debt for over two hundred and twenty pounds (R.H. Mottram, *John Crome of Norwich*, 1931, p. 122). That September he held a three day sale of his collection at Yarmouth, 'the genuine and entire property of Mr CROME, of Norwich, a great part of whose life has been spent in collecting them' (*Norwich Mercury*, 12 September 1812). The sale no doubt included a number of optimistic attributions, but Crome's advertisement claimed it to be 'a collection as is well worth the attention of connoisseurs, amateurs, artists, and the public of every description, and such as, it is presumed, was never before exposed to sale in the County of Norfolk.' The collection contained a few Old Master paintings and also drawings and prints which included works by 'Woollett, Strange, Fittler, Bartolozzi, Weirotter, Waterloo, Rembrandt &c. &c.' Tradition has it that the sale realised some two or three hundred pounds (Reeve Collection, BM): certainly, by 31 December 1815 his bank book showed him over eight hundred and thirty-eight pounds in credit (*Morning Post*, 12 April 1921). Crome also extended his activities to dealing in pictures, although at what point in his career is uncertain. Dawson Turner records having purchased a *Rocky Landscape* by Isaac Moucheron for twelve pounds from Crome as well as *Vase of Flowers* attributed to John Baptist Monnoyer (D. Turner, *Outlines in Lithography*, 1840). In 1819 Crome purchased one hundred and ninety-five pounds' worth of pictures at the sale of John Patteson of Surrey Street, Norwich, on 28 & 29 May (W.F. Dickes, *The Norwich School of Painting*, 1905, p. 126). Not all of these pictures reappeared in his own collection sale after his death, a further testimony to his practical business sense. This has considerable bearing upon his one trip abroad, of which he wrote to his wife from Paris: 'I shall make this journey pay... I shall be very cautious [how I lay] out my money' (NCM). Another purpose of his visit, accompanied by Daniel Coppin and William Freeman, was specifically to visit the art collections brought back by Napoleon.

Fortified by his knowledge of the work of the Dutch Masters and the contemporary example of Gainsborough, Wilson, Beechey and Opie, Crome established a practice as a Drawing Master. According to Dawson Turner, he became a teacher on marrying: 'There was at once about him a good temper that was proof against any trial, and an originality that was sure to captivate' (D. Turner, *Memoir of Crome*, 1838). The Gurneys of Earlham were among his earliest pupils. Richenda Gurney recounts in her journal for 17 January 1798: 'I had a good drawing morning, but in the course of it give way to passion with both Crome and Betsy [who was to become Elizabeth Fry]—Crome because he would attend to Betsy and not to me, and Betsy because she was so provoking.' (Augustus Hare, *The Gurneys of Earlham*, vol. I, p. 74). In 1802 Crome accompanied the Gurney family on a visit to the Lake District. Rachel Gurney's diary records that Crome left the party at Patterdale on 28 August. The Gurneys visited South Wales the following year but there is no record that Crome accompanied them on that occasion, although Henry Ladbrooke does record anecdotes which tell of Crome visiting Wales in 1804 with Robert Ladbrooke (*Dottings*, 1861). Crome exhibited a number of views relating to these trips in the

first exhibition of the Norwich Society in 1805, including views of Patterdale, Chepstow Castle, Goodrich Castle and Tintern Abbey. He again went to the Lakes with the Gurneys in 1806. They are recorded as being at Cambridge on 16 July and at Grantham the following day, having visited Burleigh House, but Crome appears to have again left the party early and not accompanied them to Scotland.

Crome also spent a certain amount of time at Yarmouth, where he was employed by Dawson Turner as drawing master to the Turner ladies. He was succeeded in this post by John Sell Cotman, and Crome continued his teaching as drawing master at Norwich Grammar School. That he took his teaching seriously may be seen in two of his letters to his pupil James Stark which still survive. The first, dated 3 July 1814, includes a postscript for Stark to remember to submit work to the Norwich Society even though he was then in London (Lugt Collection). His most important extant letter is that to Stark dated January 1816, in which he gives written indication of that quality which he believed an artist should strive for: 'Brea [d] th must be attended to; if you paint a muscle give it brea [d] th. Your doing the same by the sky, making parts broad and of a good shape, that they may come in with your composition, forming one grand plan of light and shade, this must always please a good eye and keep the attention of the spectator and give delight to every one. Trifles in Nature must be overlooked that we may have our feelings raised by seeing the whole picture at a glance, not knowing how or why we are so charmed' (BM Add. MS 43830, 73).

While one readily recognizes these qualities in Crome's own work, they are precepts which did not find universal acceptance. Like Cotman, Crome received an unfair share of criticism. As early as 1806 Joseph Farington records in his diary the response of two art critics at the opening of the Royal Academy exhibition of that year. The two critics were Taylor of the *Sun* and James Boaden of the *Oracle:* 'The *latter* after looking round the room sd. He had never seen so many bad pictures. On looking at Turner's *Waterfall at Schaffhausen* He sd. "That is Madness" — "He is a Madman" in which Taylor joined. — In the anti-room, looking at an Upright landscape by Croom, Boaden said, "There is another in the new manner", "it is the scribbling of painting. — So much of the *trowel* — so mortary — surely a little more finishing might be born?"' (5 May 1806). The public was not yet ready to accept unanimously works of the magnificent, monochromatic range of paintings such as Crome's *View of Carrow Abbey, near Norwich* (see p. 18). Although he later lightened his palette, even at the end of his career the critics were commenting upon the 'unfinished' appearance of his work: 'the artist loses "half the praise he would have got" had he but discreetly bestowed a little more pains upon the finishing of it' (*Norfolk Chronicle* 29 July 1820, of Crome's (36) *The Fishmarket at Boulogne*).

Crome was undoubtedly a leading spirit behind the formation of the Norwich Society in 1803 and was early credited in the press for being the founder both of the Society and of the 'Norwich School'. He showed pictures annually at the Society exhibitions until he died and yet the identification of his works remains bedevilled by problems of misattribution. The existence of numerous contemporary copies by both his pupils and, more problematically, copyists whose own stylistic personalities remain obscure, increases the mystification. Yet those oils that may be securely identified on either stylistic or documentary grounds reveal a body of work entirely original and completely confident in execution. Crome's technique, often using thin glazes for shadows, with broadly applied lights, is founded upon a painterly tradition before which even his best students falter. While George Vincent at times approaches the atmospheric naturalism of his master, his sense of composition reveals a gulf between them. Similarly, the work of John Berney Crome is markedly inferior to that of his father, although his contemporaries rushed to assure both him and themselves that Crome's mantle had truly fallen upon the shoulders of his eldest son. Of John Crome's watercolours to survive, together with his superb etchings, one recognizes a sureness of design and draughtsmanship founded upon the work of artists such as Gainsborough, Rembrandt or Waterloo (see pp. 22, 23). Attempts to isolate single influences, however, ultimately pale before the fresh vision, clear colour and strong design that lie at the heart of Crome's endeavour.

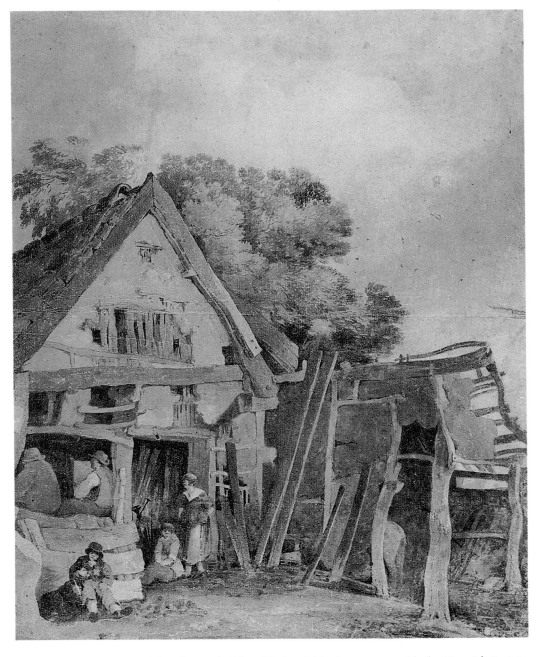

John Crome
*The Blacksmith's Shop,
Hingham, Norfolk*
c. 1807-11

pencil and watercolour
(54.1 × 44.2 cms)

Presented by P. Moore Turner
1942 (123.942)

Crome exhibited a total of four blacksmith's shop scenes with the Norwich Society: three in 1807 and one in 1811. He also exhibited two oils of similar subjects in London: one with the Royal Academy in 1808 (591) and one with the British Institution in 1818 (75). The Royal Academy oil was almost certainly one of the Norwich exhibits of 1807, possible (81) *Blacksmith's Shop, Hardingham.* Hingham and Hardingham are neighbouring villages. The building represented in the oil (Philadelphia Museum of Art) appears to be the same as that in the watercolour at Norwich, although a closer watercolour version of the oil is at Doncaster. More loosely painted than the Norwich variant the Doncaster watercolour is perhaps an indication of his watercolour technique of *c.* 1807 and possibly one of the Norwich Society exhibits of that year (19 or 100).

The case for placing the stronger modelling of the Norwich version within the period *c.* 1809-11 is strengthened by comparison with the work of Robert Dixon at this time (see p. 56) and also by comparison with the work of John Sell Cotman. The tradition that Crome's gable-end and cottage compositions owe much to the example of Gainsborough's *Cottage Door,* while true in terms of composition and subject, seems less so in relation to the style of the Norwich version. This shows a greater affinity with Crome's contemporaries, strongly suggesting the possibility that it was the 1811 exhibit (83) *The Outside of a Blacksmith's Shop.*

The Yare at Thorpe, Norwich is one of the earliest and most subtle of Crome's oils. The fluid use of a monochromatic palette is similar to that of *Carrow Abbey*, exhibited with the Norwich Society in 1805 (see p. 18). While the sense of atmospheric effect is similar, that of place is very different. Crome's control of light and atmosphere and selection of

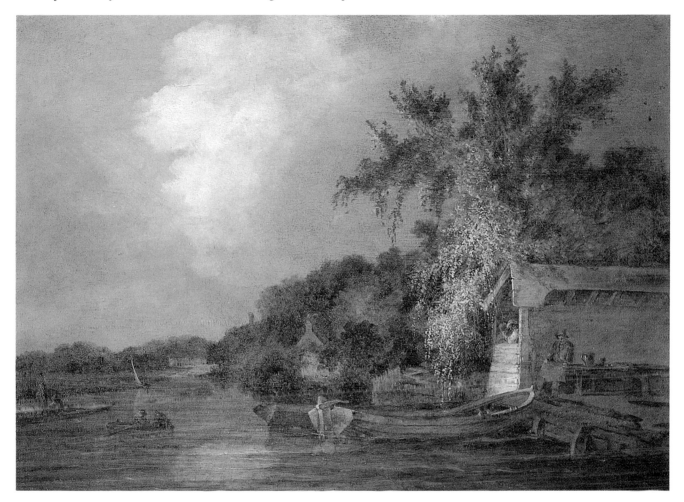

John Crome
The Yare at Thorpe, Norwich
c. 1806

oil on mahogany panel
(42.2 × 57.6 cms)

R.J. Colman Bequest
1946 (707.235.951)

subject is here particularly reminiscent of the work of the Dutch master, van Goyen. A pencil sketch survives on which the oil is based (BM 1898.5.20.21). Signed, inscribed and dated *View from King's Head Gardens at Thorpe. July 3ᵈ 1806. J. Crome*, the pencil sketch differs in the exclusion of the river traffic to the left, reinforcing the impression that Crome has translated a topographically accurate sketch into a more romantic interpretation of a sense of the place.

Although both composition and technique recall van Goyen, the painting of the luxuriant willow tree is also reminiscent of the work of Gainsborough, another early influence upon Crome. John Crome's early knowledge of Gainsborough depended to an extent upon works in local collections such as that of his friend and patron Thomas Harvey of Catton. Harvey's collection included Gainsborough's *The Cottage Door* (now in Huntingdon Library and Art Gallery, California) and *Landscape with Cows* (Gainsborough to Harvey, London, 22 May 1788). Evidence of Crome's interest in Gainsborough at this period may be seen in his exhibiting (221) *Sketch, from nature, in the Style of Gainsborough* with the Norwich Society in 1806, the year in which he also submitted two Thorpe river scenes (93,96). The river at Thorpe provided the Norwich painters with a wealth of water traffic scenes, but none was to equal the quiet tranquillity and tones of this small panel.

John Crome
St. Martin's Gate, Norwich
c. 1812-13

oil on mahogany panel
(50.8 × 38.3 cms)

E.E. Cook Bequest, through
the NACF 1955 (170.955)

John Crome exhibited a total of ten pictures with the Norwich Society with St. Martin's
in the title. The two earliest of these, shown in 1807, were pencil sketches, while the
remainder, with one exception, were also described as river scenes. Crome never actu-
ally exhibited a picture entitled St. Martin's Gate (or Fuller's Hole as the scene is some-
times called). His titles referred simply to the area of St. Martin's. The traditional notion
that the building with the archway in the background is St. Martin's Gate (taken down
in 1808) was first discounted in the catalogue for Crome's bicentenary exhibition in
1968: the gates were neither like this, nor sited parallel to the river. The scene may be
Fuller's Hole, an area just outside that of the Gates, but it does not show Fuller's Hall,
the most prominent building then in the vicinity.

At least two other versions of this subject are known, but they are not readily identifi-
able with Crome's exhibited titles. The composition was also popular with copyists,
including Thomas Lound whose version is dated 1848 (O. and P. Johnson, 1963). The
popularity of Crome's composition amongst his contemporaries and followers epito-
mizes both the consummate intimacy of vision which reveals Crome at the pinnacle of
his powers as a painter and the chasm that separates him from those whom he inspired.
While the precise date of composition remains unknown, a date within the middle of the
period 1810-16 is most likely.

Crome exhibited six paintings of Yarmouth Jetty from 1807-19, as well as several other

John Crome
Yarmouth Jetty c. 1810-14
oil on canvas
(44.8 × 58.3 cms)
Purchased 1945,
Beecheno Bequest Fund (92.945)

Yarmouth scenes which may have included the Jetty in the composition. Writers have consistently differed as to the probable date of execution: Wodderspoon, Dickes, Baker and the Cliffords suggest 1808-9; Hawcroft prefers a later date; Hemingway proposes c. 1810, while Goldberg suggests c. 1812-13. It is interesting to note that the Jetty appears in a good state of repair, suggesting a date for the picture of no earlier than 1809, when major repair work on the Jetty is recorded as complete. On 29 June 1808 the Consultant Engineer William Jessop had reported to the Port and Haven Commissioners that the Jetty was 'in so very ruinous a state that very little of it co[d]. remain on the repair of it' (PH 102).

A later dating is also supported by the higher degree of finish in Crome's technique and also in the painting of the figures. The latter finds parallels with his figure painting in the securely datable oil *View in Paris—Italian Boulevard* of 1814-15 and more especially *The Fishmarket at Boulogne* (exhibited 1820). Crome's broad figure painting is also recalled in the work of George Vincent, his pupil in the years c. 1812-16. There are a number of other surviving versions of *Yarmouth Jetty* by John Crome, one of which is in the collections at Norwich (NCM 1.4.99). The two versions now at Norwich were both copied by Thomas Lound, the former in watercolours (NCM 96.356.957) and the latter in oils (NCM 2.134.934).

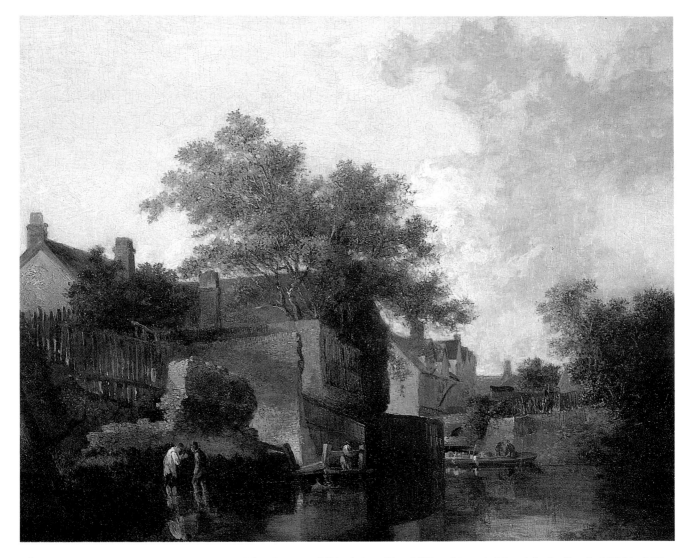

John Crome
New Mills: Men Wading
c. 1812

oil on pine panel
(28 × 35.5 cms)
Purchased 1970 (531.970)

John Crome exhibited three New Mills subjects in Norwich, the first in 1806 (75) *View on the river [Wensum] at the back of the New Mills, Norwich, evening.* The following year he exhibited another view of the back of the New Mills, this time a pencil sketch (167). *New Mills: Men Wading* is almost certainly the picture exhibited in 1812 (115) *Creek Scene, near the New Mills, Norwich.* Collins Baker was the first to suggest this, a proposal borne out by Hochstetter's map of Norwich (1789) which clearly shows the creek between the New Mills area and St. Michael's Bridge, the creek itself traversed by a small bridge. It is possible that this was shown again in the seventeenth annual exhibition of 1821 when (40) *View, looking from the New Mills towards St. Michael's Bridge, by the late Mr. Crome* was one of four pictures exhibited in Crome's memory. However, a picture of this title was submitted to his Memorial Exhibition in the autumn of 1821 (81), dated to 1820, suggesting that Crome had returned to this subject in his last year.

A total of six, possibly seven, New Mills subjects were shown in the Memorial Exhibition of 1821, yet of all the variants surviving only *New Mills: Men Wading* and *Back of the New Mills* (see p.27) survive as authentic examples. Crome etched the subject in 1813 (Theobald 5) and the two or three paintings of this scene now known all derive from the etching and are by copyists or imitators.

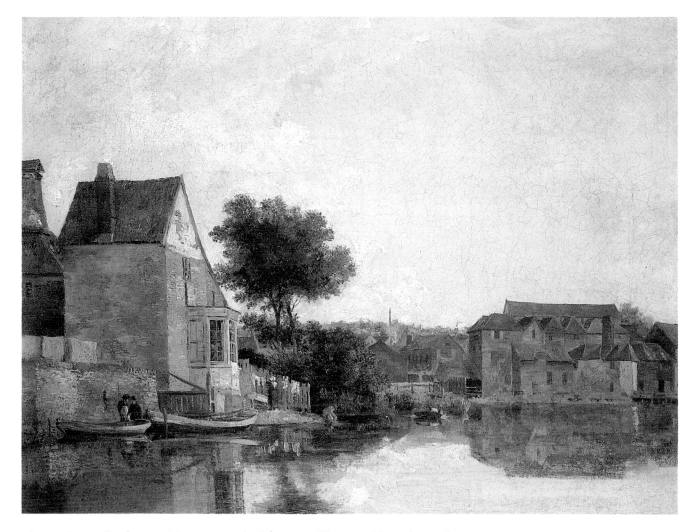

The site depicted is the river Wensum, north of the New Mills, viewed from the north and looking south towards the Mills with the city beyond. The building in the right background is the 'New' Mills, so called since the fifteenth century. The subject was also etched by Crome (Theobald 4), but although similarly titled *Back of the New Mills* the etching represents only part of the same scene, with the viewpoint reversed, looking from the New Mills towards open country. The group of buildings to the left of the oil appears to be the same as the group on the right of the etching.

This version does not appear to have been exhibited with the Norwich Society during Crome's lifetime (see p. 26). In the Memorial Exhibition of 1821 there were six pictures specifically called *Back of the New Mills* or *New Mills*. Five of these were dated according to the catalogue to the period of 1814-17 and this version is presumably one of these. Hawcroft followed this reasoning in ascribing this picture to *c.* 1814-17, while the Cliffords have suggested *c.* 1815-18, pointing out that this type of picture presumably influenced the work of Henry Ninham, particularly in the palette of soft greys and pinks. Its style and subject-matter were also followed by Crome's pupil James Stark, whose *Old Houses at Norwich* was formerly ascribed to Crome (formerly Mellon Collection, Sotheby's, 18 November 1981, lot 6). Goldberg follows Baker in preferring a date of 1810-12.

John Crome
Back of the New Mills
c. 1814-17

oil on canvas
(41.3 × 54 cms)
Bequeathed by J.J. Colman,
1899 (2.4.99)

This is one of John Crome's most celebrated etchings. It is not recorded precisely when Crome turned to etching, but his earliest dated example is in softground, *Colney*, dated 1809. His total etched *oeuvre* is of nine softgrounds and twenty-five pure etchings, a few of which bear the dates 1812 or 1813. Few original impressions survive from Crome's lifetime, his practice being to take test impressions, quite lightly bitten.

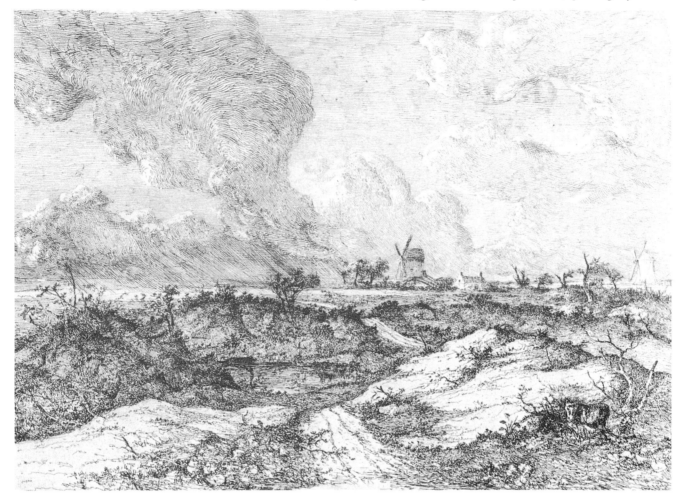

John Crome
Mousehold Heath c. 1810-11

etching, second state
(22.9 × 30.5 cms)
Theobald Gift 1921 (9.25.21)

Evidence that he intended at one stage to publish his etchings may be seen in a prospectus inviting subscribers which he issued in 1812. It was not, however, until 1834 that the plates were finally published on behalf of Mrs Crome, accompanied by a memoir written by Dawson Turner. These, and subsequent impressions, are all later states, bearing additional work by Henry Ninham and also W.C. Edwards of Bungay. All Crome's original copper plates are now in the collection of Norwich Castle Museum and bear witness to the additional re-biting and engraving.

This, the second state of *Mousehold Heath*, retains that silvery tonality and delicacy of line which places Crome at the forefront of the revival in etching, not simply in Norwich, but in the subsequent nineteenth-century tradition of British painter-etchers. The later states show the reworking of the sky in particular, ruled in with diamond point by W.C. Edwards at the behest of Dawson Turner. Edwards attempted to make the plate 'more applicable to the public taste', trusting that he had 'much improved' it (W.C. Edwards to Dawson Turner, 8 May 1837, Trinity College Library, Cambridge). In the same letter Edwards commented that 'the whole of the plates want the same treatment, but I have not time to undertake them.' His work later caused much controversy and Henry Ninham took pains to disclaim responsibility for their ruination (*Norwich Mercury*, 4 December 1858).

An old label on the back of this picture establishes its early history. Joseph Geldart, father of the artist of the same name (see pp. 81, 94), records that he purchased the picture, 'painted by old John Crome' from Crome's widow about two months after Crome's death in 1821, paying thirty pounds. It was subsequently lent to the Crome

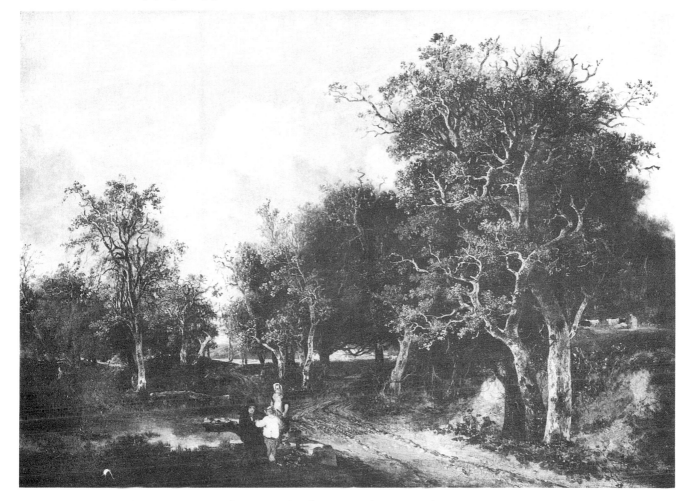

Memorial Exhibition that autumn (76), when it was dated to 1820. That it was a late work is almost certainly confirmed by the identification of this picture with that *Grove Scene* exhibited with the Norwich Society in 1820 (53). The critic of the *Norfolk Chronicle* commented of this picture that it was one of two pictures 'in his usual free and unconstrained manner, and with more than the degree of labour which he ordinarily finds time to bestow on his works.—53— "Grove Scene" exhibits the touch of a vigorous pencil [paint brush], great truth of perspective, and an agreeable effect of light and shade' (*Norfolk Chronicle*, 29 July 1820).

The influence of Meindert Hobbema upon this composition has often been remarked upon. The debt is specifically to Hobbema's late work, its degree of careful finish combined with that sense of breadth that had always been Crome's hallmark. It is interesting to see Crome returning to the Dutch example throughout his career, and not simply at a single stage in his development. This is also evident in his etched work, particularly in his selection of grove scenes as subject-matter when, according to Dawson Turner, he specifically acknowledged the influence of Ruysdael (see also p. 20). Crome's especial sense of atmospheric effect prevents the picture from becoming a mere pastiche of the seventeenth-century formula, a trap into which his pupil James Stark fell during the 1820s.

John Crome
Grove Scene c. 1820
oil on canvas
(47.6 × 65.1 cms)
R.J. Colman Bequest
1946 (727.235.951)

John Crome
Postwick Grove
c. 1814-17

oil on millboard
(48.9 × 40.6 cms)
R.J. Colman Bequest
1946 (728.235.951)

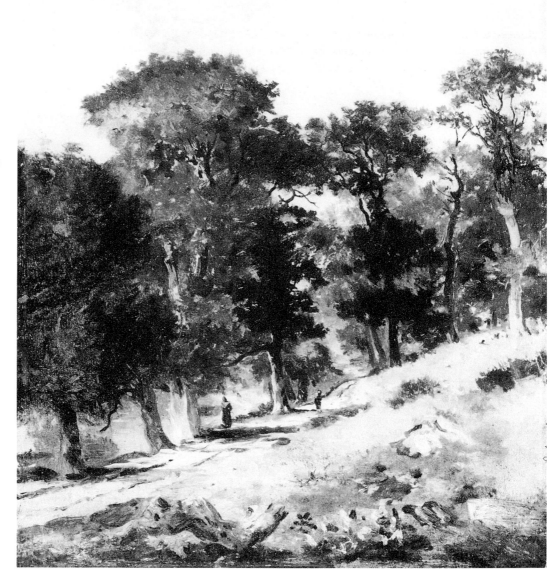

Crome never exhibited a picture of this title, although number 32 in the Crome Memorial Exhibition of 1821, lent by Mrs de Rouillon was entitled *View in Postwick Grove* and dated to 1816. The broad treatment of the lights and darks of the trees, similar to that of the *View in Paris—Italian Boulevard* (NCM 1.935), suggests a date of *c.* 1816 is likely. The scene is certainly from well within the Grove. However, Lord Stafford of Costessey Park also owned a Crome oil entitled *Postwick Grove* which he lent to the Norwich Society loan exhibition of 1828 (11).

There is, however, one other picture recorded which may be identified with the view of Postwick Grove at Norwich. John Berney Crome's sale of 5 September 1834 (third day) included (101) *Postwick Grove, by [late Mr. Crome], a sketch.* This lot suggests that an unfinished and possibly late oil sketch remained in Crome's studio on his death. The quality of *Postwick Grove* suggests a sketch painted in the open air in a truly innovative mode which Baker was the first to recognise as combining 'the freedom and interpretative brushwork of a Constable sketch with the *plein air* of the best Barbizon work' (Baker, *Crome*, 1921, p. 41). Crome often exhibited 'sketches in oil', which were not always appreciated by the press: by 1819 the *Norfolk Chronicle* commented that much of his work came 'under the denomination of *studies* rather than of *pictures*' (14 August).

CROME'S PUPILS

Within eighteen months of his father's death, **John Berney Crome** (1794-1842) was being hailed as his true successor. The *Norwich Mercury* considered that he 'emulates the industry and promises to sur- pass the talents of his father, for he is trained to art by a liberal education (3 August 1822). J.B. Crome played a key role during the life of the Norwich Society. It fell to him to act as spokesman during those periods when the Society was at crisis point, following the secession led by Robert Ladbrooke and the temporary closure of the Society's exhibition venue in 1826-27. At that time, aided by James Stark, he campaigned for local patronage and funds. His own physical and financial decline in the early 1830s came at just the time when the Norwich Society needed him most. John Sell Cotman reported to Dawson Turner on 30 January/1 February 1834: 'Everything is to be feared for Mr. C. as far as pecuniary matters. He has spent two evenings with me in considerable low spirits, and sad tales are afloat here about him, I most sincerely and deeply regret it, for I have ever found him a man strict to his honour and a man to be depended upon' (Barker Collection).

John Berney was born the eldest son of John and Phoebe Crome on 8 December 1794 and baptised on 14 December at their parish church, St. George's, Colegate, Norwich. Educated at the Norwich Free School (or Grammar School), he rapidly achieved success. His obituarist, a childhood friend, remem- bered that he 'attained considerable classical acquirement' and when Captain of the School in 1813 he delivered a Latin Oration to the Mayor of Norwich on Guild Day. He exhibited a sketch with the newly- formed Norwich Society of Artists as early as 1806 and exhibited annually thereafter.

In January 1816 John Berney Crome visited France in the company of George Vincent (see pp. 34-5, 42), following the example of his father. This was the first of his visits abroad and although his sub- sequent work shows him strongly influenced by the Dutch Masters such as Aert van der Neer, he appears to have been unimpressed by the French painters. His father writes in his letter of January 1816 to James Stark: 'We have heard from John; I believe he is not petrified from having seen the French School. He says in his letter something about Tea-Tray painters. I believe most of those who visit them whistle the same note. So much for the French Artists'. (BM Add. MS 43830 73). J.B. Crome's visit was brief, for the *Norwich Mercury* of 20 January finds him advertising the resumption of his activities as a drawing master in the outlying centres of Bungay, Beccles, Yarmouth and Hingham.

From this time onwards J.B. Crome took an increasingly active role in the artistic life of Norwich. In 1817 both he and Stark were praised for their 'great and rapid strides' (*Norwich Mercury*, 9 August) in their exhibited work. The following year he held office as Vice President of the Norwich Society for the first time and also addressed the Norwich Philosophical Society, instituted in the autumn of 1812, with his 'Remarks on painting, as connected with poetry' (*New Monthly*, 1 May 1818). This address was presumably the first draft of his lecture entitled *Essay on Painting and Poetry*, written on paper water- marked 1828 now in the collection of Norwich Castle Museum (NCM 1.958). In 1819 he became Presi- dent of the Norwich Society of Artists and he also advertised as Landscape Painter to H.R.H. the Duke of Sussex; but with the death of his father in 1821 his teaching commitments escalated. Together with his brother Frederick, two years his junior, John Berney Crome continued their father's teaching practice, both 'in and around Norwich, as usual' (*Norwich Mercury*, 5 May 1821). In 1823 he was again President and the *Norwich Mercury* critic commented upon his marked industry, considering 'the constant occu- pation of his time in the task of tuition' (2 August). On 23 August 1823, following discussion in the *Norwich Mercury* the previous week concerning the continued absence of some of the seceding artists from the exhibition, John Berney Crome wrote an open letter encouraging all to return to the fold. A notable product of this brief exchange was that Robert Ladbrooke exhibited once again with the Norwich Society the following summer.

On 28 December 1824 John Berney Crome married Dorcas Sarah Burcham, a young girl who tragi- cally died within three years. On 17 September 1830 Crome married for a second time, his bride being Sarah Ann Clipperton of the parish of Braydestone, near Blofield. During the early 1830s, however, his financial position became increasingly unsteady. He was already losing pupils in 1827—whether due to his teaching style or changing fashions is uncertain— and by January 1834 John Sell Cotman recounted how 'a short time back he travelled with his horse and gig and manservant seventy miles but for three

John Berney Crome

pupils; and now he fears it will be less.' (Barker Collection). Matters came to a head over the following weeks when he was taken to court by the jeweller George Rossi, for debt. An account by Rossi shows that Crome partially repaid his debt by giving him an oil, *Moonlight*, valued at twenty-eight pounds (Reeve Collection, BM). He was, however, unable to avoid holding a sale of his house and its contents over three days, 3-5 September 1834. He subsequently removed to Yarmouth, where he suffered from increasingly poor health. His obituary notice in the *Norwich Mercury* (17 September 1842) refers to his suffering 'dreadfully from an incurable disease but his spirits were buoyant and enabled him to maintain much of his original vivacity... He had an elegant and classical turn of mind and deserved a better fortune'. His painting had not consistently achieved the promise of the early 1820s, but at its best it matched that of his father's fellow pupils and his friends, James Stark and George Vincent.

James Stark

The work of **James Stark** (1794-1859) perhaps best epitomises that image of a Norwich School painting which is at once a product of the study of the seventeenth-century masters and yet also indisputably a picture of the Norfolk landscape in the nineteenth century. Stark received consistent praise from the local press and early recognition in London, to the extent that by 1825 the *Norwich Mercury* commented: 'His works are now so much known and extolled in the great metropolitan marts of talent that praise from us would not add to a reputation which the citizens of Norwich may be proud to remember is "native here"' (6 August). Stark spent over thirty years of his life in London, and his spell in Norwich during the 1820s was effectively brought about by debilitating illness, rather than through choice. When it fell to Stark to address the Norwich Society in 1827 he took the opportunity to harangue the city of Norwich 'where patronage is and ever has been *unknown*' (*Norwich Mercury*, 26 May 1827). The Norwich Society, of which he had been a member since 1813, duly elected him Vice President for the two years during which the Society was struggling to survive, 1828-9 and President for the years 1829-30.

James Stark was the youngest son of a Scottish dyer who was himself a man of some literary and scientific distinction. Michael Stark had settled in the parish of St. Michael Coslany, Norwich and it was here that James was born on 19 November 1794. He was educated at the Free School where he met John Berney Crome, through whom he was probably first introduced to John Crome. In 1811 he became articled to Crome for some three years before making his first move to London in 1814. An early London friend and subsequent influence was the young William Collins. Stark was later to record his debt to Collins in a reminiscence sent to Wilkie Collins in 1847 recalling their early days. He had begun exhibiting as soon as 1809 in Norwich and 1811 in London and success came early when the Dean of Windsor purchased his picture *The Bathing Place, Morning*, exhibited at the British Institution in 1815 (144). The Dean was the first of a long line of patrons which was to stretch throughout his career. The directors of the British Institution voted him an honorary gift of fifty guineas which was presented to him by the Marquis of Stafford and the Earl of Aberdeen. His patrons subsequently included the Marquis of Stafford, Sir John Grey Egerton, the Countess de Grey, Lord Northwich, Charles Savill Onley M.P., the Academicians Thomas Phillips, Francis Chantrey and Sir George Beaumont, and also the governors of the Royal Institution at Edinburgh—a list which reveals the extent of the success that could attend a provincial artist in London. In common with John Berney Crome he also exhibited widely in other provincial centres including, in the late 1830s and 1840s, Worcester, Glasgow, Liverpool, Manchester, Bath, Birmingham, Southampton, Newcastle, Dublin, Bristol, Exeter and Edinburgh.

Stark enrolled as a student of the Royal Academy Schools on 26 March 1817 but had to return to Norwich due to ill health two years later. On 17 July 1821 he married Elizabeth Younge Dinmore of King's Lynn. His poor health at this time, although often referred to, does not appear to have restricted his output, except insofar as his compositions tended to follow the models of the Dutch Masters. On 24 March 1821 the *Norwich Mercury* reprinted a London review which commented that Stark had 'got by heart the express and almost infinite touchiness of HOBBIMA...and avoids the damning character of a plagiarist' by retaining his eye for direct observation. By December 1825, however, the *London Magazine* reported '...we must object to his iteration of subject; a practise which shows he is more conversant with Hobbema and Ruysdael than with nature...What he has done is good; but he has as yet painted but one picture'. By 1839, however, the *Norwich Mercury* found that he had 'freed himself from his original and local manner', whereby his work had become 'brilliant with beauty and light. The exchange from Hobbima to nature is indeed a marvellous improvement' (17 August). Such reviews provide an indication of Stark's development as a painter, which is confirmed by datable works.

In 1827 Stark issued 'Proposals' for his projected publication *Scenery of the Rivers of Norfolk*, to be steel-engraved after his paintings by other artists, including George and W.J. Cooke who became firm

London friends. In 1830 he moved to 14 Beaufort Row, Chelsea where he lived for the next ten years. His wife died on 19 September 1834, only three years after the birth of their son Arthur James, who was himself to become a painter, assisting his father in the 1850s. The catalogues of the British Institution exhibitions for 1852 and 1854 record that two pictures were specifically credited as joint works by father and son, the animals being the latter's contribution.

In 1834 his book of thirty-five engravings was finally published (see p. 37) and it was at this time that he finally moved away from works 'more conversant with Hobbema and Ruysdael than with nature'. In 1840 he moved to Windsor (see p. 41) where he lived for ten years before moving back into lodgings in central London. Throughout this period he enjoyed the stimulus of friends and fellow artists, exhibiting annually. Despite his poor health, when he died at his lodgings in Mornington Place, Regent's Park on 24 March 1859, he was one of the longest lived of the Norwich School of Painters. His body was returned to Norwich, to be buried in the family enclosure in the Rosary Cemetery.

George Vincent

Although both John Berney Crome and James Stark were regarded in their own lifetimes as leaders of the Norwich School following the death of John Crome, the work of **George Vincent** (1796-1832) reveals him as the artist who most immediately imbibed the spirit of the master. Vincent in fact lived most of his working years in London, receiving only his early training from Crome. Of all the Norwich painters, it is George Vincent whose work most often invites comparison with the work of his contemporaries exhibiting in London, John Constable and J.M.W. Turner. Although the quality of his work is not consistent, a number of his grandest compositions place him in the forefront of British artists exhibiting in the 1820s (see p. 44).

George Vincent was born in the parish of St. John at Timberhill, Norwich and baptised on 27 June 1796. His father was James Vincent, a Norwich weaver and shawl manufacturer. He was educated at the Norwich Free School where he met John Berney Crome who was two years his senior. He exhibited his first pictures with the Norwich Society in 1811, while his two entries the following year were both 'after Crome' suggesting that he received lessons from John Crome at least by 1812. He received his first notice in the local press in 1814, the year he sent his first picture to the Royal Academy. In January 1816 he accompanied John Berney Crome to Paris, following in the footsteps of John Crome who had gone to Paris two years previously (see p. 20). On 17 August that year the *Norwich Mercury* noted: 'Messrs. Stark and Vincent, [Crome's] pupils, manifest conception and facility'. Less than eighteen months later the same paper reported 'we are happy in being able to state that the Marquis of Stafford, who stands at the head of English collectors, became the purchaser of pictures painted by Mr. STARKE and by Mr. VINCENT.' (24 January 1818).

Vincent had moved to 7 Wells Street in London during the latter part of 1817 and then moved to live as a neighbour to James Stark at 86 Newman Street. In 1819 Vincent exhibited only at the Royal Academy and the British Institution and the absence of his work from the walls of the Norwich Society was regretted by the local press. It is likely that he spent a good part of the summer of 1819 in Scotland and he exhibited a number of Scottish views throughout the remainder of his career. He continued to exhibit both in London and Norwich, receiving, it would seem, eulogistic praise from the Norwich press and commissions and purchases from the London patrons. A measure of his regard for his former master is that he 'came from town on purpose to attend the funeral' of John Crome (*Norwich Mercury*, 28 April 1821).

In 1822 Vincent married the daughter of Dr. Cugnoni, a lady who, according to Arthur James Stark, was thought at the time to be extremely wealthy. He moved to a house in Camden Town which it subsequently proved he could ill afford. A group of letters survive in the British Museum, written by George Vincent to his friend William Davey, a neighbour of James Stark in Norwich, which recount the sad story of his later career between the years 1824-27. The letters reveal that, like John Berney Crome, George Vincent was plunged into severe financial problems, which had led 'so much infamy' to be 'unjustly levelled' at him for some 'past folly'. On 27 July 1824 he gloomily reflected 'I believe from the sufferings my mind experiences and has done for the last two years, that my stay in this world will not be for a very long duration'. He continued to suffer from poor health, although he made trips to both Portsmouth and Norwich in September that year, in a bid to gather material for two major paintings of the battles of the Nile and Trafalgar. Time ran out for him in December 1824 when he was finally imprisoned in the debtors' prison, the Fleet. This effectively deprived him of any hope of quickly settling his debts: 'I can paint small pictures here but not any of size, but this is not the only evil. Being excluded from the world I shall find it no small difficulty to dispose of my works when painted...' He was released in February 1827.

It should not be surmised that the experience of poor health, penury and imprisonment effectively exhausted George Vincent. Immediately on his release he received the encouragement of an anonymous commission from the patron James Wadmore, for whom he painted a large picture, *Greenwich Hospital from the River*. Vincent continued to exhibit in London and Norwich, while one of his few known watercolours, *The Needles* (NCM 122.930), reveals him again visiting the south coast in 1830. His end came quickly, in his thirty-sixth year, when he died at Bath in April 1832. His passing was noted all but briefly in the *Norwich Mercury* (14 April 1832), while a small selection of his works were exhibited in his memory at the following winter exhibition of the Society of British Artists.

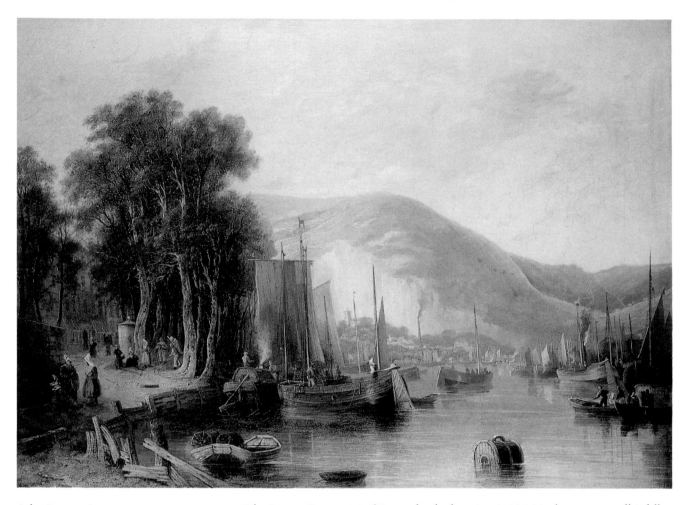

John Berney Crome
Rouen c. 1822-23

oil on canvas
(74 × 102.2 cms)
Purchased 1935 (131.935)

John Berney Crome visited France for the first time in 1816, in the company of his fellow artist George Vincent and Mr B. Steele, a surgeon who later married Hannah Crome. From 1817 he exhibited eight titles with the Norwich Society showing views of Rouen. *Rouen* almost certainly dates from 1822-23, when he exhibited three such views. This version shows the Seine river traffic and the town hugging the river bank, dwarfed by the steep escarpment of Mount St. Catherine in the distance. A complementary view of Rouen, of similar size and showing the riverside boulevards and the renowned Bridge of Boats, is in the Colman Collection (No. 755).

Although John Berney Crome is popularly known for his moonlight views, the evidence of his exhibited pictures shows him to be one of the Norwich painters who most consistently referred to sketches derived from his continental travels. He also exhibited extensively in London and provincial centres outside Norwich. A survey of his Rouen subjects alone finds him exhibiting at the Hull and East Riding Institution in 1827 (227), the Royal Manchester Institution in 1828 (112), 1838 (109), 1840 (530), the Liverpool Royal Institution in 1829 (75), the Royal Academy, London in 1839 (512) and the Royal Hibernian Academy, Dublin in 1841 (58). His confidence in this subject may well stem from the response he received in Norwich. The *Norfolk Chronicle* critic, 29 July 1820, found his Rouen painting of that year one 'of which the Norwich School may

be justly and peculiarly proud'. Purchased by the Countess de Grey, that version, exhibited with the Norwich Society in 1820 (44) and the British Institution in 1821 (48), remains the finest of his Rouen compositions (Sotheby's, 17 June 1981, lot 21).

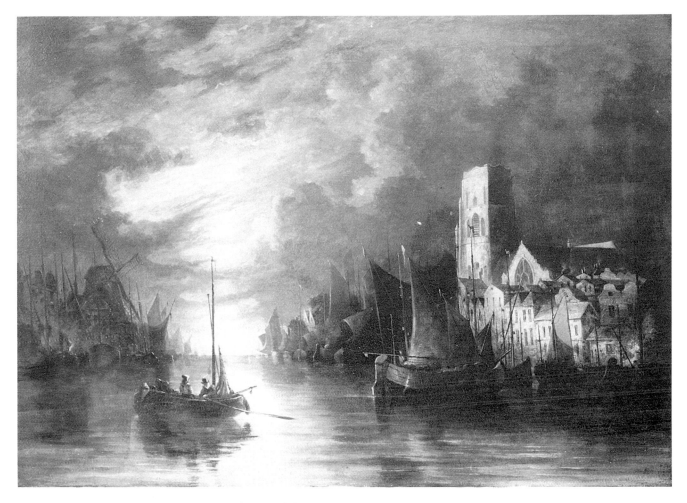

John Berney Crome
Amsterdam late 1820s?

oil on canvas
(73 × 101.5 cms)

Presented in memory of
Dr Basil K. Nutman by his widow
1982 (277.982)

Of John Berney Crome's two hundred and fifty exhibits with the Norwich Society between 1806–33, at least seventy were moonlight or evening scenes. The writer of his obituary in the *Norwich Mercury* (17 September 1842) commented: 'Mr. Crome's talent was of no mean order. He made moonlights his peculiar study and at the time of this his early death had elevated himself to considerable celebrity in this branch.' John Berney Crome was in fact extending the example of his father, whose own moonlit views and paintings of low chromatic scale find their finest expression in his *Bruges River—Ostend in the distance—moonlight* (NCM 3.4.99) exhibited at Norwich in 1816 (49).

John Berney Crome exhibited moonlit views of the environs of Amsterdam throughout the 1820s, including works which caught the attention of the local press in 1824 and 1829. Such scenes did not find universal approval, some finding them too dark for their taste, but the *Norfolk Tour* for 1829 refers to perhaps the most important contemporary analysis of one of his pictures: 'Mr. Crome's moonlight is good, and has the grey and brown hues of Vanderneer, whose moonlight scenes have been considered the best as to natural effects, but, except the parts under the immediate light of the moon, no specific colour should be seen. The browns and yellows here mingle well into the black shades of night, and have nothing of that flat grey blue, which has justly made coloured moonlights to be compared to a shilling on a slate.'

John Berney Crome
*Great Gale at Yarmouth
on Ash Wednesday, 1836*

oil on canvas
(53.5 × 86.8 cms)
R.J. Colman Bequest
1946 (762.235.951)

John Berney Crome had been living at Yarmouth for some two years when a great gale and very high tide struck the town on Ash Wednesday 1836. The scene shows the beach completely submerged and the house fronts at the mercy of the waves. Although a number of houses have been partially demolished, Ansell's Buildings, the first lodging houses erected on the front, are shown to be still intact. Two other buildings which

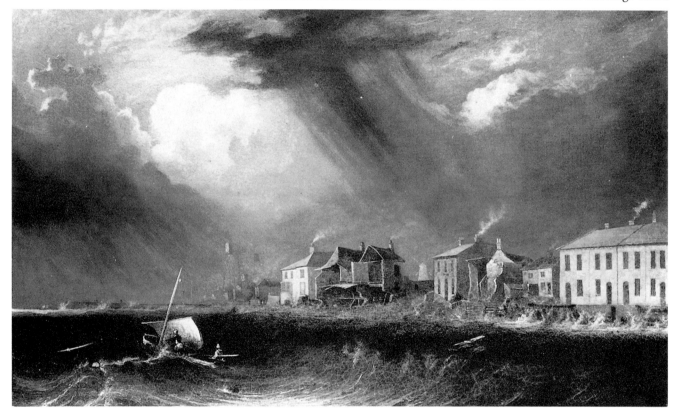

remain standing are Trafalgar House and Berners House. The *Norwich Mercury* (20 February 1836) described the aftermath of the gale:

> The scene of devastation on our beach, occasioned by the late high tides, exceed the powers of description. Wednesday morning in some measure prepared us for the event; the sea was at that time breaking over the Jetty, and reached as high as the houses. It was prophesied by nautical men that if the next tide was equally high, the consequences would be most disastrous and unfortunately, so it proved. The sea in the evening undermined the foundations of most of the dwellings, throwing down the walls of many, to the great injury of those of the inmates who had not taken the precaution to remove their property. Furniture was seen floating in all directions, in the presence of the astonished and alarmed multitude. The summer residence of the Right Hon. Lord Berners is more than half destroyed, while the houses of the Misses Ansell and the Right Hon. Lord Nevill were surrounded; in fact, such a scene of general devastation never in the memory of the oldest inhabitant presented itself. The sea at one time reached some way up Jetty Road. While a person was assisting the landlord of the Holkham Tavern to remove his bed, etc. to a back warehouse, the sea burst in and broke down the front wall. At one part of the South Denes the sea and river might be seen meeting. Part of the South Quay was flooded. It was unusually high at the bridge and likewise some of the lower parts of the town. Amidst this wide spreading destruction we are glad to say no lives were lost.

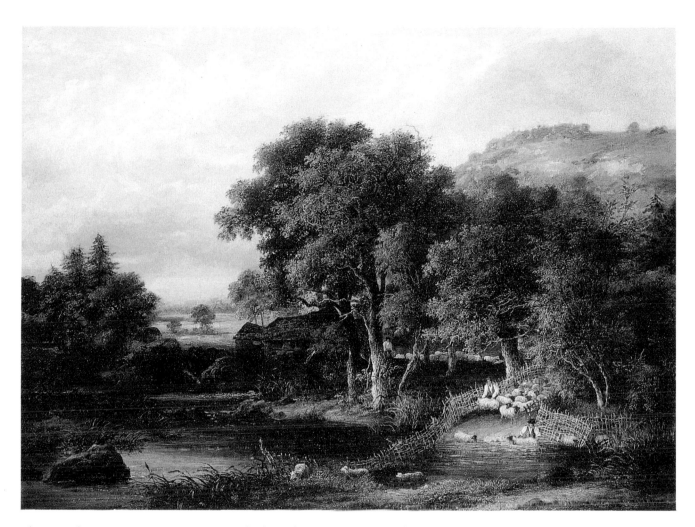

Sheep Washing represents a composition and subject that is at once typical of the work of James Stark in particular and of the Norwich School painters in general, typifying the problems of attribution and identification associated with both. Stark produced no less than five paintings of this subject throughout his career. The subsequent history of each has led to confusions of size, date and description, which renders it almost impossible to equate surviving examples with those exhibited during Stark's lifetime. The artist exhibited the subject twice in Norwich, in 1822 (8) and 1849 (38) and three times at the British Institution, in 1824 (25), 1848 (131) and 1858 (185).

The scene may be identified as based upon a view of Postwick Grove. Stark included a similar view, *Postwick Grove*, in his publication, *Scenery of the Rivers of Norfolk, from Pictures painted by James Stark* (Norwich and London, 1834). The engraving by William Forrest after Stark's painting may be regarded as the most accurate representation of the location, and the accentuation of the raised ground in *Sheep Washing* is just one of a number of compositional differences which owe as much to the example of Hobbema as to a desire to depict the actual place. Another version of this subject remained in the ownership of Stark's descendants through his daughter Julia, until entering the collection at Norwich in 1957 (NCM 169.957).

James Stark
Sheep Washing
oil on mahogany panel
(61.8 × 81.8 cms)
R.J. Colman Bequest
1946 (1301.235.951)

James Stark
Lake Scene

oil on canvas
(46.4 × 61.6 cms)
R.J. Colman Bequest
1946 (1309.235.951)

James Stark
Keston Pond 1830s

pencil and watercolour
(25.8 × 40.6 cms)
R.J. Colman Bequest
1946 (1316.235.951)

James Stark displayed considerable talent as a watercolourist. His free use of clear washes in combination with a soft pencil appears to have developed from his habit of drawing sketches on the spot, annotated with colour notes and inscriptions of the places visited. Sketches in the Victoria and Albert Museum and Norwich Castle Museum seem to indicate a preference for sketching tours in the autumn. His use of watercolour developed further in the late 1820s and 1830s, to the extent that his work in this medium foreshadows that of Henry Bright and John Middleton.

Stark exhibited a watercolour entitled *Keston Common, Kent* with the Society of British Artists in London in 1839 (559) and an oil at the British Institution in 1854, (45) *Keston Common*. It is possible that the former is the Norwich watercolour, *Keston Pond*. Stark also submitted a picture entitled *Keston Common* for exhibition at Liverpool in 1840. A similar subject in oils, *Lake Scene* (NCM 1309.235.951) serves as an illuminating comparison with *Keston Pond*. The broad treatment of the watercolour, together with its warm yellows and light greens are matched in the oil, providing an indication of the extent to which Stark's use of watercolour encouraged him to move away from the heavier Dutch-influenced tonality of his earlier oils. His work in watercolour is rarely finished, but always clear and well defined.

James Stark
*Whitlingham from Old Thorpe
Grove c.* 1837-43

oil on canvas
(43.5 × 61 cms)
R.J. Colman Bequest
1946 (1299.235.931)

The breadth of both technique and composition place this painting relatively late in Stark's oeuvre. The summary handling of the fresh, blonde range of tones gives the painting a light airiness which is far removed from the more consciously studied formulae of the grove scenes with which he made his reputation in Norwich. Here Stark abandons the device of massed trees to act as a framework for his composition. Instead he allows the lie of the land to orchestrate the patterns of the view, the foreground being enlivened with absolute economy by the lone ploughman at work, with a flock of birds in his wake.

 The light, open composition bears all the hallmarks of a directly-observed and well-loved view. It was painted for the artist's sister, Mrs John Skipper of Thorpe, Norwich, from a spot near her home. Another, smaller view painted in the same vicinity but nearer to the church, which is here only just visible beneath the horizon, is also at Norwich (NCM 1307.235.951). Both pictures were purchased by J.J. Colman from the sale of William Skipper, Stark's nephew, at Yarmouth in 1882. The latter picture, painted with a similar palette but with a sketchier technique, is inscribed with the date 'Nov. 1845'.

James Stark
*Whitlingham from
Old Thorpe Grove* 1845

oil on panel
(25.6 × 36.5 cms)
dated, bottom right: *1845*
R.J. Colman Bequest
1946 (1307.235.951)

James Stark
Cromer c. 1835
oil on deal panel
(60.8 × 85.8 cms)
Purchased 1975 (688.975)

The open composition, broad handling and clear, light tones of *Cromer* mark it as one of

James Stark's later works, which owe much to his experience of working with the fluid medium of watercolour at this time. The painting also recalls the example of his friend William Collins R.A. (1788-1847), with whom he had visited Cromer in 1815. An album of Stark's sketches (NCM 1-76. 337.972) contains a number of Cromer and Norfolk Coast scenes of the kind Stark would have used whilst in London during the 1830s. That Stark was working on paintings of Cromer in 1835 is confirmed by the artist E.W. Cooke's entry in his journal for 10 November 1835, where he comments upon having seen Stark's 'pictures and sketches about Cromer and Yarmouth' at Stark's house that day.

James Stark exhibited four pictures of Cromer in London. The first *Scene on the Beach at Cromer* was shown at the Society of Painters in Oil and Watercolours in 1818 (115). The second was exhibited at Suffolk Street in 1836 (541), entitled simply *Cromer Beach.* The same year Stark exhibited *Scene near Cromer* at the British Institution (194), a picture which is almost certainly that now known as *View of Mundesley, Near Cromer* ('James Stark and the Norwich School,' Lowndes Lodge Gallery, 1983 no.28). This painting is comparable in technique to *Cromer,* which Stark exhibited with the British Institution in 1837 (11). He also sent Cromer subjects to Glasgow (1843), Dublin (1845), Bristol and Leicester (1849), Worcester (1850) and Glasgow (1853).

This impressive exhibition piece was first shown by James Stark at the Royal Academy in 1843 (719). He was then living at 10 York Place, Windsor and it is probable that the majestic subject of *The Forest Oak* was based upon studies made in Windsor Great Park, or perhaps St. Leonard's Forest, near Windsor, the sources for a good number of his subjects during the 1840s. The picture remained unsold, but found a buyer the following year when sent to the Royal Manchester Institution (101). Receipts at Norwich Castle Museum record that the picture was purchased by M.W. Atkinson for sixty-three pounds and subsequently sold by the Manchester art dealer A.T. Leeming to J.J. Colman on 28 January 1898 for three hundred and seventy-five pounds. *The Forest Oak* was, therefore, one of the last pictures purchased by Jeremiah James Colman before he died in September that year.

The heavy solidity of the painting, while appropriate to the massy weight of the subject, demonstrates that Stark did not wholly lighten his palette in his later London years. Reviews of his exhibits at the Royal Academy and the British Institution in the early 1850s record a 'spirit and freshness' in his work of, for example, 1854, when in previous years his colour had been considered somewhat heavy. The motif of wood-cutters at work in the forest is one of the recurring images of Stark's later grove scenes.

James Stark
The Forest Oak c. 1843
oil on canvas
(83 × 111.5 cms)
J.J. Colman Bequest
1898 (9.4.99)

George Vincent
Rouen after 1816

oil on canvas
(63.4 × 91.7 cms)
Purchased 1952 (1.952)

George Vincent presumably visited Rouen whilst en route for Paris with his fellow artist John Berney Crome in January 1816 (see p. 34). John Crome provides a brief account of their journey across the Channel: 'They had a charming voyage over, Vincent belshing as loud as the steam packet, much to the discomfiture of some of the other passengers' (John Crome to James Stark, January 1816, BM Add. MSS 43830, 73). Unlike John Berney Crome, or indeed, John Sell Cotman, who was to make his first trip to Normandy the next year, Vincent never exhibited a continental scene and *Rouen* remains his only painting deriving from this visit. This is in sharp contrast to John Berney Crome, who was to exhibit at least eight titles with the Norwich Society showing views of Rouen.

The building in the middle distance is the Porte du Bac, as viewed from the West. In the middle distance also can be seen the trees of the Cours Dauphin, with Mont Gargan in the background. The bridge to the right is the Pont Corneille. The view of the Porte du Bac differs slightly from the image of the building, lithographed by Langlumé in 1816 after a picture by the Rouen-born artist, Théodore Basset de Jolimont. Presumably Vincent's picture derives from his own sketches of the site, painted after his return to England. His choice of subject and concentration upon the picturesque old buildings and their colourful awnings reflects a taste made fashionable by contemporary artists such as Samuel Prout (1783-1852) and Richard Parkes Bonington (1802-28).

George Vincent visited Scotland in 1819, exhibiting his first Scottish subject, *View of Edinburgh from the Calton Hill, Evening*, at the British Institution in 1820 (41). Two years later he exhibited *View of Ben-an from the island on Lock Catrine*, first at the Royal Academy (297) in the spring and then with the Norwich Society that summer. It is not recorded whether these were the same painting. The subject was also one of Vincent's submissions to the Royal Manchester Institution in 1829 (186). In each case he followed the contemporary Romantic fashion by appending lines of verse to the title (in this case from Scott's *Lady of the Lake* Canto I).

Vincent exhibited his moonlight scene of Highlanders spearing salmon with the Norwich Society in 1825 (45), the *Norfolk Chronicle* reviewer regarding the composition as 'capital' (6 August). He showed a painting the following year at the British Institution (366), of similar dimensions, entitled simply *The Salmon Fishery*. Vincent had written to Davey in October 1824, mentioning a painting which he never completed, of his desire to paint a 'midnight scene' which would give him the opportunity 'of trying [his] skill in Rembrandt effects'. With this painting George Vincent has achieved that ambition, recalling the work of both Rembrandt and Crome. He produces effects of moonlight and firelight which sparkle even in the deepest darkness of the scene, in a subject which surely challenges his contemporary John Berney Crome.

George Vincent
Entrance to Loch Katrine— moonlight; Highlanders spearing Salmon 1825

oil on canvas
(76.2 × 101.6 cms)
R.J. Colman Bequest
1946 (1362.235.951)

George Vincent
Pevensey Bay 1824

oil on paper laid
on millboard
(20.6 × 27.5 cms)
signed and inscribed,
bottom left centre:
GV to WD 1824
(William Davey)
R.J. Colman Bequest
1946 (1357.235.951)

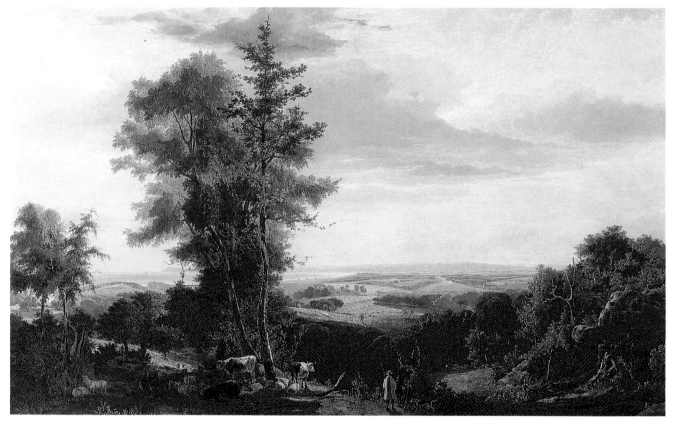

George Vincent
*A distant view of Pevensey
Bay, the landing place of
King William the Conqueror*
1824

oil on canvas
(146.1 × 233.6 cms)
Purchased 1945 (17.945)

The magnificence of this sweeping panoramic view invites comparison with the landscape paintings of both John Constable and J.M.W. Turner. The Redgraves in their *A Century of Painters* (1866) were the first to compare Vincent to his contemporary John Constable, in that he 'painted subjects seen under the sun, as did Constable, but his treatment was wholly different, broad masses of greyish shadow were tipped and fringed with the solar rays'. The broad, fluid treatment of the middle distance conjures up a vision of undulating, cultivated fields with haymakers at work in an idyllic rural setting. In common with current fashion, Vincent alludes in his title to the historical significance of the place depicted, whilst also investing the scene with the sense of a contemporary Arcadia. He exhibited the picture at the British Institution in 1824 (61).

Vincent painted at least two other pictures of Pevensey Bay. The first, now in the collection of Norwich Castle Museum (NCM 1357.235.951), is a small oil sketch of fishermen on the shore, with Beachy Head in the distance. Vincent originally sent this from London as a present to his friend William Davey of Foundry Bridge Road, Thorpe on 13 August 1824. He exhibited another picture of similar title with the Royal Manchester Institution in 1829 (158), which is probably that referred to by Dickes (*The Norwich School of Painting*, 1905, p. 514) as a view painted from Fairlight, near Hastings.

Although none of Vincent's pictures exhibited during his lifetime refer in their titles to the fish auctions held on Yarmouth beach, surviving paintings indicate that he tackled the subject more than once. While many of the Norwich painters exhibited scenes of Yarmouth Beach and Jetty, notably John Crome, John Sell Cotman, Joseph Stannard and Robert Ladbrooke, Vincent's treatment of the scene owes perhaps most to John Crome's oil, *The Fishmarket at Boulogne*, probably exhibited at Norwich in 1820. Like Crome, he places the main event and bartering in the middle distance, filling his foreground with still life details.

Yarmouth Beach had been the subject of two of Vincent's contributions to both the Norwich Society and the British Institution in 1821. These included his ambitious *Dutch Fair on Yarmouth Beach* now in Great Yarmouth Museum, which shows him extending his range beyond even the scope of John Crome. The impetus for Vincent to depict such scenes undoubtedly came as much from his knowledge of the exhibited work of his contemporaries such as Turner and Constable as from his on-the-spot sketches at Yarmouth. In addition to his *Fish Auction, Yarmouth Beach* of 1828 Vincent painted a similar, although larger, view of the same scene in 1827 (NCM 120.927), of which there is a copy dated 1828 now in private ownership. The copy is a similar size to *Fish Auction, Yarmouth Beach* and may have been intended as a companion piece.

George Vincent
Fish Auction, Yarmouth Beach
1828

oil on canvas
(64 × 92.4 cms)
Sir Henry Holmes Bequest
1940 (4.118.940)

George Vincent
Trowse Hythe, near Norwich

oil on canvas
(31.8 × 41.3 cms)
signed with monogram,
bottom right: *GV*

Purchased from the
Beecheno Bequest Fund
1939 (27.939)

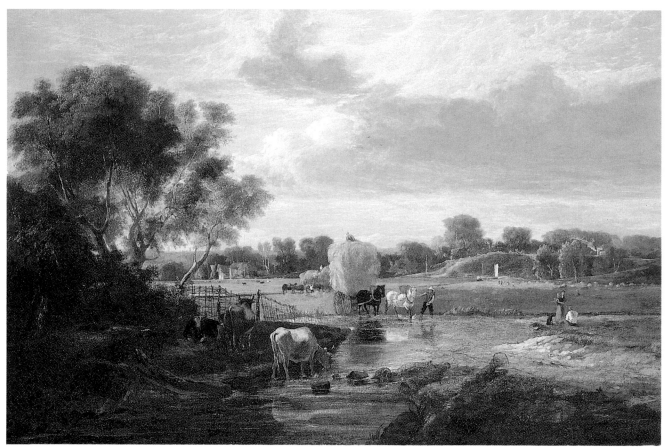

George Vincent
Trowse Meadows, near Norwich
1828

oil on canvas
(73 × 109.5 cms)

J.J. Colman Bequest
1898 (13.4.99)

This is the finest of three versions of this scene painted by George Vincent. The view looks over Trowse Meadows towards Whitlingham with Crown Point and Thorpe Wood in the distance. The dainty painting of the trees, the broad treatment of the middle distance and above all the spectacular cloud formation, lit by an invisible sun, are all features associated with the best of Vincent's late work.

This, the largest version, was almost certainly exhibited with the Norwich Society in 1828, either as (107*) *Norfolk Scenery* or (142) *Scene at Trowse near Norwich*. The *Norfolk Chronicle* (16 August) singled out the former '...in which we recognise the fine verdant range of Thorpe Meadows, and the sweetly picturesque heights near Crown Point and Trowse. The figures of horses, cows and men which animate, without disturbing the repose of this agreeable composition are judiciously introduced and ably executed.' John Thirtle's trade label on the frame indicates that it passed through Thirtle's hands for framing, possibly for the Norwich Society exhibition. Thirtle took the opportunity to make his own copy in watercolours (NCM 1352.B17.235.951). A small oil sketch by Vincent (NCM 27.939) appears to have been a first version of the composition. It does, however, differ in significant details (see illustration) and is closely related to a third version, painted on panel, signed and dated 1830 (O. and P. Johnson Ltd., 1968).

CROME'S CONTEMPORARIES

John Ninham (1754-1817) and Charles Hodgson remain the most elusive of Crome's contemporaries. The former is traditionally said to be of Huguenot descent and a short obituary in the *Norfolk Chronicle* for 23 August 1817 indicates that he had died on 16 August. He was recognised for his versatility and, in the years before Norwich was to see a proliferation of artists earning a livelihood as drawing masters, John Ninham diversified his talents as a trade painter. He established a business at 11 Chapelfield, Norwich specialising in heraldic, house, furniture and sign painting as well as engraving and copper plate printing. He never became a member of the Norwich Society, nor exhibited at their annual exhibition. However, the *Norfolk Chronicle* reviewer of the 1808 exhibition could not forego mentioning his most recent heraldic work for the Anchor Insurance Office in London Lane, 'a very bold and naturally carved anchor on a rock, executed by Mr. Ninham, of this city, whose versatility of genius cannot be easily parallelled' (20 August).

John Ninham

The career of **Charles Hodgson** (1769-1856) is outlined in a memoir by his son David, now in the Reeve Collection, in the British Museum. According to David Hodgson, Charles was the eldest of four sons to James Hodgson of Leeds and Elizabeth Murrell of Yarmouth, 'born in 1769 in the parish of St. Giles, January 30th'. On the death of his father, Charles, at the age of fourteen 'was placed under the care of Mr. Simon Browne, an excellent English schoolmaster'. He became well read in English Literature and took up the post of English Assistant at the Grammar School of North Walsham and subsequently married a North Walsham girl, Nancy Chiswell. After a spell at Yarmouth (see p. 51) he moved to Norwich *c*. 1798-9. He embarked upon a new career as headmaster of a boarding school, before becoming a master in mathematics at Norwich Grammar School.

Charles Hodgson gradually turned to painting, primarily in watercolours, going on a sketching tour of North Wales in 1805. He was accompanied by W.C. Leeds, the first President of the Norwich Society, a local merchant who left Norwich shortly after 1807 'his affairs becoming embarrassed'. In 1810 Hodgson was appointed President of the Society and for a number of years exhibited works which, in oil or watercolour were, according to his son, 'chaste, natural and transparent in colouring'. This opinion was echoed in the local press. In 1821 the *Norwich Mercury* commented: 'Mr. C. Hodgson has one picture in oil, which manifests taste, skill and delicacy of handling.—We regret not seeing this gentleman's beautiful and correct architectural drawings, in which his extraordinary talent has been so eminently conspicuous' (18 August 1821). His talent was recognised by the Duke of Sussex who appointed him his Architectural Draughtsman in 1825. The following year he moved to London and then visited Leeds before settling in Liverpool where he died on 5 November 1856. Despite his contemporary success, however, his work today remains largely unrecognised.

Robert Ladbrooke

Robert Ladbrooke (1769-1842) served his apprenticeship under a Mr. White, 'who was at once painter, printer and engraver' (*Norwich Mercury*, 15 October 1842). His development as an artist ran parallel with his friendship with John Crome and in 1792 he was one of the witnesses of Crome's marriage to Phoebe Berney. A year later he himself married Mary Berney, Phoebe's sister, on 3 October 1793 at the same church, St. Mary Coslany, thus cementing strong ties with the Crome family. However, it appears that there were some personal differences and presumably jealousies between them, which came to a head when Ladbrooke led a breakaway group from the Norwich Society to exhibit on an alternative site to Sir Benjamin Wrenche's Court, on Theatre Plain in 1816.

Ladbrooke's exhibited pictures are often of subjects typical of the Norwich School, but a full evaluation of his work is hampered by a lack of surviving recognised examples. Four of his views of Norwich, one dated 1806, were aquatinted by S. Alken and these indicate that his compositions at this time were still based upon late eighteenth-century models. A later, more ambitious project was his publication of five volumes of six hundred and seventy-seven lithographs of views of Norfolk Churches. Started in 1821, it was published in 1843, completed only with substantial help from his son John Berney Ladbrooke, the resulting plates adding little to our knowledge of his quality as an artist. The local press commented on occasion about his tendency to paint in the manner of Claude and Poussin and the *Norfolk Chronicle* (1 August 1818) noticed 'a scientific acquaintance with the Old Masters' in his pictures shown with the Theatre Plain exhibition of 1818, including debts to the Flemish School as well

as to Claude. After a concerted local campaign Robert Ladbrooke was persuaded to exhibit once again with the Norwich Society in 1824. His return was welcomed in the press, although his work did not pass without a criticism for 'the autumnal tinting of the trees and the uniformity of their masses' (*Norwich Mercury*, 14 August 1824).

The *Norwich Mercury* (15 October 1842) recorded in Robert Ladbrooke's obituary notice that he was of 'a cheerful and kindly disposition', respected by all who knew him. He had four sons by his first wife Mary, who died on 15 June 1807. His eldest son Robert became a carver, gilder and framemaker, while his three younger sons all became painters (see p. 121). His will, dated 23 June 1842, reveals that he owned a considerable amount of real estate when he died on 11 October 1842.

The early death of **Robert Dixon** (1780-1815) at the age of thirty-five, on 1 October 1815, robbed Norwich of one of its most versatile artists who had most consistently been in the public eye. His work as a theatre scene painter, interior designer and house painter, his exhibited and published work and his drawing lessons in both Norwich and the County (including Scole, Diss, Palgrave and Harleston) provoked a warm response from his friends and acquaintants. Within a week of his death his former colleagues at the Norwich Society announced an exhibition of his works for the benefit of his widow and six children. Some two hundred and twenty-seven pounds was raised, including the largest donation of fifteen pounds from the Norwich Society itself (*Norwich Mercury*, 7, 14, 28 October; 11 November 1815).

The history of Dixon's career is very much that of his work for the theatre circuit in East Anglia. In addition to his stage scenery and redecoration schemes for the Norwich Theatre Royal, he was also involved in the decoration of the new theatre at Ipswich which opened in 1803. By this time his theatre work was well known, but 'never was his pencil exerted with more success than in the scenery and decorations' of the Ipswich Theatre (*Iris*, 4 June 1803). By 1805 Dixon had also established his teaching practice at 6 St. Clement's Churchyard but he also advertised a house-painting business: 'Drawing-rooms, Vestibules, &c. ornamented in the newest and most approved stile. Clouded and ornamental ceilings, Transparencies and Decorations in general' (*Norwich Mercury*, 27 April 1805). His scene-painting continued to be appreciated by 'lovers of the classic and chaste style of decoration' (*Norwich Mercury*, 8 January 1814).

Dixon exhibited with the Norwich Society for the first time in 1805, becoming a member the following year and Vice President in 1809. His correspondence with John Papworth of the Associated Artists in Water Colours survives in that society's Minute Book now in the Victoria and Albert Museum. It appears that Papworth had requested that Norwich Artists who might like to exhibit with his society could submit work for consideration. Dixon's reply of 6 December 1808 suggests that, characteristically, he had undertaken to act on behalf of his peers, but had met with apathy: '... I have taken every possible step to arrange matters with my brother Artists in this place, to the end that we might by one conveyance enclose the necessary number of drawings from each. In fact I have been waiting upwards of a fortnight to accomplish this business...' The result was that he was the only artist from Norwich to exhibit with the Associated Artists in Water Colours (see p. 57). It seems that the dissension which was brewing amongst his contemporaries within the Norwich Society helped to lessen the attraction of membership for Dixon, whose qualities of independence and inflexibility as well as generosity were commented upon in his obituary.

James Sillett

James Sillett (*c.* 1764-1840) was born in Norwich, the eldest son of James Sillett of Eye, Suffolk. He began his career as a heraldic painter in Norwich, but went to London where he worked as a copyist for the Polygraphic Society. According to his own pronouncement he was for 'some time a Student in the Royal Academy' and although he is not recorded among the published list of entrants, his ticket of admittance to all the Royal Academy Winter Lectures for 1796 is preserved in the Reeve Collection of the British Museum. He first exhibited at the Royal Academy in 1796 and whilst living in London is said to have joined his Norwich contemporary William Capon (1757-1827) as a scene painter at Drury Lane and Covent Garden for the actor-manager John Philip Kemble (1757-1823).

In 1801 Sillett married Ann Banyard of East Dereham and it is likely that their daughter Emma was born within a year. He had returned to Norwich by the autumn of 1801, when he advertised as a miniature painter and drawing master on the corner of Gun Lane, St. Stephens. The following year he moved next to Harvey and Hudson's Crown Bank, near Tombland and the birth of their son Edwin James on 16 April 1803 is recorded in the church register of St. George's Tombland. In 1804 the family moved to King's Lynn, where James Sillett re-established his teaching practice. He continued to

specialise in flower and fruit painting as well as teaching, but also produced a series of topographical drawings which were later published in 1812 in Richard's *History of Lynn*. In 1806 he exhibited seven works with the Norwich Society and in January 1808 opened an exhibition of some two hundred works at Mr. T. Lockett's Coffee-House, near the Tuesday Market Place at King's Lynn. In 1810 he became an Honorary member of the Norwich Society when he returned to the city. The following summer he emulated the example of John Sell Cotman by 'opening a Port-folio of Drawings, to be lent for copying by subscription' (*Norwich Mercury*, 4 July 1811). In 1814 he became Vice President of the Norwich Society and the next year President.

A measure of the emotionalism rife amongst the Norwich painters at this time can be seen in Sillett's decision to join Robert Ladbrooke and John Thirtle in establishing a rival exhibition to that of the Norwich Society within a year of having been its President. Yet, having shown ninety exhibits on Theatre Plain in three years, Sillett was the first to return to exhibit with the Norwich Society once the rival exhibition had collapsed. By comparison, it was another six years before Ladbrooke exhibited in Norwich again and eight years before Thirtle was to do so. In 1828 he exhibited a view of Rotterdam and Dickes has suggested that this is an indication of a visit to Holland. Two other pictures shown by Sillett that year were in the manner of Molenaer and Zeeman, and it is likely that his Rotterdam picture was simply a copy. The year 1828 saw the publication of his *Views of the Churches, Chapels and other Public Edifices of the City of Norwich*, which was almost certainly seen as complementary to Ladbrooke's *Views of the Churches of Norfolk*. Sillett was to die two years earlier than Robert Ladbrooke 'at the advanced age of 76' on 6 May 1840, his obituary appearing in both the local press and the *Art Union* (15 June 1840).

Crome's fellow exhibitors in Norwich were not exclusively landscape and still life painters. **Joseph Clover** (1779-1854) contributed portraits to the Norwich exhibitions regularly from 1813. He had started his artistic career as an engraver, but according to the *Norfolk Tour* of 1829 had been advised against continuing in this medium by Boydell. He took to portraiture under the encouragement of John Opie whom he followed to London, where he was to live in various lodgings until taking up a tenancy agreement at 85 Newman Street from March 1816–March 1848. The sitters for his exhibited portraits during this period reveal his success in attracting patrons. These included a number, such as the Marquis of Stafford and the Countess de Grey, who were also patrons of James Stark, who shared his lodgings for a brief period. Some of Clover's surviving sketchbooks now in Norwich Castle Museum reveal that he travelled extensively in Britain and also journeyed to Normandy in 1816. He visited Norwich periodically throughout his career in order to fulfil local commissions, notably three commissions from the City of Norwich (see p. 63). One other portrait painter who exhibited in Norwich at this time was **George Clint** (1770-1854). Born in London, he exhibited at the Royal Academy from 1802, becoming an Associate in 1821, and gaining a reputation with the Norwich Society for pre-eminence in the field of portraiture. Clint's Norwich patrons included Lord and Lady Suffield and Rear Admiral Windham. His commitment to Norwich as well as London is perhaps best seen in his speech at the annual dinner of the Norfolk and Suffolk Institution in 1829: 'Mr. Clint said that his best efforts would be used for the promotion of this Institution. Norwich was a place he never quitted without a tear, and he looked with longing expectation to the time when he could come and end his days amongst its people' (*Norfolk Chronicle* 16 May 1829). Another London portraitist who exhibited at Norwich 1813-21 was **Michael William Sharp** (active 1801, died 1840) who, like Clint, also contributed some conversation pieces.

George Clint

John Ninham
Beach Scene c. 1790s

oil on canvas (34.9 × 50.5 cms)
R.J. Colman Bequest
1946 (1191.235.951)

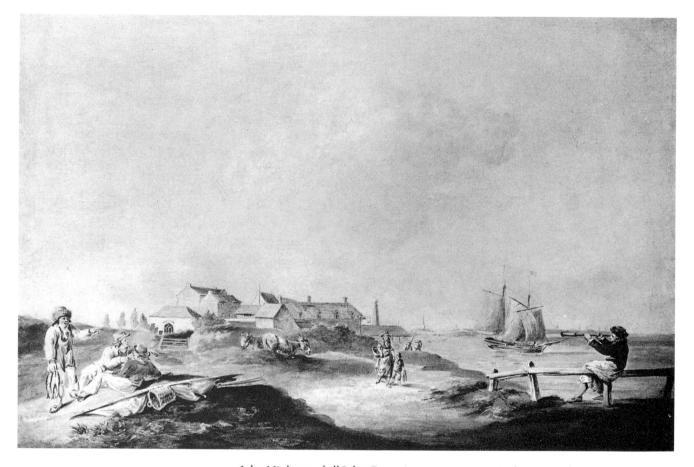

John Ninham, of all John Crome's contemporaries, is the artist whose personality and work remain the least known. Of the few works which have been attributed to him, only those connected with his engraving projects have any sure foundation. These include a plan of the Battle of the Nile, engraved by Ninham in 1798 (NCM 135.932). A series of twenty-two monochrome wash drawings (NCM 76.94) showing the interiors and exteriors of the eleven gates of Norwich, dated to *c.* 1792-93, were subsequently etched by Walter Hagreen and published by Robert Fitch in 1861. Another drawing in this series, *Hassett's House, Pockthorpe 1791*, was later etched by Ninham's son, Henry. A plan of Norwich published on 10 February 1802 by T. Smith of Norwich was engraved after a drawing by John Ninham.

Beach Scene was purchased by J.J. Colman direct from Henry Ninham (see p. 118) and is a key work in establishing John Ninham's style as an oil painter. The drawing of the figures and the naïve rendering of the scene echo his monochrome wash drawings, suggesting a similar date of execution. That his work is firmly rooted in the eighteenth century may be seen both in this picture and another oil tentatively attributed to Ninham, *Panoramic View of Norwich* (NCM 54.975).

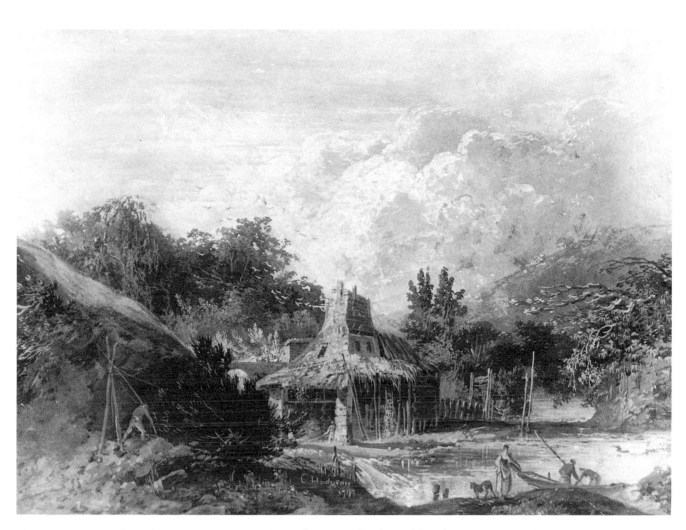

Charles Hodgson achieved a certain reputation during his career for 'beautiful and correct architectural drawings, in which his extraordinary talent has been so eminently conspicuous' (*Norwich Mercury*, 18 August 1821). Unfortunately such drawings are now virtually unknown, probably as a result of confusion with the work of his son David, who also specialised in architectural drawings to the extent that his name was invariably coupled with that of his father by the local press.

Both in the context of his own career and in that of the Norwich School in general, this is an unusual drawing. In 1805 Charles Hodgson exhibited four landscapes which were specifically described as in 'body colours', one of these being a moonlight scene (45). He also exhibited (116) *View in Switzerland, after Chiparte* and three other *View(s) in Switzerland*. This is the only occasion when he exhibited such scenes and it is likely that they were all derived from prints after artists such as Chipart (born 1774). *Landscape* is an early example of his style in this medium, composed around the time when, according to David Hodgson, he was employed as 'a clerk in the Banking house of Messrs. Turner and Co. at Yarmouth', before he moved to Norwich *c.* 1798-9.

Charles Hodgson
Landscape 1797

watercolour and bodycolour
(30.1 × 40.4 cms)
signed, bottom centre:
C. Hodgson 1797
Sir Henry N. Holmes Gift
1931 (37.931)

Robert Ladbrooke
Foundry Bridge, Norwich
c. 1822-33

oil on canvas
(66.7 × 98.4 cms)
W.T.F. Jarrold Bequest
1938 (26.938)

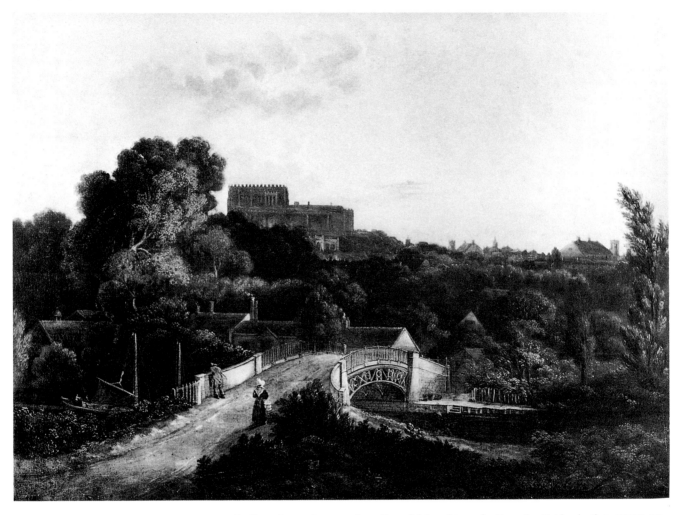

Ladbrooke made several studies of this subject, the Foundry Bridge built in 1810. His earliest exhibited example was *Sketch of the Foundery Bridge,* shown with the Norwich Society in 1811 (13). He subsequently exhibited a picture entitled *Foundery Bridge with the Castle in the distance—Evening* with the Society in 1815 (29). It was a favourite practice for Ladbrooke to append suitable verses to his pictures by poets who included Milton, Thomson and, in his 1815 version, Dryden: '... so bright a track still leaves the setting sun, that vanishes in glory.' Ladbrooke exhibited the subject again with the British Institution in 1819 (137), *A View of the Foundry Bridge, Norwich,* but this was a larger canvas than the version illustrated here.

Foundry Bridge, Norwich may be dated to the period 1822-33 as it shows the new Shirehall, completed in 1822, clearly visible, as are the old castle battlements, prior to their restoration which commenced in 1834. While the period 1816-18 had been a particularly prolific one for Robert Ladbrooke, he exhibited fewer pictures in the 1820s. Although the local press expressed regret that he had ceased to exhibit in Norwich since 1818, his return to the fold in 1824 was overshadowed by the work of his younger contemporaries. The *Norfolk Chronicle* commented that his one submission in 1825, a grove scene, was 'very rich in tone and composition, bringing forcibly to our minds the wood scenes of Hobbima' (6 August).

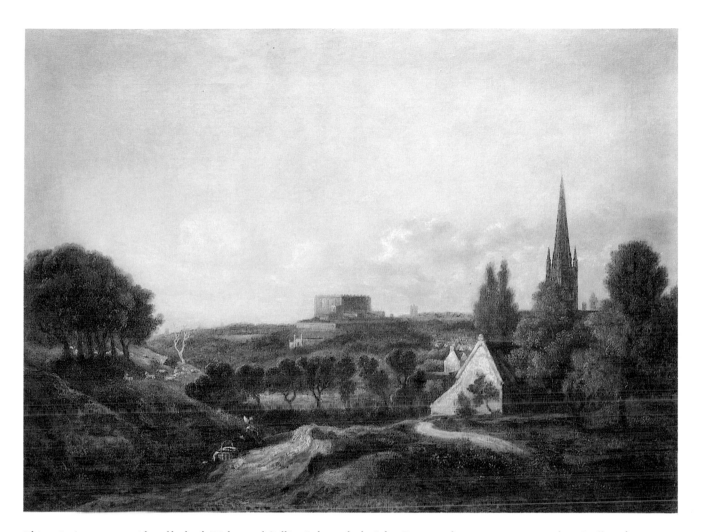

This painting was considered by both Dickes and Collins Baker to be by John Crome and was dated to *c.* 1816 by the former and 1812 by the latter. However, Crome died in 1821 and as the painting shows the completed Shirehall, it must date from after 1822 when that building was finished. Of this picture Dickes observes that 'the light comes with wonderful effect', while Collins Baker comments upon the 'steely blue sky' and 'general tone, like a Constable'. Despite being founded upon a misattribution, such observations reveal something of the qualities to be found in a painting by Ladbrooke, the recognition of whose work is often hampered by misconceptions concerning his ability as an artist. A characteristic of his work is the thin painting of many of his skies, a feature both of this painting and of another oil at Norwich, *Yarmouth Harbour (Moonlight)* (NCM 1016.235.951). The colour of the prepared canvas is here used as a middle tone with an effect similar to that of his use of oil on panel (see p. 54).

Robert Ladbrooke painted a number of distant panoramic views of Norwich throughout his career. His earliest such view exhibited at Norwich was *View of the cathedral, Norwich from Thorpe grove* in 1805 (57). One of his most appealing views of this kind was *Merry-making, with a view of Norwich, from Richmond Hill Gardens,* exhibited with the seceding artists on Theatre Plain, in 1816 (14) and now in the collection of Rowntree Mackintosh.

Robert Ladbrooke
A View of Norwich Castle and Cathedral after 1822
oil on canvas
(74.4 × 99.4 cms)
Purchased 1981 (475.981)

The catalogue of the sale of Robert Ladbrooke's estate after his death organised by the auctioneer William Wilde at the Royal Hotel, Norwich (10, 11 November 1842) includes a large number of 'sketches, painted entirely on the spot'. His obituarist

Robert Ladbrooke
Landscape c. 1820s?

oil on pine panel
(21.3 × 32.8 cms)

R.J. Colman Bequest
1946 (1019.235.951)

writing in the *Art Union Monthly* also mentions 'numerous "sketches" painted entirely on the spot, dispersed by auction shortly after his death, and which, for *simplicity* and *truth*, have very rarely been surpassed' (A. Hemingway, *The Norwich School of Painters 1803-1833*, 1979 pp. 19-21). *Landscape* has traditionally been called *Mousehold, Norwich* but also bears a contemporary manuscript label on the back with the title *Near the Race Ground*. It seems, however, to be a Broadland scene with a winding river and bears little relation to the raised ground of Mousehold Heath.

The painting has the appearance of an on-the-spot sketch, in common with three other oil sketches on small panels in the collection of Norwich Castle Museum. These all have similar qualities, particularly the use of relatively thick impasto for highlights as well as shadows, in contrast to transparent glazes for the skies. The glazes are thinly applied, while the panel has little or no ground, the colour of the wooden panel acting as a middle tone. The pigment is applied here to a creamy consistency, in a manner quite different from that of John Crome whose work he more closely parallels in his earlier career. It is difficult to resist the conclusion that it was sketches such as these to which Ladbrooke's obituarist refers. When painting in this manner Robert Ladbrooke is perhaps at his finest, deserving recognition for a freshness of palette easily forgotten if only his early work and replica compositions are considered.

Robert Dixon
On the East Coast 1809
pencil and watercolour
(30.3 × 43.1 cms)
signed, bottom left:
Robt Dixon 1809
R.J. Colman Bequest
1946 (970.235.951)

On the East Coast is a finished watercolour which derives from a large number of colour sketches made by Dixon in Cromer and the surrounding district during the period 1809-10. A series of seashore sketches now in the collection at Norwich reveal Dixon at his best. His on-the-spot studies of fishermen on the shore line and the effects of sunlight and twilight on the sea and the horizon have an immediacy and perception akin to John Constable's studies. Andrew Hemingway has suggested that Dixon and his contemporaries may well have been influenced by the publication *Cromer considered as a Watering Place* (1806) by Edmund Bartell, a local surgeon and amateur artist, who became a member of the Norwich Society in 1808, when he himself exhibited two views of Cromer. Dixon, along with John Crome, John Sell Cotman and Robert Ladbrooke all exhibited Cromer views in 1809.

Dixon exhibited six Cromer subjects with the Norwich Society in 1810, two of which were entitled *Beach Scene, Cromer*. The east coast also provided him with subjects for his *Norfolk Scenery* published 1810-11.

Robert Dixon
Cromer Beach—Morning

pencil and watercolour
(13.3 × 22.8 cms)
inscribed, top right:
Cromer Beach, Morning
and bottom left, in a
different hand:
Cromer Beach—R. Dixon—
R.J. Colman Bequest
1946 (953.235.951)

Robert Dixon
Farmyard Scene c. 1809
pencil and watercolour
(56 × 45.8 cms)
Miss Lilian Dixon Gift
1945 (135.945)

Robert Dixon
Sketch at Pulham Market
1810
softground etching
(19.8 × 25 cms plate)
inscribed in plate,
bottom left of subject:
*Drawn & Etch'd by
Rob.t Dixon;*
bottom centre margin:
*Norwich Pub.d as the Act
directs by R. Dixon
Sep.t 1810 SKETCH at
PULHAM MARKET.*
Robert Fitch Collection
1894 (76.94)

According to his obituarist (*Norwich Mercury*, 7 October 1815), Dixon settled in Norwich, after studying at the Royal Academy, in 1800. In 1798 he had exhibited what was possibly a theatrical design at the Royal Academy and it was for his scene-painting for the Norwich Theatre that he first established his reputation in Norwich. He also practised as a Drawing Master and exhibited with the Norwich Society 1805-10. *Farmyard Scene* is typical of his work which may be dated from this period. A large exhibition piece, it is comparable to John Crome's *Blacksmith's Shop, Hingham* (see p. 22) but displays a heaviness of tone and theatricality presumably influenced by his work for the theatre. A similar subject, now in the Victoria and Albert Museum, is dated 1809.

Dixon specialised in rural cottage scenes and in 1810-11 he published a series of softground etchings, entitled *Norfolk Scenery.* He announced the publication of the first number in the *Norwich Mercury* on 6 January 1810, inviting subscriptions for the series 'illustrative of the Picturesque Scenery of Norfolk, in imitation of his Pencil Sketches'. The final thirty-eight plates reveal an assured, sensitive response to the spontaneous quality of the softground medium which belies the relatively unsophisticated manner of his drawing. The originality of his contribution in this medium, so early in the century and only one year after Crome's first experiments, has yet to be fully appreciated.

Robert Dixon
Under the Old City Walls,
St. Magdalen Gates, Norwich
c. 1808-9

pencil and watercolour
(20.8 × 30.9 cms)
signed, bottom left: *R. Dixon.*
Inscribed with title
James Reeve Gift
1904 (3.67.04)

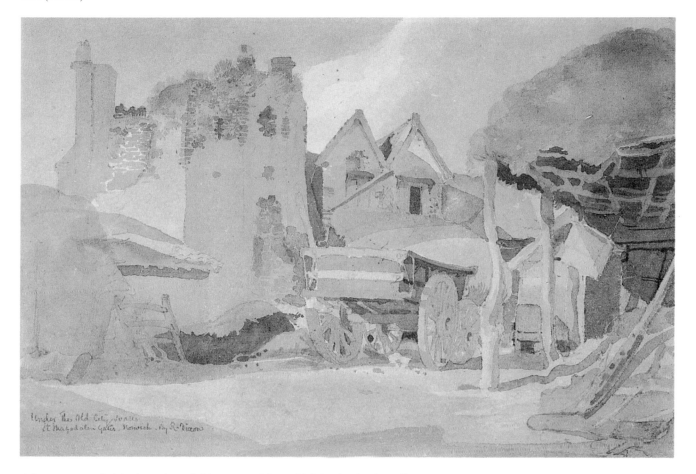

A larger, more finished version of this composition which is also in the collection at
Norwich (NCM 135.945) is dated 1809. This has figures added in the foreground and is
almost certainly an exhibition piece. In 1809 Dixon exhibited *Ruins of a Tower on the
City Walls* with the Society of Associated Artists in Water Colours in Bond Street,
London– one of two pictures which were subsequently returned to Norwich in time for
them to be shown at Sir Benjamin Wrenche's Court (*Norwich Mercury,* 5 August
1809). This was in the year of Dixon's Vice-Presidency of the Norwich Society.

The smaller version of the composition (above) shows the qualities of a preliminary
study. The assured use of clear tones of wash in his coloured studies show him respond-
ing to the example of John Sell Cotman and also John Thirtle. It is possible that this was
one of Dixon's exhibits in 1805 with the Norwich Society, *Near Magdalen gates,
Norwich* (131), but a slightly later date is more probable, in common with surviving
colour studies of *c.* 1808-9.

Robert Dixon
*Back of Magdalen Gates,
Norwich* 1809

pencil and watercolour
(57.5 × 79.8 cms)
signed, bottom right:
ROB! DIXON 1809.
Presented by Miss Lilian Dixon
1945 (135.945)

Robert Dixon
Beeston, near Sheringham 1810
pencil and watercolour
(55 × 75 cms)
signed, centre right:
Robert Dixon 1810
Miss Lilian Dixon Gift
1945 (135.945)

Robert Dixon exhibited for the last time with the Norwich Society in 1810. His titles for that year reveal at least seven scenes relating to the north coast of Norfolk, three of which were specified as *evening* views, including (154) *Runcton and Beeston (looking from Howard's hill, Cromer) evening*.

Beeston, near Sheringham is a large exhibition piece which indicates something of the effect that Dixon's experience as a scene painter had upon his work in watercolour. The breadth and scale of the composition is complemented by a clarity of wash which shows Dixon moving away from the traditional use of underpainting, to benefit from the experience of his outdoor watercolour sketches. This watercolour is an indication of how his work might have developed. His work with the theatre included a programme of redecoration, which must have taken up much of his energies, at a time when he was increasingly suffering from ill-health. He had ceased to be a member of the Norwich Society by 1812 and according to his obituary he had undergone 'bodily sufferings' for some five years when he finally died at the early age of thirty-five, on 1 October 1815.

James Sillett
Old Oak, Winfarthing
c. 1812-17

pencil and watercolour
(22.3 × 30.9 cms)

R.J. Colman Bequest
1946 (1234.B59.235.951)

James Sillett
Merry's Pompadour Auricula

pencil and watercolour
with some gum arabic
(28 × 22.9 cms)
signed, bottom right:
J Sillett

Presented by H. Bolingbroke
1960 (3.144.960)

In 1820 a brass plate was fixed to the Winfarthing oak which recorded its dimensions: 'in circumference, at the extremity of the roots, 70 ft.; in the middle 40 ft.' (Todd Collection, NCM). This magnificent old oak evidently attracted Sillett as a subject suited not simply for a landscape setting but also for as close an observation of nature as his studies of still life. The neat, somewhat mannered attention to detail was repeated in a similar, crisply painted oil version, dated 1812 (NCM 89.947). A second oil version, dated 1817, is in a private collection. The subject was also later drawn and etched by Henry Ninham.

There is no record of Sillett having exhibited this subject during his lifetime. Although he did show a number of landscape subjects, the main emphasis of his work was upon still lifes featuring fruit, flowers, birds, fish and game, dead or alive. The precise quality of his pictures suggests the eye of the natural historian as much as of the artist, some of his exquisite botanical studies being comparable to those of his Norwich contemporary, William Jackson Hooker (1785-1865). Sillett was anxious that his contemporaries and pupils should 'not be misled by prejudice, or suffer themselves any longer to be persuaded, that there is more beauty in the delineation of a pig-stye or cart-shed than in the human figure or the beautiful productions of the flower-garden.' (*Norwich Mercury*, 4 July 1812.)

James Sillett
Flowers and Fruit 1827

oil on canvas
(60.5 × 50.3 cms)
signed, bottom left:
J. Sillett 1827
Presented by the East Anglian
Art Society 1894 (11.75.94)

James Sillett was consistently held in the highest regard in Norwich for his faithful studies from nature, particularly his paintings in both oils and watercolours of flowers and fruit. His only rival in this sphere during his later career was his own daughter and pupil, Emma Sillett (active 1813, died 1880) who began to help him with his teaching 'of the 'younger Female Classes' in 1817 (*Norwich Mercury*, 5 July 1817). James Sillett exhibited his first flowerpiece in 1798 at the Royal Academy, advertising shortly after his return to Norwich his intention to publish, by subscription, 'a Series of Flowers, accurately drawn after nature, equally intended for the amusement of the florist, or to draw after' (*Norwich Mercury*, 26 September 1801). Ten months later he announced an exhibition in which 'those who are partial to Flowers, will there find a small collection in bloom in all seasons' (*Norwich Mercury*, 24 July 1802).

James Sillett's reputation as a painter of fruit and flowers was used against him at one point. A measure of the rivalry amongst the numerous drawing masters in Norwich may be seen in his decision to announce 'that in consequent of a report which has been industriously circulated by interested persons, he thinks it necessary to state to the public, and particularly to Parents and Ladies and Gentlemen superintending schools, that his mode of teaching is by no means confined to *Fruit, Flowers &c.* as has been insinuated...' (*Norwich Mercury*, 4, 11 July 1812).

James Sillett announced his intention to publish by subscription a series of views of all the churches and 'public edifices' in Norwich to be engraved in aquatint after his drawings in August 1820. He planned to issue the views in monthly numbers of three at a price of seven shillings and sixpence each number. By the 5 August most of the drawings were 'nearly finished' and some of the engravings ready. In the event the whole series of fifty-nine *Views of the Churches, Chapels, and other Public Edifices of the City of Norwich* was not complete until 1828, each view being a lithograph rather than an aquatint. This watercolour is one of a series of the original drawings now in Norwich Castle Museum, and was reproduced as plate 59 in the *Views*.

On 1 February 1832 Sillett presented a set of the lithographs to the Norfolk & Norwich Museum: '…I make no claim to any merit in the process except that of correctness, it being my intention from the first to endeavour to convey the objects precisely as they stood & appear'd at the period, seeing as I did the many alterations, patchings up, delapidations, & still worse, ill-judged clumsy repairs, silently, yet continually, going on…'. This drawing of the Guildhall does indeed show features that were subsequently lost in restoration work to the design of T.D. Barry in 1861, notably the balcony with its small columned building.

James Sillett
Norwich Market, the Guildhall
c. 1820

pencil and grey wash
watercolour (13.5 × 21.5 cms)
R.J. Colman Bequest
1946 (1234.B6.235.951)

George Clint
Sir John Harrison Yallop 1815

oil on canvas
(240 × 149.2 cms)
Civic portrait C5

Sir John Harrison Yallop was Sheriff of Norwich in 1805 and Mayor in 1815 and again in 1831. Together with his brother-in-law Nathaniel Bolingbroke he presented the King with a petition in favour of Reform during his second Mayoralty, for which he gained his knighthood. He died at Brighton in June 1835, aged seventy-two.

George Clint began his career as an engraver and miniature painter but gradually specialised in portraiture and in particular theatrical portraits of the leading actors of the period. He was encouraged to continue with portraiture by William Beechey and, like Beechey, he developed strong links with Norwich. He exhibited annually with the Norwich Society from 1823, often submitting portraits shown the previous spring at the Royal Academy. He gained a considerable reputation in Norwich during the 1820s, having been commissioned by the City to paint the portrait of William Hanks, Mayor in 1816, as well as Sir John Harrison Yallop, Mayor the previous year. By 1830 the *Norwich Mercury* critic commented that he did not believe a painter then existed 'in this Kingdom' who could surpass Clint in his ability to capture a likeness with that degree of finish considered so important at the time (*Norwich Mercury*, 7 August 1830).

Joseph Clover
Thomas Back Esq. 1810-11
oil on canvas
(239.4 × 147.3 cms)
Civic portrait C20

Thomas Back had been Sheriff of Norwich in 1801 and Mayor in 1809. On 26 April 1810 he laid the first stone of the old Carrow Bridge in Norwich. A banker, whose business Kett & Back was at 23 White Lion Street, he remained in public life until his unfortunate death, by an apoplectic fit, in the Council Chamber on 21 February 1820.

The announcement that Joseph Clover had been selected to paint the portrait of the late Mayor of Norwich, Thomas Back, came in June 1810. The commission was evidently made upon the strength of 'natural talent so early matured' (*Norwich Mercury*, 23 June 1810) to be seen in Clover's portraits at the Royal Academy that year, aided by the knowledge that his grandfather was Joseph Clover of Norwich, renowned as the 'Father of Veterinary Art'. The portrait was completed and hung in St. Andrew's Hall in August the following year, having first been exhibited at the Royal Academy (474), that spring. At the same time, Clover held an exhibition of his work in rooms on Elm Hill as further testimony to the city of his talents. He was later commissioned to paint two more portraits for the city, those of Barnabas Leman, Mayor in 1813, and Crisp Brown, Mayor in 1817.

Joseph Clover
The Harvesters
c. 1806

oil on canvas
(62 × 51.9 cms)
Purchased 1976 (501.976)

Joseph Clover
On North Tyne in
Chipchase Park
August 1810

pencil and watercolour
(25.5 × 18.2 cms)
verso, inscribed as title
Presented by Miss Mary Clover
1939 (3(27-31)141.939)

According to a manuscript note of 20 September 1831 by Thomas Preston of Stanfield Hall, Wymondham, the subject of this picture, painted early in Clover's career when he was a pupil of Opie, is from a poem by Robert Bloomfield. The model for the old man was David Thomas, who was John Opie's usual model for his historical or narrative pictures. The little girl was modelled by Eliza Sale. Preston states that the picture was painted following the principles published by the Norwich painter Thomas Bardwell (?1704-67) in his *Practice of Painting made Easy*, first published in 1756 and still one of the standard texts for the English painter in oils at the beginning of the nineteenth century.

Clover first exhibited at the Royal Academy in 1804 soon after moving to London to become the pupil of John Opie. In 1807 Clover exhibited *Harvest vide Bloomfield's 'Farmer's Boy'* (10) – possibly the picture reproduced here. The influence of John Opie is evident in the free handling of the pigment, a technique which foreshadows that of Clover's oil sketches. A good number of these survive in the collection at Norwich. Although he is best known for his portraiture in oils, Clover's landscape sketches in both oil and watercolours reveal him to have been one of the most spontaneous and immediate of the Norwich painters.

Michael William Sharp
*Portrait of Mrs. John Crome
seated at a table by an open
workbox* 1813-14

oil on oak(?) panel
(43.5 × 34 cms)
signed, bottom right:
M W Sharp 1813 (?)
Purchased 1935 (86.935)

Michael Sharp was born in the parish of St. Paul's, Covent Garden but spent his early years in Norwich when his father moved there from London to earn his living as a music master. Michael Sharp took lessons from John Crome and also Sir William Beechey (*Norfolk Tour* 1829). He first exhibited in Norwich from a London address in 1813. The following year he exhibited his portrait of Mrs. Crome at both Norwich (66) and the Royal Academy (136). John Crome had married Phoebe Berney on 2 October 1792 in the church of St. Mary Coslany. Sharp was a good friend of the Crome family and in 1813 John and Phoebe Crome named their seventh and youngest child, Michael Sharp Crome, in his honour.

In 1816 Michael Sharp became Vice-President of the Norwich Society and President the following year. He last exhibited with the Society in 1821, one of his pictures being (93) *Portrait of the late Mr. Crome*, now in the collection at Norwich (NCM 1229.235.951). His pictures were well received in Norwich, his best work being considered that which combined 'that floridity of colouring and lightness of touch' noticed in his work prior to 1818, with 'a depth of tone and solidity of effect' associated with the Flemish Masters (*Norfolk Chronicle*, 8 August 1818).

JOHN SELL COTMAN

While the oil painters of the Norwich School are dominated by the example of John Crome, it is John Sell Cotman whose original genius underlies the upsurge of talent among the Norwich watercolourists. Cotman's individual response to the patterns of Nature mark him out as unique amongst the watercolourists not only of Norwich but of his contemporaries in London as well. Although the work of his pupils who copied his designs was often execrable, a number of his contemporaries, notably John Thirtle, and his own sons, Miles Edmund and John Joseph, learnt much from his example, if not his teaching method. His true legacy as a watercolourist is seen most clearly in the work of John Thirtle who responded with the utmost sensitivity to the muted tones of Cotman's earlier works. Throughout his career he was dogged by the vagaries of public opinion which, although often supportive, particularly of his architectural pieces, was invariably qualified in its praise.

Born in the parish of St. Mary Coslany, Norwich on 16 May 1782, Cotman developed swiftly as the greatest draughtsman of the Norwich School. His career often took him beyond the immediate surroundings of his home town. He visited Wales twice and both Yorkshire and Normandy three times. After his early years in Norwich he moved first to London, then successively to Norwich, Yarmouth, Norwich and finally London once more. While London was always the focus of his aspirations, it was at Yarmouth that he established his family and home under the patronage of the Yarmouth banker and antiquarian, Dawson Turner. At all other periods in his career the cities of both London and Norwich were his true homes.

Cotman's early career was marked by a period of rapid development as an artist. His first move to London, probably in 1798, resulted in his joining the circle of Dr Munro's teaching 'academy' in the footsteps of the young J.M.W. Turner and Thomas Girtin. He soon joined the sketching society which had developed around the personality and talent of Girtin. It was Girtin who discovered the value of painting in more translucent washes of colour. These were less muddied in their effect than the eighteenth-century method of painting in watercolours founded upon underpainting to achieve effects of mass and shadow. Cotman developed Girtin's discovery, recognising the tonal values of flat washes of colour, often superimposed.

It was while he was based in London that Cotman embarked upon a number of sketching tours between 1800-1805, which were to have a dramatic effect both upon his social life and his artistic development. In 1800 and 1802 Cotman travelled to Wales in search of the Picturesque and saw the castles and mountainous terrain which would remain as images to fire his imagination for the rest of his life (see pp. 70, 75). On his second trip to Wales he was almost certainly accompanied by the artist Paul Sandby Munn, who also travelled with him on his first trip to Yorkshire in 1803.

The influence of Yorkshire upon Cotman was as significant as it was to both Girtin and Turner. Just as Turner was encouraged by Walter Fawkes of Farnley Hall and Girtin by Lord Harewood, so Cotman gained an introduction to the Cholmeley family of Brandsby Hall, some fifteen miles north of York, through the good offices of a lifelong patron, Sir Henry Englefield, the brother of Mrs Cholmeley. Mrs Cholmeley found the young artist 'maniere'd and gentlemanlike', commenting 'Cotman is quite a treasure—only 21 years old and such a draughtsman' (Harriet and Mrs Cholmeley to Francis Cholmeley, 10 July 1803). Cotman returned to stay with the Cholmeleys in both 1804 and 1805 and it was through their acquaintance that he was invited with Francis Cholmeley junior to visit Rokeby Hall to stay with the Morritts. The owner of the Hall, John Morritt, is perhaps best known as the purchaser (in 1814) of the famous *Rokeby Venus* by Velázquez. Cotman stayed at Rokeby Park some three weeks 'industriously employed upon a subject that call[s] forth all my powers' (JSC to Francis Cholmeley, 29 August 1805). The park is situated about half a mile from the village of Rokeby, an extremely fertile area characterised by luxuriant woods overhanging the banks of the rivers Greta and Tees. It was this visit which resulted in some of the finest and most delicate watercolours in the history of European watercolour painting. His work at this time demonstrates an exquisite control of the medium which is totally his own and at one with his unique vision of the patterns of Nature. Perhaps the most outstanding and original of the series of watercolours resulting from Cotman's stay at Rokeby is *Devil's Elbow, Rokeby Park* (p. 66). The scene depicted is characteristic of both the Greta and the Tees in this area, to the extent

John Sell Cotman

opposite

John Sell Cotman
'Devil's Elbow, Rokeby Park'
c.1806-7

pencil and watercolour
(45.1 × 35.1 cms)
R.J. Colman Bequest
1946 (134.217.947)

that the precise location of Devil's Elbow is unknown. The grandeur of Rokeby was later to inspire Sir Walter Scott who visited the park in 1809 and 1812 and dedicated his long poem *Rokeby* (1813) to his host, Mr. Morritt. During the month of August 1805 Cotman made a number of trips beyond Rokeby Park; south-west along the Greta to Brignall Banks and north-west to Barnard Castle. These trips provided Cotman with material for at least seventeen watercolours, six of which he exhibited.

In the winter of 1806 Cotman returned to Norwich with the avowed intention 'of turning myself about during my stay and studying [oil] painting, which of late, I have done but little, having been engaged too much in other things' (JSC to Dawson Turner, 8 December 1806). He also determined to open a 'School for Drawing and Design'. Neither enterprise was to be the unqualified success he hoped for. Despite his prolific output in watercolour and oil at this period, the local public appears to have been slow to purchase his work. He was a major exhibitor with the recently-formed Norwich Society, showing a total of 149 works at their annual exhibitions from 1807 to 1810. His prodigious creativity during these years is amply demonstrated by the fine array of watercolours dating from his first Norwich period now in the collections at Norwich.

During this time he also wooed and won a local Felbrigg girl. On 6 January 1809 he married Ann Miles in Felbrigg Church. Shortly afterwards he opened a circulating library of drawings for pupils to copy, by which to teach the 'Cotman style' of drawing. This enterprise was in competition with a good number of his fellow artists, including John Crome, who were also advertising as drawing masters. In 1810 he took up the etching needle, publishing his *Miscellaneous Etchings* the next year, the first of a series of published etchings in which he consciously emulated the work of Piranesi. He held high hopes for this aspect of his career. 'I feel I have a horse that will carry me nearer the temple of fame than ever I was' (JSC to Francis Cholmeley, 5 March 1811). His *Architectural Antiquities of Norfolk* was published in 1818.

His move to Yarmouth found Cotman with little time for creative work other than his etching projects. Poor health and eye trouble, combined with printing and production problems, plagued his publication programme. Almost all Cotman's etched work derives from the period 1810-22. Although this was a period of unremitting labour for him, it was not simply one of hackwork. While under the aegis of Dawson Turner he undertook the prodigious task of executing over four hundred plates in the publication of six volumes of etchings, but it is apparent that he was dedicated to the work. He spent most of his time in voracious pursuit of subjects and was helped by assistants in the production of plates. Throughout his career he combined antiquarian and archaeological interests with an instinctive response to Nature. Although the publication of etched work demanded 'A Herculean Labor' (JSC to Francis Cholmeley, 23 July 1822), it also held out the 'distant view of reputation' (JSC to Francis Cholmeley, 14 February 1820) and the possibility of a secure livelihood.

It was while he was at Yarmouth that he embarked upon his three Normandy tours in 1817, 1818 and 1820. Cotman's letters from Normandy reveal that his experiences were sometimes extremely uncomfortable, but his final trip in 1820 was to the southernmost region of Normandy where he found 'everything a painter could wish for ... the Wales of France' (JSC to his wife, 26 August 1820). He was enraptured by the region and many of the Normandy monochrome watercolours that derive from this final tour are now in the collection at Norwich Castle Museum. It was the publication of his *Architectural Antiquities of Normandy* in 1822 which probably brought him closest to 'the temple of fame'. In 1821 Cotman showed two etchings with the Norwich Society, (129) *West Front of the Cathedral at Rouen* and (131) *West Front of the Church of St. Peter at Lisieux*. On 18 August the *Norwich Mercury* critic effused: 'Mr. J.S. Cotman has two magnificent etchings of buildings, from his work on Normandy. This gentleman's talent has been so highly appreciated by the world of art, that no commendation we can bestow would add a grain to his celebrity. This work is truly honorable to himself, his country, and his nation.'

Cotman returned to Norwich in December 1823 to be received by a mixture of critical acclaim and some confusion. This period of his life coincided with technical and visual innovations in his work which were not always readily appreciated. The *Norwich Mercury* critic wrote of him as 'a man of unquestionably superior genius' in 1824 and the following year he was elected a member of the Old Water-Colour Society without being required to submit the customary drawings for approval. Mrs Palgrave informed her father, Dawson Turner, that 'Mr. Cotman's known talents rendered that unnecessary' (January 1825, Kitson, 1937, pp. 261-2). Nevertheless, although Cotman was pleased by his reception at his first showing with the Society, 'higher than I calculated upon', (JSC to Dawson Turner, 2 July 1825), the critic

of *The Examiner* disliked his 'sudden opposition of reds, blues and yellows'.

The most distinctive feature of Cotman's watercolours during his second Norwich period is a heightened sense of colour which is almost flamboyant. The *Norfolk Chronicle* described his work in 1829 as 'too gaudy, and we regret in them the absence of that sweet grey tone which is so charming in nature' (1 August). This new sense of colour was matched by a new technique in which Cotman would add a flour or rice paste to his watercolour to form a semi-opaque medium which intensified colour, also causing it to remain moist upon the paper for longer than pure wash. This enabled Cotman to wipe, drag or otherwise manipulate the colour in a manner which reflected the intensity of his vision.

During the early 1830s Cotman's reputation was in the ascendant and in 1833 he was President of the Norwich Society of Artists for the second time in his career. The following year he obtained the post of Drawing Master at King's College School, London: 'This is what I have ever loved and tried to realize ... Much as I have ever loved London I have never trod its gold paved streets feeling so much a man of business, and so much to belong to it as now' (JSC to his wife, 15 January 1834). It was through the intervention of Lady (formerly Mrs) Palgrave and Dawson Turner that Cotman obtained both this appointment and a house in Bloomsbury. Throughout this period Cotman was aided by his family in the production of drawing copies for his pupils. He would add his signature to those works produced by his son Miles Edmund or his daughter Ann which he considered 'crack subjects ... Little do they [the students] ken by whom they are done, when given under my name' (JSC to J.J. Cotman, 13 November 1835). The existence of many copies in the 'Cotman style', which he disseminated throughout his teaching career, has contributed to a confusion in the public mind as to the true quality of his genius. However, the derivative student work often confused with that of John Sell himself is not to be confused with major works of fantasy from his final London years, such as *The Drawing Master* (see p. 76).

In the autumn of 1841 Cotman went on a last sketching tour of Norfolk, visiting his friend James Bulwer, his father and son, John Joseph, and his patron, Dawson Turner. The weather was dreadful but 'the wilderness of Norfolk' fired his enthusiasm, resulting in a magnificent series of on-the-spot sketches taken during this last visit to 'rare and beautiful Norfolk', as well as the unfinished oil painting derived from that visit, *View from My Father's House at Thorpe* (see p. 77). On his return to London from Norfolk Cotman was faced once again with family problems which had never been far from his mind. His son Alfred, in particular, caused 'distressing and dangerous scenes' (JSC to Dawson Turner, 20 November 1841). Although he proceeded to work up some of his drawings, he became seriously ill. An entry in Robert Geldart's diary for 20 June 1842 finds him visiting the Cotmans in London: 'Old Cotman, who was seriously ill, showed us Normandy drawings in sepia.' On 22 July Cotman's daughter Ann wrote to John Joseph a touching account of their father's last days: 'I am quite sure he does not wish to get well, or he would have made some effort to do so.' On 24 July Cotman died. He was buried six days later in St. John's Wood Chapel Churchyard, Marylebone.

John Sell Cotman
Mountain Scene 1800

pencil
(11.2 × 24 cms)
inscribed with notes:
Bright Light and *Gray;*
and dated, bottom right:
July 23 1800;
top right, part of
circular stamp of
Norwich School of Art
On loan from
Norwich School of Art
1967 (52.L1967.9)

John Sell Cotman
Barmouth Estuary 1801

pencil and watercolour,
with gum (17.4 × 28.8 cms)
signed, bottom right:
J S Cotman 1801
R.J. Colman Bequest
1946 (125.217.947)

This is one of the best preserved of John Sell Cotman's early drawings and still retains the grey-blue tones associated with the work of Thomas Girtin (1775-1802) and so characteristic of Cotman's watercolours of *c.* 1800-01. The composition is derived from sketches Cotman presumably made whilst touring the Barmouth area between 18 and 30 July 1800. Cotman exhibited two views of the Barmouth Estuary during his career, one at the Royal Academy in 1804 (37) and another with the Norwich Society in 1829 (125), while five other variations of the scene are known.

One dated on-the-spot sketch survives from Cotman's journey northwards in 1800 from Aberystwyth (18 July) to Harlech which he had reached by 30 July. Dated 23 July 1800, this shows a high mountain range which is almost certainly that of Cader Idris from across the Barmouth river (NCM 522.L1967.9). At the age of eighteen, Cotman was following the example of many of his contemporaries in the current fashion of travelling the length and breadth of the British Isles in search of the Picturesque. His few weeks in Wales in 1800 and again in 1802 were to make a lasting impression upon his creative imagination, giving him a supply of sketches to which he would refer for source material throughout his career.

John Sell Cotman
St. Botolph's Priory, Essex 1811

etching
(25.8 × 36.5 cms plate)
inscribed in plate, bottom
centre of subject:
ST-BOTOLPHS-PRIORY-ESSEX-
Drawn and Etched by J.S. Cotman
and bottom left in margin:
Norwich Published Febry 20th by
J.S. Cotman St Andrews Street. 1811
Purchased 1956 (254.956)

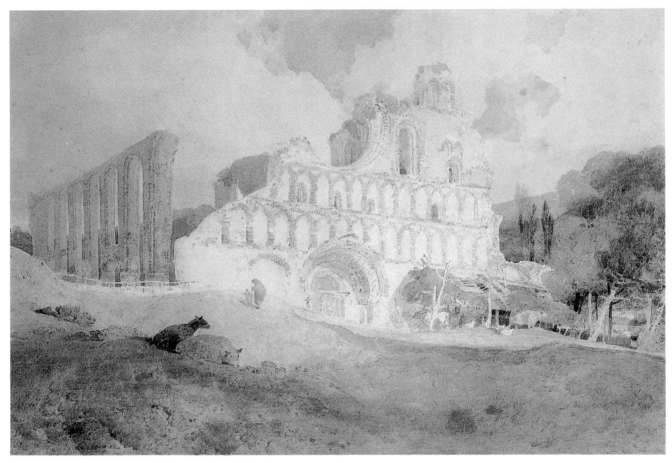

John Sell Cotman
St. Botolph's Priory,
Colchester c. 1804-5

pencil and watercolour
(35.7 × 52.1 cms)
R.J. Colman Bequest
1946 (128.217.947)

Kitson suggests that Cotman sketched the ruins of St. Botolph's Priory on his way from London to join Dawson Turner and his family at Covehithe on the Suffolk coast in July 1804. It is equally likely, however, that Cotman could have broken any of his journeys between Norwich and London to see the Priory, which is just south of Colchester Castle. The twelfth-century edifice, with its picturesque silhouette, decorative architectural features and antiquarian interest was a subject with real appeal for Cotman. This watercolour remains one of the most harmonious of his architectural watercolours, despite the fading of the blues, and was probably exhibited with the Norwich Society in 1807 (140).

The delicate handling of the trees to the right, together with broad treatment of the washes in both foreground and sky, show Cotman at the outset of his most triumphant period as a watercolourist of original vision. Cotman later etched a version of this subject, published in 1811, in which he aimed to emulate the work of the Italian architectural draughtsman and etcher, Piranesi (1720-78). He informed his friend Francis Cholmeley that 'this was etched decidedly for the Piranesi effect' (5 March 1811). In consequence, the etched version shows a close view of the West Front, with the landscape setting reduced, emphasizing the antiquarian interest of the subject.

John Sell Cotman
West Front of Castle Acre Priory
published 1813

etching
(30.4 × 43 cms)
inscribed, bottom left,
with monogram and
Drawn, Etched & Published by
J.S. Cotman Yarmouth Jan^{ry} 1813,
bottom right *XXIV*
Presented by Lady Holmes (190.940)

Castle Acre Priory was founded at the end of the eleventh century by William de Warenne for some twenty-five to thirty Cluniac monks. Cotman first visited the impressive remains in August 1804, his earliest surviving letter being written to Dawson Turner from there on 9 August that year. In that letter he drew a thumbnail sketch of this view (Kitson, 1937, pl. 29). A watercolour of the same view also dates from *c*. 1804 (ibid. pl. 30). The etching, however, represents a sense of design firmly related to his new mastery of the medium. The positive lights of the façade are in keen counterpoint to the strong dark diagonal to the right of the composition and the distant dark forms to the left.

First published in 1813, with the inscribed dedication to Thomas William Coke, this subject formed plate 24 in Cotman's *Architectural Antiquities of Norfolk* (1818). Cotman etched four other aspects of the Priory, two of which include the words 'drawn in 1804' within the titles. Writing to Dawson Turner on 25 August 1811 he stated his intention to include Castle Acre among 'my chief objects' but on 20 September he regretted not having gone there and planned to return with a companion. The inscription on this plate may suggest a visit in January 1813.

John Sell Cotman
Domfront, View from the Town
c. 1820-23

pencil and brown wash
(26.2 × 40.4 cms)
R.J. Colman Bequest
1946 (289.235.951)

Cotman's only visit to Domfront was during his third Normandy tour, in 1820. He arrived on 20 August and stayed there for several days. In a letter to Dawson Turner of 26 August he mentions the 'Rocks extremely grand' amidst a terrain of 'the most woody country possible one mass of forest'. It was an area in which he found 'inexpressible beauty'. The view is taken from the hillside below the castle at Domfront, looking into the Val des Rochers, the gorge of the river Varenne. The composition reveals an instinctive response to the almost architectural qualities of the rocky landscape, with the dwellings set with humility beneath the majestic rock formations. A number of versions exist, including an autograph version now at Leeds (29.30/38(1352)), a copy by Elizabeth Turner (Barker Collection) and a meticulous replica, probably by Miles Edmund Cotman.

In a long retrospective letter to Francis Cholmeley, Cotman reveals his reasons for embarking upon his third tour from Yarmouth. Although he had wished to continue a collection of views of the cathedrals of Normandy, he had conceived the notion 'of giving a picturesque tour distinct from the first work...I shall be able to shew that Normandy is not a *flat country* at least'. He remarked that it reminded him of 'the most beautiful parts of Yorkshire' (25 September 1820).

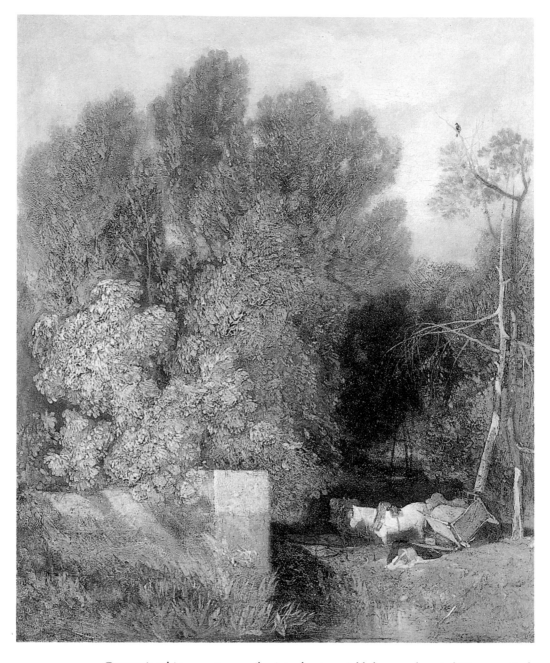

John Sell Cotman
The Mishap c. 1824-28

oil on mahogany panel
(43 × 35.4 cms)

J. J. Colman Bequest
1898 (6.4.99)

Cotman's achievement as an oil painter has invariably been underrated. He was actively painting in oil at least by the summer of 1806 when he first advertised that he would give lessons 'in Painting and in Water Colours' (*Norwich Mercury,* 1 July 1806). Cotman painted in oils intermittently throughout his career and the collection of his oils at Norwich Castle Museum provides a unique survey of the breadth of his talent as an oil painter. He became so enthusiastic about the possibilities of the medium that he wrote to James Bulwer on 31 May 1839: 'I have been, and am, painting hard, and I am so fond of it that I think I shall never execute another drawing.'

During the mid 1820s Cotman was encouraged by Dawson Turner to concentrate upon his drawings, but he continued to receive commissions for oils. About this time he appears to have undertaken a series of closely related landscape compositions which all feature luxuriantly leafy trees painted with a fully-loaded brush. He exhibited a number of tree subjects with the Norwich Society over the period 1824-8. Paintings now at Norwich which must also date from this period are a small oil sketch known as *In the Bishop's Garden, Norwich; The Silent Stream, Normandy; Silver Birches* and *The Baggage Wagon,* the pair to *The Mishap.* The series reveals Cotman's increased awareness of the three-dimensional possibilities in representing the patterns of nature through the medium of oils.

John Sell Cotman
Cader Idris c. 1828-33
oil on oak panel
(24.4 × 31.6 cms)
Purchased 1941 (103.941)

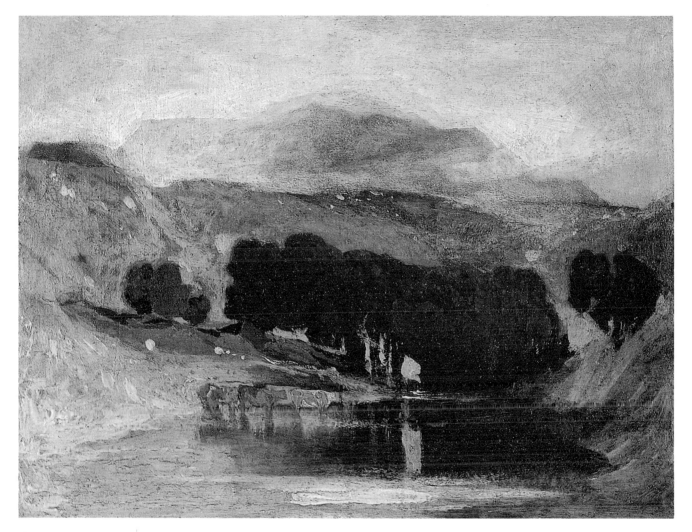

The mountain ridge of Cader Idris remained a haunting image in Cotman's mind throughout his lifetime. This is perhaps the most lyrical of all the versions in different media which survive and is comparable with the visionary quality of his paste drawings of this period. The painterly technique of *The Mishap* has here been developed with absolute freedom, the thick blobs of colour creating a magical atmospheric effect.

The composition derives from a drawing of 1808 which was itself a remembered image dating from his early tours of the area. The composition was also reproduced in reverse as a soft ground etching, reproduced as plate 15 of Cotman's *Liber Studiorum* published in 1838. Slight variations between the original design and the oil demonstrate the extent to which Cotman continued to respond to the memory of the majestic silhouette of Cader Idris long after his first sketches on the spot. The continuity of Cotman's creative imagination is well demonstrated by the numerous versions of this image. His soft ground etchings are among some of Cotman's most personal and evocative works and that of Cader Idris complements the oil version in its embodiment of a recurring memory, visualised through the crumbling line of the soft ground medium.

John Sell Cotman
Cader Idris, North Wales
softground etching
(12.7 × 17.5 cms plate)
inscribed in plate, top right:
15; bottom centre:
Cader Iris. [sic] *N. Wales*
Purchased from Walker Bequest Fund
1923 (86.23)

John Sell Cotman
The Drawing Master 1839
called *The Green Lamp*
pencil, chalk, watercolour and
bodycolour with some gum
(33.1 × 47.6 cms)
signed: *J S Cotman 1839*
with illegible inscription
R.J. Colman Bequest
1946 (225.217.947)

John Sell Cotman
The Drawing Master c. 1839
pencil and coloured chalks
on blue paper
(24.1 × 33.8 cms)
Purchased 1984 (307.984)

This drawing was one of six Cotman submitted for the first exhibition of the Norfolk and Norwich Art Union, only two of which did not relate directly to his post as Drawing Master at King's College School, London. The *Norfolk Chronicle* (12 October 1839) found the picture 'remarkable for freedom of manner and richness of tone; for massiveness and depth of shadow in contrast with equal breadth and vivid effect of light'. The setting traditionally shows Cotman with his wife and daughter Ann in their drawing room at Bloomsbury, working by the lamp which Cotman called his 'Lamp of Aladdin'. The lamp is not present in the recently discovered preliminary drawing. Instead, a lantern clock with hanging weights is on the wall. This has been sponged and rubbed out in the watercolour. The preliminary sketch indicates that the palatial baroque setting is far more likely to be a large public room—quite possibly in King's College School.

The Drawing Master represents the height of Cotman's romantic virtuosity and is the latest of his securely datable works in this style. A writer for the *Art Union* (October 1839) regarded it as 'a brilliant and beautiful piece of colouring, in that rich and gorgeous style for which Mr. C. has lately rendered himself famous'. He did not, however, approve of Cotman's use of a green coloured piece of paper pasted on as the lamp shade, finding it 'somewhat derogatory to Art'.

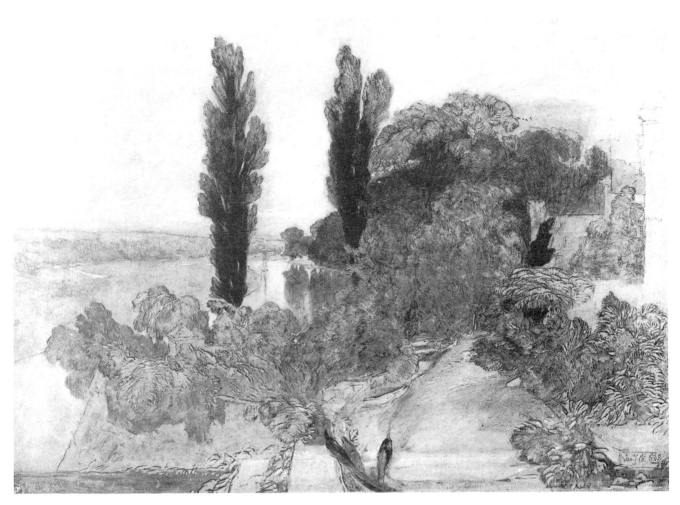

Whilst in London in September 1841 Cotman determined to take a holiday in Norfolk to revisit old haunts and friends, including the Rev. James Bulwer, the Rev. John Gunn and his wife Harriet and the Turner family at Yarmouth. He was away in Norfolk for almost two months, despite intermittent torrential rains. His biographer Sydney Kitson refers to him as an 'elderly truant' at this time, sketching with the carefree abandon of his youth in Wales and Yorkshire. A considerable number of drawings in black and white chalks survive from this trip, mostly now in the Reeve Collection at the British Museum and in the collection at Norwich. Many are annotated with colour notes, indicating that he envisaged developing them in the medium of either oil or watercolour.

From My Father's House at Thorpe is derived from sketches possibly made during his visit to his father on 3 November. A preliminary chalk study now in the British Museum establishes those elements of the composition which are probably closest to the actual view from his father's home at Thorpe (BM 1902-5-14-165). A second sketch in the same collection establishes a more romantic and aggrandised view, which is closer to the final oil and introduces the three peacocks in the foreground (BM 1902-5-14-166). The studies, together with the unfinished oil, provide a last insight into the artist's creative imagination.

John Sell Cotman
From My Father's House at Thorpe
c. 1841-2

oil over black chalk on canvas
(68.4 × 94 cms)
Inscribed, bottom right:
Jany 18. 1842
Presented by the East Anglian Art Society 1894 (1.75.94)

COTMAN'S FAMILY & FRIENDS

John Thirtle

John Sell Cotman's teaching methods as a Drawing Master resulted in a myriad sub-standard copies of his compositions made by pupils whose talents could never rise above the adequate. By contrast, two of his sons, his brother-in-law and two close family friends responded to his example at different stages of his career with both technical facility and understanding. The most talented and individual of these was **John Thirtle** (1777-1839), of whom Henry Ladbrooke was later to comment: 'As a man of genius Cotman was much Crome's superior & as a colorist Thirtle far surpassed them both' (letter to J.B. Ladbrooke, Reeve Collection, BM).

Little is known of the life of John Thirtle. He was baptised on 22 June 1777, the son of John and Susanna Thurtle [sic] of St. Saviour's parish, Norwich. His father was a shoemaker who is traditionally said to have lived and worked in Elephant Yard. According to James Reeve he was sent to London at an early age to learn the trade of framemaker. If he served a full apprenticeship of seven years in London, he may still have been there when Cotman left for London in *c*. 1798. According to John Joseph Cotman, Thirtle was in the habit of seeking out John Sell Cotman's work even at this early date (Reeve Collection, BM). The first documented record of Thirtle's return to Norwich is in the catalogue of the first exhibition of the Norwich Society in 1805, when he exhibited five works. In 1806 he is listed in the catalogue as a 'Miniature-Painter and Drawing Master' of St. Saviour's, Norwich. James Reeve states that Thirtle 'opened a print shop not far from his father's residence this he altered and adapted to a Gilder's business which he carried on in conjunction with his profession as an artist and teacher of drawing'.

John Thirtle appears to have been one of the most successful artists in Norwich because he of necessity diversified his career according to demand. That his framemaking business was lucrative is evidenced by the number of pictures by J.S. Cotman, J.B. Crome, Dixon, Lound, Sillett, Stannard and Vincent in the collections at Norwich whose frames bear Thirtle's trade labels. The labels come in three types, the earliest being a simple caption, which is later expanded in fine copperplate to *Thirtle Carver Gilder Picture & Glass Frame Maker Magdalen Street Norwich*. The third is expanded and embellished with a border design. He was patronised by Cotman's sons as well as John Sell himself and was a lifelong acquaintance of Joseph Clover whose account books at Norwich Castle Museum record a last payment on 19 May 1838, the year before Thirtle's death. Thirtle's continued business in this field was no mean achievement in the face of fierce competition from Jeremiah and later William Freeman who virtually cornered both the framing and printselling markets in Norwich, as well as becoming active members of the Norwich Society of Artists.

In 1812 Thirtle was chosen as Vice-President of the Norwich Society and at the age of thirty-five, on 2 November in St. Saviour's Church he married Elizabeth Miles of Felbrigg, the sister of Ann Miles whom Cotman had married only three years earlier. Thirtle could have met his future wife either through Cotman or through the Norwich Society as both she and her sister Katherine had exhibited a picture each with the Society in 1811. In 1813 Thirtle was again Vice-President of the Society and President the following year. James Sillett was his Vice-President. Their positions within the Norwich Society at the time of their secession with Robert Ladbrooke in 1816 are a good indication of the high feelings and sense of principle which must have attended the rift. Although Thirtle showed fifteen works on Theatre Plain in 1816, he exhibited only six in 1817 and none at all the next year. The *Norwich Mercury* regretted his absence: 'We lament exceedingly that Mr. Thirtle, who made up the seceding triumvirate, should not have found time for a single drawing. His occupation is doubly to be regretted, because he stands highest and alone in the particular and beautiful department of watercolours, in which he has evinced so much decided excellence' (1 August 1818). 1818 was the year in which four of his drawings were published as engravings for the first volume of *Excursions in the County of Norfolk*, published by Longman & Co., London. A fifth subject, *Costessey Park*, was included in the second volume, published in 1819. Sydney Kitson states that Thirtle was called to Yarmouth to help Cotman who was himself heavily involved in producing drawings for Longman's *Excursions* and also with his teaching commitments. Thirtle did not exhibit at Norwich again until 1828.

It seems that Thirtle's teaching and business commitments occupied most of his time after 1818. By 1824 he is known to have been drawing master to Mary Catherine Blofeld (1803-51), the daughter of

Thomas Calthorpe Blofeld of Hoveton House, Norfolk, who adopted his manner, but remained amateur. Another pupil at this time was probably James Pattison Cockburn (1779-1847). Henry Ladbrooke, meanwhile, commented of Thirtle that 'He was the most liberal man in imparting the knowledge of his art to any whom he took a liking for...' (published posthumously, *Eastern Daily Press*, 22 April 1921). Thirtle himself was not averse to learning from other artists besides Cotman, exhibiting a number of figure subjects which were copies after other artists, including Richard Westall (1765-1836) and Joshua Cristall (1767-1847). His subject-matter remained firmly rooted in Norwich and Norfolk, however, and, of ninety-seven exhibits at Norwich, only five of his landscapes were of non-Norfolk subjects. Among his most outstanding legacies in the history of watercolour painting are his panoramas of Norwich. His death at the age of sixty-three came 'after a long and painful illness' which was, in fact, consumption. He left his wife an estate of £2,000—no mean testimony to his success as a businessman in later life.

Miles Edmund Cotman

John Sell Cotman's eldest son **Miles Edmund Cotman** (1810-58) bears the names of both his maternal and his paternal grandfathers. Born on 5 February 1810, his career as an artist developed rapidly under his father's tutelage. He first exhibited with the Norwich Society at the age of thirteen and received his first press notice two years later for the 'creditable specimens of his industry and talents' (*Norfolk Chronicle*, 6 August 1825). By 1829 his work was firmly coupled in the public mind with that of his father: 'Cotman and his son have contributed very luxuriantly in the water-colour department, and have again given proof of their great though distinct talent' (*Norwich Mercury*, 25 July 1829). His sixty exhibits with the Norwich Society before its close in 1833 reveal him responding to a variety of his father's subject-matter, including a number of foreign views presumably derived from prints or the drawings of John Sell's artist friend, W.H. Harriott (active 1811, died 1839). The *Norwich Chronicle* commented of these drawings on 7 August 1830: 'Mr. E. Cotman's spirited representations of public buildings in continental towns, are worthy of the name he bears, and of the kindred talent which in him has been so successfully cultivated.' It was regretted the following year when only one of his works was exhibited, but it was understood that this was due to pressure of work in fulfilling direct demand.

Miles Edmund's reputation has inevitably suffered by constant reference to the influence of his father. The commonality of their styles and subject-matter has obscured an appreciation of the best of Miles Edmund's work. Richard Mackenzie Bacon noted that he had 'seconded, and worthily, his family claims, both in his own style and that of his father. His sketches are alike soft and effective, remarkable for truth of design and chastity of colouring—they are, in three words—pure, natural, masterly—we know not which to prefer of his several pieces' (*Norwich Mercury*, 4 August 1832). Such praise at the age of only twenty-two, which includes a reference to 'his own style', is an indicator to a more generous assessment of Miles Edmund's career. While he remains a less significant figure than his father, his work does reveal an increasingly independent artistic personality.

When John Sell Cotman left Norwich for London in January 1834, Miles Edmund remained in Norwich, responsible for continuing his father's teaching practice from a classroom in Fletcher's court. Miles Edmund proved equal to the task, although within the first week of his father's leaving, he had to seek John Sell's advice concerning a visit to Mrs Chapman, the headmistress of a local girls' school. He had been 'quite expecting she had determined on having me as drawing master', but Mrs Chapman had yet to make up her mind, having one pupil 'who *will not* learn of a Cotman, either Father or son, one who is a staunch admirer of Crome's style and cannot endure ours' (Miles Edmund to John Sell, 6 February 1834 (BM). Despite such hiccoughs, Miles Edmund felt that there were compensations. A week later, on 14 February, he wrote to John Joseph Cotman of his preference for ladies as pupils: '*nothing like Ladies they are* the things to teach—soft—ductile creatures!!' (BM).

Once the house contents at St. Martins at Palace Plain were finally sold Miles Edmund was called to London and took the place of his brother John Joseph as Cotman's aide. In December 1836 he was officially recognised by the school council at King's College as Assistant Drawing Master to his father. The late 1830s were especially busy for Miles Edmund and, to judge from dated watercolours which entered the collection of his friend the Rev. James Bulwer, the years 1838-41 saw the development of a more 'dashing' technique (see p. 88). On 7 April 1838 John Sell wrote to his son Walter: 'Miles Edmund and I are now hard at work, he never working better, and I not the worse' (BM). The same letter also details some of the pictures upon which they were working jointly, including *Lee Shore, with the wreck of the Houghton pictures, books &c., sold to the Empress Catherine of Russia* (Fitzwilliam Museum, Cambridge). Both Miles Edmund and John Sell worked so hard during this period that they were

frequently ill. When John Sell left London for what was to be his last holiday in Norfolk in September 1841, he acknowledged that Miles was 'really ill'. Nevertheless Miles Edmund continued to stand in for his father, during both his absence and illness, succeeding to his post shortly after John Sell's death.

As a tribute to his father Miles Edmund prepared copies of twelve of John Sell's last Norfolk drawings, which were published as a set of lithographs in 1843. Faithful facsimile drawings, these add little to our knowledge of Miles Edmund's individual personality as an artist. In 1846, however, Charles Muskett published ten etchings by M.E. Cotman which do indeed show that quality which W.F. Dickes coined 'the idolence of genius'. Muskett also published a rare set of eleven etchings with an extra plate of a standing figure, while a twelfth unpublished plate is *At Whitlingham*.

During his later years Miles Edmund exhibited consistently in Norwich and London (1835-56), also sending pictures to Manchester. A good number of these were in oils and he developed a technique as assured as that of his father. He spent most of his London years at the family home in Brunswick Square but in 1851 his address was 9 Holles Place, Haverstock Hill. Through ill-health he left London and joined his brother John Joseph at Thorpe, after which they moved to Great Plumstead. He spent his last days at North Walsham, thirteen miles north of Norwich.

He was admitted to the Norfolk and Norwich Hospital where he died on 23 January 1858. Paying tribute to Miles Edmund's art, 'faithful and elegant in the extreme', his obituarist commented obliquely upon his early death: 'Had not this gentleman's devotion to his profession been interrupted by severe attacks of a malady connected with the brain, the arts might have received from his hands more important works than he had been able to accomplish at the time of his death' (Reeve Collection, BM).

John Sell Cotman's second son, **John Joseph Cotman** (1814-78) possessed most of the family's traits *in extremis*. His character was correspondingly eccentric, while his talent as a creative artist was far to outstrip that of Miles Edmund, approaching his father's work with his vibrant and individual essays in colour. John Joseph was born on 29 May 1814 in Southtown, Great Yarmouth. He wrote a journal of his early life in which at one point he recounts his impression of his father: 'Intense labour and want of sufficient success tended much to depress his spirits and render his temper harsh, the effects of which on our own, was much felt' (Cotman Family Collection). In 1823 the family moved to St. Martin's at Palace Plain in Norwich where John Joseph received his schooling.

John Joseph Cotman

John Joseph's first job was in his uncle's haberdashery shop in London Street, but he 'felt degraded' and turned to sketching, absorbing the influence of his father's rapid, passionate sketching style of the late 1820s. When John Sell Cotman was appointed Professor of Drawing at King's College School, London he took John Joseph with him to assist in teaching and making drawings for the pupils to copy. A series of letters written to John Joseph by his friend Arthur Dixon, the son of Robert Dixon, during the first six months of 1834 gives a brief insight into the tribulations of the Cotman family. John Joseph's younger brother Alfred Henry was a considerable cause for concern, his mental state showing signs of strain which were to come to a head within five years. John Joseph's mental state appears to have fared little better and he was sent to Cromer for a holiday in July 1834 while John Sell and Miles Edmund organised the Norwich house contents sale which was to take place that September. John Sell wrote him a short note on 23 July: 'Enjoy all the delights that fresh air and sea can give you...' (BM). By November he was again unwell and Arthur Dixon wrote to him '...this is a very blue-devilly month, and we have had some very warm days, which is exceedingly inimical to your well-being'.

In 1835 John Joseph returned to Norwich to take over responsibility for teaching the 'Cotman style' there. On 27 October that year John Sell wrote from London with some practical and heartfelt advice: 'I send you Tass's bill of terms for Miss Gunn. J.J. Gurney's terms should not be less than half a guinea per lesson; you gain no credit by working under price; if a man does not value himself he will be undervalued by the world, depend upon it' (BM). John Joseph's unstable temperament caused him increased suffering, however, and early in 1837 his family was obliged to place him in care, to 'keep quiet and contented' under the charge of 'Mr. Watson'. This was probably J.W. Watson, one of three partners of a private asylum at Heigham Hill, Norwich. Although John Joseph recovered to continue with his teaching his reputation inevitably suffered. On 5 June 1838 Anna Gurney wrote from Earlham, to Joseph John Gurney regarding a suitable drawing master: 'I quite hope to take up drawing this summer & do as much as I can of it—I wish I had a good Master—but I do not like any Norwich one—Since Cotman paid such a long visit to Bedlam—I have no fancy for him—though I believe he is quite in his senses now—at least he is out of confinement & going on as usual—yet as I take my lessons all alone—I do not intend to have him.' (A.J. Eddington, *Supplementary extracts from the Gurney manuscripts*, item 103, Gurney

MS, Friends House Library, London.)

John Joseph's writings reveal him continually struggling with depression. He commenced a second journal on 18 December 1838 when he was 'impatient to begin, knowing that I shall enjoy it much...' His own attempts at self-analysis are revealing: '...one of the defects in my character is now, and has been, indecision and want of perseverance. When depressed I feel that want of power leaves me poor and useless, but I think on looking back that if I can compel myself to travel in the road I have marked out, I may yet attain that stability and self respect which will give me as large a share of happiness as falls to the lot of men...' His family proved supportive: John Sell had encouraged him on 12 January 1838 '...when I first came to London I did not draw half so well as you do...on this point you can have nothing to fear my dear John' (BM).

However father and son could not always see eye to eye. John Joseph fell ever deeper into debt and in 1841 John Sell strongly opposed his announcement that he intended to marry Helen Cooper, daughter of a Norwich silversmith. The engagement was broken off although they eventually married in 1847, five years after John Sell's death. Throughout his career John Joseph struggled to earn his living through teaching, but remained in debt. In 1840 he recommended the establishment of a Norfolk and Norwich School of Drawing, to be organised by the City Corporation. He also applied for teaching posts at schools in London but was never appointed, despite glowing testimonials to his ability and character from local citizens, including James Stark and Frederick Sandys. Between 1849-51 he delivered a series of lectures at the Thorpe Institute, repeating them at the Young Men's Institute for Yarmouth and Southtown during 1851 (see also p. 90). He left Thorpe late in 1855 for The Smee, Great Plumstead, his house sale being held by F. Clowes the auctioneer on 11 December 1855. He was joined at Great Plumstead by his brother Miles Edmund, whose ill health had caused him to leave London the previous year.

Joseph Geldart

On the death of Miles Edmund, John Joseph returned to Norwich. His eccentric behaviour became notorious in Norwich, reaching such a pitch that his wife Helen left him (see p. 92). In order to pay his debts he was forced to sell his father's and brother's watercolours and the family drawing copies made for pupils. Late in life he was befriended by James Reeve, Curator of the Norwich Museum and a series of letters written to Reeve from the Norfolk and Norwich Hospital bear testimony to the friendship they shared. John Joseph had been admitted for an operation for cancer and on 3 March 1878 he wrote in pencil from hospital to Reeve: 'A thousand thousand thanks for all that you have done & are doing for me.' He died twelve days later, destitute, and it was Reeve who paid for his funeral.

The 'Cotman Style' was taken up by two friends of the family, Joseph Geldart and James Bulwer. Although both artists were amateurs and proved to be ready *aficionados* of John Sell and his sons, there is no direct evidence that Bulwer was ever a pupil. **Joseph Geldart** (1808-82) did, however, receive lessons from John Sell Cotman. Concerning a drawing of *Via Mala* (NCM 202.235.951) Geldart recalled how 'at my first lesson it was made before me by J.S. Cotman from a very slight and imperfect sketch made by me the year before' (S.D. Kitson, *The Life of John Sell Cotman*, 1937, p. 285). Born in Norwich on 15 February 1808, Joseph Geldart was the fourth son of Joseph Geldart, Wine Merchant, and Elizabeth Aggs. He was articled to a solicitor and friend of John Sell Cotman, Thomas Brightwell, and it may have been through Brightwell that he met Cotman. Six years John Joseph's senior, Geldart appears to have been as significant an influence upon him, both as friend and artist, as John Sell was upon Geldart himself (see p. 94). After retiring from the editorship of the *Norfolk News*, Geldart eventually moved permanently away from Norwich and died at Bowden, Cheshire on 6 May 1882. His leaving must have been a blow to John Joseph, who wrote of his friend in 1838: 'Good accounts from Joseph at Florence. I am almost afraid to say that I count on his return. I have since his time gone back *far far*.'

Rev. James Bulwer

The **Rev. James Bulwer** (1794-1879) was also closely associated with both John Sell and his sons, especially Miles Edmund, from whom he commissioned a number of drawings to illustrate his grangerised Blomefield's *Norfolk*. James Bulwer was born the son of James Bulwer of the Manor House, Aylsham and Mary Seaman of Norwich on 21 March 1794. He entered Jesus College, Cambridge in 1814 and was ordained Deacon by the Bishop of Norwich in November 1818. His friendship with both John Sell and Miles Edmund was consolidated in London, during his period as Minister of St. James, Chapel, York Street, in the parish of St. James, Westminster. Licensed to this position on 24 March 1833, he preceded the Cotman family's move to London by a year. It was during this London period that he commissioned work from Miles Edmund. His role of family friend to all the Cotmans earned him John Sell's tribute as 'quiet easy, dignified, simple, and more what I can fancy the apostles to have been than anything I have ever heard...he is a perfect kitten' (JSC to Dawson Turner, 8 January 1834).

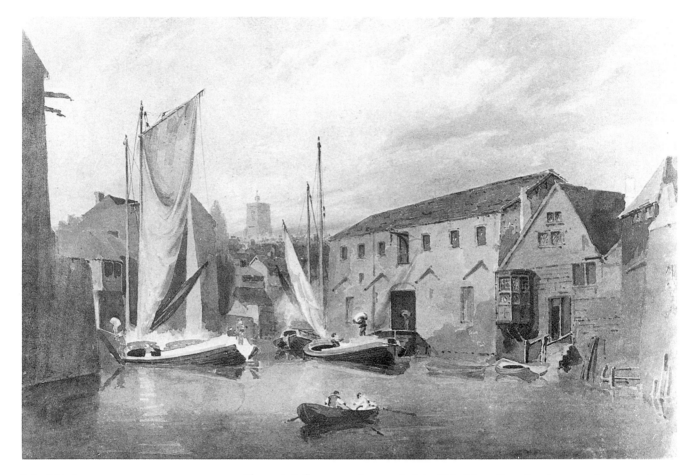

John Thirtle
View on the River Wensum,
Norwich c. 1803-8

pencil, watercolour and white
bodycolour (26.5 × 38.9 cms)
R.J. Colman Bequest
1946 (1352.B47.235.951)

The main influences to be seen in John Thirtle's earliest drawings are the watercolours of Thomas Girtin (1775-1802), John Crome and John Sell Cotman. The muted tones of this remarkably well-preserved watercolour, together with the crisp architectural drawing and the well-defined spatial design show the influence of Cotman most strongly, but also that of Girtin. It is an early example of the subject-matter which Thirtle was to make especially his, the river-traffic, warehouses and bridges of the Norwich cityscape. His sensitive use of wash over delicate pencilwork is always assured in its effect, while the spatial patterns that he creates, although Cotmanesque, remain solidly three-dimensional and unmistakably his own.

 This drawing was once in the collection of James Reeve. His manuscript catalogue (NCM) describes the subject as 'Duke's Palace—previous to the erection of the bridge Stark's Dye houses on right, Wherries on left, river in foreground St. Giles Church in the distance.' The Church in the drawing is shown with a cupola similar to that of St. Giles. The watercolour was traditionally believed to have been drawn for James Stark, but it is no longer possible to confirm that the warehouses on the right show the dye works of Stark's father, Michael Stark. The foundation stone for Duke's Palace Bridge was laid on 28 August 1821 and the bridge completed by December 1822. It was demolished for road widening in 1972.

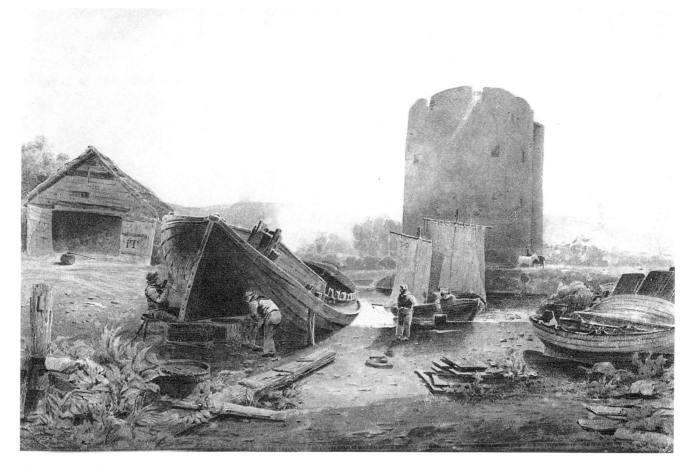

This drawing shows a view of Cow Tower which stands, some fifty feet high and thirty-six feet wide, to the north-east of Norwich on the right bank of the river Wensum, close by Bishopsgate Bridge. The ruins of St. Leonard's Priory are on the centre-left horizon. Thirtle showed two Cow Tower subjects with the Norwich Society, in 1810 (135) *View on the river near Cow's tower, Norwich* and in 1812 (190) *Boat Builder's Yard, near the Cow's Tower, Norwich*. The latter is most probably the drawing illustrated here, which is one of four major exhibition pieces by Thirtle in the collection at Norwich. Two similar boat-builder subjects are in Norwich Castle Museum (1352.B58.235.951) and a private collection. A later, similar exhibit was shown with the Norwich Society in 1829 (127) *Boat Builders, Carrow*.

This drawing has retained most of its original colouring and well illustrates Thirtle's debt to John Sell Cotman's early Norwich period drawings. Thirtle's surviving manuscript *Hints on Water-colour Painting* now at Norwich (NCM 183.950) reveals his awareness of the need for 'a correct outline a proper Distinction of Lights & Shadows, a harmony of Coloring.' He here follows his own advice with a soft palette of greys, grey-blues and sage greens, achieving contrasts with a similarly soft range of cream, buff and brown.

John Thirtle
Boat Builder's Yard, near the Cow's Tower, Norwich c. 1812
pencil and watercolour
(44.5 × 65.4 cms)
inscribed (on boathouse door)
with monogram: *IT*
Purchased 1974 (2.59.974)

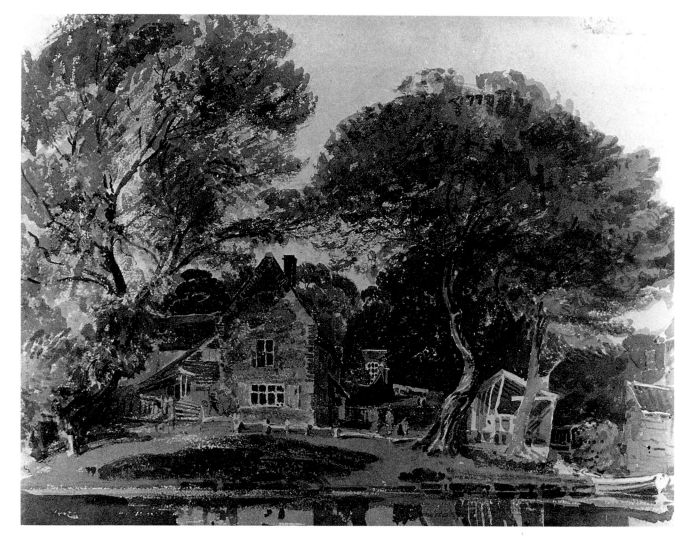

John Thirtle
*Cottage by the River at
Thorpe, Norwich c.* 1814-17
pencil and watercolour
(30.7 × 39.3 cms)
inscribed, top right, with
colour notes and a sketch of
a boat and figures
R.J. Colman Bequest
1946 (1352.B10.235.951)

This drawing displays a fluid economy of expression which reveals Thirtle at the height of his creative powers. It is a study for a more finished watercolour now with Rowntree Mackintosh Ltd. Thirtle exhibited with the Norwich Society in 1814 (138) *Cottage at Thorpe* which may have been the Mackintosh version; this is further elaborated by the addition of a wherry and figures to the right. The riverside view in this study is continued in a fine drawing now in the Whitworth Art Gallery, Manchester, *Old Waterside Cottages*, which also shows the two trees and the summer house and adjoining shed, but includes towards the right a double-gabled cottage.

A number of similar on-the-spot watercolour studies of Norfolk river scenes survive, all characterised by Thirtle's heightened awareness that 'to become a good Colourist you must Colour your sketches on the spot & grudge no time they May Occupy it is no use to do it slightly by so doing youl observe how chaste & rich Nature is & it will Enable you to discriminate between Rich & Gaudy Colourg...' (*Hints on Watercolour Painting*). Thirtle was not always to follow his own advice and his later work, particularly his exhibition pieces, do become comparatively 'Gaudy' in common with current taste during the 1820s and 1830s. However, it is also true that much of the apparent 'gaudiness' of Thirtle's surviving work is due to fading of the more fugitive colours such as indigo.

John Thirtle
Buxton Lamas, Norfolk
c. 1814-17
pencil and watercolour
(28.1 × 39.8 cms)
R.J. Colman Bequest
1946 (1352.B7.235.951)

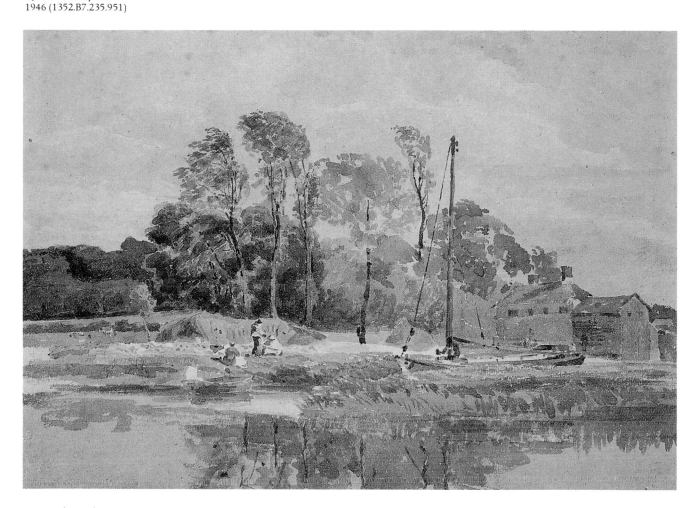

Dating from the same period as *Cottage by the River at Thorpe, Norwich*, this drawing
similarly retains its original colouring. The limpid washes of colour follow a low key,
with soft greys expressing light in both the water and the reflections within it, and in the
sky. Thirtle's talent during the period *c.* 1814-17 was at its most forward-looking, a fact
which did not pass unnoticed. The editor of the *Norwich Mercury*, himself a member
of the Norwich Society since 1810, was Richard Mackenzie Bacon. In his review of
9 August 1817 he characteristically lamented the fact that the breakaway group, of
which Thirtle was a key member, invited 'invidious comparison'. His greatest praise
was for John Thirtle, whose 'drawings in watercolour are certainly without rivals in
either place. They have a warmth, a richness and a brilliancy that is very captivating.'
Thirtle's only rival for such praise, John Sell Cotman, had not exhibited in Norwich that
year, having been in Normandy since June.

Buxton and Lamas are adjacent villages, situated in North Norfolk, four miles south-
east of Aylsham, on either side of the river Bure. The buildings to the right may well be
the extensive water mill on the river outside the village of Buxton. The identification of
the site is that given in the Colman Collection catalogue.

John Thirtle
Thorpe Staithe c. 1829

pencil, watercolour and white
bodycolour
(25.3 × 34.2 cms)
R.J. Colman Bequest
1946 (1352.B24.235.951)

John Thirtle
*River Scene with a Billy Boy
at Thorpe, Norwich*

black chalk, pencil, white
bodycolour and brown wash
(24.1 × 30.2 cms)
inscribed with colour notes
R.J. Colman Bequest
1946 (1348.235.951)

During the 1820s and early 1830s Thirtle's work developed a higher intensity of colour, often with additional touches of white bodycolour to accentuate highlights. His compositions also became correspondingly more solid and angular in accordance with contemporary taste for a more pronounced finish to exhibited paintings. This drawing is quite likely to have been that exhibited with the Norwich Society in 1829 (180) *Scene on the River [Yare] at Thorpe—Evening.* The *Norwich Mercury* (25 July 1829) praised Thirtle for having 'given a rich harmonious tone to his watercolour painting', commenting a fortnight later upon 'the same sweet charm of colour and of scene' for which his drawings 'have always been so pre-eminent.'

There is a chalk study of this composition in the collection at Norwich Castle Museum, which Thirtle may well have used as the basis for this watercolour. On a sheet of paper watermarked for 1828, it provides an interesting indication to the way Thirtle worked up his finished watercolours. In addition to his limpid watercolour sketches painted on-the-spot he would briefly sketch the main elements of his composition in black chalk, adding colour notes in pencil such as, in this case 'whole of the distance/ light [?] Purplish Gray' (NCM 1348.235.951). The stretch of the river Yare through Thorpe, characterised by several fine buildings of the eighteenth century and earlier, was a favourite sketching spot for Thirtle and his contemporaries.

Miles Edmund Cotman
Hayboats on the Thames
c. 1832-35

pencil and watercolour
(27.2 × 45.6 cms)
Presented by the National
Art-Collections Fund 1949
(2.78.949)

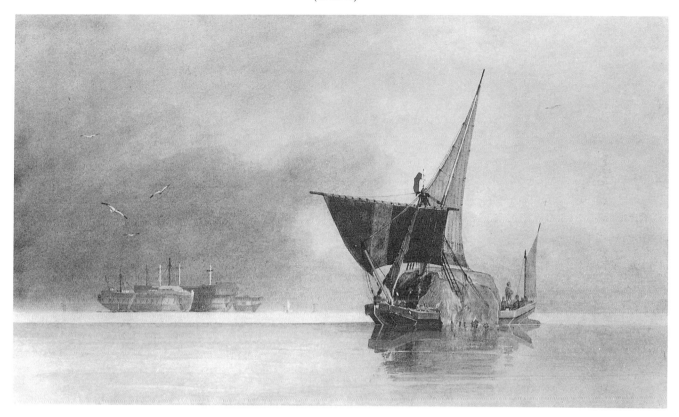

Miles Edmund Cotman's watercolours have a strong affinity with the work of his father during the late 1820s and early 1830s, when John Sell was increasingly using a more highly charged colour range. Miles Edmund also painted similar subject-matter to that of his father, particularly shipping scenes. The Cotman family owned a small boat, called the *Jessie*, in which they made several trips along the East Anglian coast to the Thames Estuary and also to the river Medway. Miles Edmund was with his father and brother John Joseph on just such a summer trip in 1828 from which a number of sketches survive, by both father and sons. John Sell's sketch of a hayboat on the Medway, dated 19 September 1828 (BM) may be regarded as the prototype for Miles Edmund's feeling for this subject.

Miles Edmund Cotman
Hay boats in a calm
on the Medway

etching
(6 × 8.3 cms plate)
Purchased 1969 (114.557.969)

From 1828-33 Miles Edmund exhibited fifty-two pictures with the Norwich Society, of which more than half were of marine subject-matter. Of his ten etchings, published in 1846, two depicted hay boats on the Medway, one of which is dated 1832 in the plate. In the same year he exhibited *Hay Boats on the Thames* with the Norwich Society (46), a subject he later exhibited at Suffolk Street in 1835 (636). Although the strong cobalt blue of the drawing follows the example of his father, its prosaic linear quality reveals him to be markedly more pedestrian than John Sell. Miles Edmund's etching *A Hay Barge* is ultimately a more sensitive rendering of a similar subject.

Miles Edmund Cotman
Park Scene

pencil and watercolour
(20.7 × 28.9 cms)
Presented by Miss Margaret Davies
1937 (5.98.937)

Miles Edmund Cotman
Wooded Landscape with Cattle
c. early 1840s

oil on canvas
(76.2 × 121.3 cms)
R.J. Colman Bequest
1946 (623.235.951)

There is no record that Miles Edmund Cotman exhibited this oil but it is difficult to believe that he did not do so. The scene may be tentatively identified as Gunton Park, a favourite sketching spot for Miles Edmund, five miles to the north-east of Aylsham. While it is not always possible to differentiate between oils and watercolours among M.E. Cotman's exhibited works, he did exhibit an oil with the Society of British Artists at Suffolk Street, London, in 1841 (74) *Scene at Gunton, Norfolk.*

Miles Edmund painted a number of woodland views in watercolour, several of which survive in the collection at Norwich Castle Museum. These are characterised by a fluid handling which shows the artist developing a technique which, although founded upon that of his father, gradually moved away from the initial influence of John Sell's later drawings. John Sell Cotman had himself exhorted Miles Edmund to 'be dashing and Sketch-like, to get him out of his hard, dry manner' (JSC to J.J. Cotman, 13 November 1835, BM). By contrast, the oil *Wooded Landscape with Cattle* retains that crispness of finish associated with Miles Edmund's more mannered work, in a composition strongly influenced by his father's woodland subjects in oil of the late 1820s and 1830s. Miles Edmund later painted a series of woodland views around Whitlingham, Norfolk, in oils, adopting a more 'dashing' technique in common with his brother John Joseph.

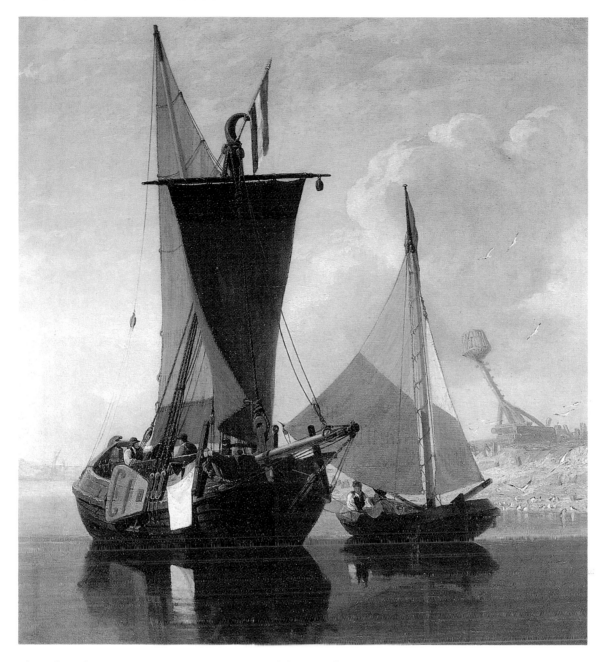

This subject first appears among M.E. Cotman's exhibited works at Norwich in 1832 and last with the Norfolk and Norwich Association for the Promotion of the Fine Arts in 1855: (196) *Boats on the Medway, Calm.* This was probably the same oil as that exhibited with the British Institution the previous year (191). M.E. Cotman had also exhibited an oil of the same title at the British Institution in 1845 (227), the measurements of which suggest that it may be identified as the version now at Norwich Castle Museum. Miles Edmund also sent a picture of the same title to the Royal Manchester Institution in 1845 (422) being priced at twelve guineas, three guineas cheaper than in London, making it possible that it was the version illustrated here. An earlier version had been sent to Manchester in 1842 (258).

The location of the subject may be identified from Miles Edmund's inscription *On the Medway* on a signed drawing in pencil and charcoal now in a private collection. This shows the same pair of Dutch boats accurately drawn but in reverse, perhaps suggesting that the artist intended to make an etching from the composition. The composition of the oil is certainly forceful, combining accurate drawing with a masterly design centred upon the dramatic sweep of the sails. The design is matched by a luminous sense of colour, whereby subtle tones of blue, grey, umber and sienna are enlivened by rare splashes of colour, including dazzling whites.

Miles Edmund Cotman
Boats on the Medway, a calm
c. 1845

oil on canvas
(55.3 × 50.2 cms)
J.J. Colman Bequest
1899 (12.4.99)

John Joseph Cotman
*The Old Whitlingham Road,
Norfolk* 1868

pencil and watercolour
(38 × 67.2 cms)
signed, bottom left:
J.J. Cotman 1868
R.J. Colman Bequest
1946 (61.235.951)

John Joseph specialised throughout his career in large compositions often based upon leafy lanes peopled by single figures. His vigorous pencilwork echoes his father's style of *c.* 1829-30, that period when John Joseph would have been most susceptible to the influence of John Sell. In 1832 the *Norwich Mercury* comments that his single picture at the Norfolk and Suffolk Institution revealed him to be 'pursuing the same route with felicitous promise' as his father and brother (4 August). He first exhibited a Whitlingham subject the following year, which the same paper considered 'very effective' (10 August 1833).

John Joseph invariably signed and dated his work, and appears to have done so consistently through the 1860s and 1870s and it is during this period that his work develops a truly idiosyncratic quality. He adopted an original range of colour contrasts which vivified the local topographical scenery in which he specialised, infusing his own passionate nature into his pictures in a manner which now seems remarkably modern. His topographical work also reveals a strong belief in the values of composition and drawing, a subject upon which he lectured in 1850. During his talk he dwelt upon the means of achieving practical facility in drawing and concluded that the true objective in drawing must be 'to lead the mind to the *study* and *appreciation* of *all* that is *beautiful* both in Art & Nature' (Cotman Family Collection).

The high colour values of this striking oil render the scene a highly individual example of John Joseph Cotman's work in this medium. He had first been encouraged to paint in oils by his father in May 1837 when John Sell Cotman was himself doing so, inspired by the works of J.M.W. Turner and William Etty in particular. John Sell at the end of his life had reached a high sense of the brilliance that could be achieved in oils as well as water-colours and this was his primary legacy to his son John Joseph.

While the composition of *Trowse Meadows, Norwich* echoes that of a number of his watercolours of the 1860s, the heightened sense of colour extends this scene beyond a simply topographical representation. The placing of white clouds against an electric blue sky, the tangle of foreground foliage and the single figure of the drover beside the five-barred gate are all elements as much associated with the father as the son. John Joseph's rapid sketch-like technique translates easily into the medium of oil, capturing a mood that successfully demonstrates the power of colour as an emotive force.

John Joseph Cotman
Trowse Meadows, Norwich
c. 1860

oil on canvas
(33.4 × 51.4 cms)
R.J. Colman Bequest
1946 (39.235.951)

John Joseph Cotman
A Composition c. 1860s
pencil, watercolour and
bodycolour (22.7 × 49.3 cms)
signed, bottom left and right:
J.J. Cotman
R.J. Colman Bequest
1946 (65.235.951)

This composition represents John Joseph Cotman's use of rich colour contrasts at its most vibrant. The scene possibly has some topographical foundation but, as with much of his work from his last eighteen years, the impact of the predominant colours of the composition outweigh any desire to identify a specific locale. John Joseph Cotman's entire career was undermined by an unstable temperament which in later years was

aggravated by bouts of drinking and deep depression. He despaired of ever earning his livelihood as an artist and was constantly in debt. On one occasion he found himself in court accused of theft, whereupon he 'addressed the bench on the case in his customary frantic manner, and it was at length found necessary to remove him' (*Norfolk Chronicle*, 16 September 1865).

John Joseph was a victim of his temperament from an early age. In 1838 he recalled in his Journal that 'at...about five years old ones temper began to shew its self passionate to a degree' (Cotman Family Collection). His manner became increasingly eccentric after his wife and children left him in 1858, unable to tolerate his erratic behaviour. The isolation of John Joseph's private life was complete, while his powers of creative expression were heightened to the point where his most lyrical colouristic effects invite comparison with the late works of his contemporary Samuel Palmer. John Joseph's work such as *A Composition* survives as testimony not simply to a romantic eccentric but to a creative colourist of the highest imaginative order. His dramatic use of colour conveys a powerful psychological effect which is itself 'passionate to a degree'. John Sell Cotman had himself recognised a fellow spirit as a colourist as early as 1838: 'you have a good eye for colour, one of *the very best* points in the game—*good taste*' (20 February 1838, BM).

The imaginative drama of this composition is evidence of James Bulwer's considerable amateur talent. His earliest datable compositions derive from two visits to Spain, Portugal and Madeira. Bulwer produced twenty-six views in the Madeiras which were

Rev. James Bulwer
Beeston Regis Church c. 1840s
pencil and watercolour
(15.2 × 22.3 cms)
R.J. Colman Bequest
1946 (27.B143.235.951)

subsequently lithographed by artists who included W. Westall and F. Nicholson, and published in folio with letterpress in 1827. These show little influence from John Sell Cotman, while in 1828 Cotman submitted a work to the Old Water Colour Society, derived from plate XXIII of the '26 Views', *Cliffs on the North-East side of Point Lorenzo, Madeira.*

One of Bulwer's most significant artistic influences was William James Muller (1812-45) whom he met whilst living at Clifton, Bristol, in the early 1830s. Bulwer exhibited with the Norfolk and Suffolk Institution for the first and only time in 1832. After a period in London, he finally returned to Norfolk in 1839 and was licensed to the curacy of Blickling with Erpingham on 14 August 1841. In October that year John Sell Cotman visited him, intending to share a passion for sketching the churches of Norfolk. On 24 September that year John Sell had written to Bulwer: 'Get your sketching maps in good order, my dear Bulwer, for I meditate a descent on you; and 'tis hard if, between us, we don't demolish a church or two' (National Gallery of Canada, Ottawa). It was probably during this period that Bulwer's sense of composition fell most under the influence of John Sell as a result of sketching at his side. Otherwise, his linear technique is closer to that of Miles Edmund, while his compositions demonstrate a strong antiquarian intention.

Joseph Geldart was an amateur artist of exceptional talent who early befriended the

Joseph Geldart
Lane Scene with covered cart
c. late 1830s

black and white chalk on
grey paper (21.2 × 26.8 cms)
R.J. Colman Gift
1930 (13.103.930)

Cotman family. John Joseph Cotman recalled in his Journal of 1838 how during his early years he 'met a new friend whom I admired and strove to imitate'. Both artists developed a vigorous style of draughtsmanship, specialising in the use of charcoal and wash. Although Geldart reputedly destroyed much of his work, regarding it as experimental, sufficient sketches in charcoal survive to reveal a talent for Cotmanesque landscape and also portrait sketches (see, for example, his portrait of Robert Leman, p.129). A number of his continental sketches have been misattributed as the work of John Sell Cotman. Only two oils by Geldart are recorded, *On Mousehold Heath* and *Trowse Bridge*. The latter is now in the collection at Norwich Castle Museum (983.235.951).

On 7 November 1844 Geldart attended the original meeting of the 'anti-Mercurial gang' of non-conformist tradesmen which took place at the home of Jeremiah Colman. The meeting resulted in the birth of the *Norfolk News*, of which Geldart became the first editor. The first issue was published on 4 January 1845, but Geldart took increasingly less interest in the paper and in 1850 retired. He occasionally contributed letters 'from Geneva and Milan under the style of a Norwich man abroad' (*The Norfolk News*, 6 January 1945). An article on *John Crome*, contributed to *The Graphic*, 13 August 1881, reveals him to have been an articulate writer.

THE STANNARD FAMILY & THE REV. E.T. DANIELL

At first acquaintance, the work of the Stannard family appears as something of a phenomenon within the Norwich School of Painters. While the leading artists of the School found some dialogue with the Metropolis and with their Norwich contemporaries, the Stannard family early established their different *métiers* and there is little apparent artistic interplay between them and their colleagues exhibiting with the Norwich Society. Indeed, the only member of the family to join the Society before its demise in 1833 was Mrs Joseph Stannard, who became an honorary member in 1831. Nevertheless both Joseph Stannard and his wife exhibited with the Norwich Society, as did his brother Alfred and his wife (albeit only once, in 1829).

Joseph Stannard

The focus of this artistic family was **Joseph Stannard** (1797-1830). His talent was first noted in the local press in 1817, when his work was felt to 'bespeak a rising genius and foretell much excellence as a Landscape Painter' (*Norfolk Chronicle*, 2 August 1817). Born on 13 September 1797, he was not quite twenty years old when he received this public notice on his showing of thirteen pictures with the seceding group on Theatre Plain. He is traditionally believed to have been a pupil of Robert Ladbrooke and, although the influence of Ladbrooke upon his work appears negligible, there is evidence of some early relationship. In 1815 Joseph Stannard exhibited (38) *Landscape, after Ladbrooke* and the following year joined Ladbrooke on Theatre Plain. This was the exhibition at which Ladbrooke showed (150) *Portrait of a Young Artist* which was probably his portrait of Stannard as a boy in front of the easel, a painting now in the collection at Norwich (NCM 1017.235.951).

Joseph Stannard's early exhibits with the Norwich Society between 1811-15 had been a mixture of subject matter and possibly of styles. His works exhibited at Theatre Plain from 1816-18 saw him making rapid advances. The *Norwich Mercury* on August 1818 remarked upon one 'landscape in oils which shows as much improvement since last year as any thing exhibited'. During this period his exhibited titles reveal the main thrust of his energies to have been in the field of landscape subjects. With the demise of the seceding group, Stannard—unlike Ladbrooke—returned the following year to exhibit at Sir Benjamin Wrenche's Court. His titles for 1819-20 reveal that he had changed direction, having established some links with the Theatre Royal at Norwich, painting both portraits and scenes such as (23) *Scene in the Melo-drama of the Broken Sword*, exhibited in 1819 and (215) *Portrait of Mr. Beacham, in the character of Riber, in the Miller and his Men* shown in 1820. In 1819 he also showed (160) *Scene in a Norwich Ale-house*. This was his only picture that year to receive any press notice: 'The Still-Life parts of the picture are many of them nicely wrought.' The picture, now untraced, depicted 'all the well-known itinerants of the city' (*Norwich Mercury*, 14 August 1819). Stannard's excellence in figure drawing among the Norwich painters may be seen in his watercolour studies, equalled only by the Joy brothers of Yarmouth. 1819 was also the year of Stannard's first exhibit in London, at the British Institution, (217) *Scene at Brydon* [sic], *Near Yarmouth*. His address at this time is recorded as at 18 St. Andrew's Street, Norwich.

In 1821 Joseph Stannard visited Holland and when, the following year, he exhibited (3) *The Ferry, from a celebrated Picture of Berghem's in the "Musee des Tableaux", Amsterdam*, the *Norfolk Chronicle* felt he had 'done himself infinite credit' (3 August 1822). There is no evidence of the length of Stannard's stay in Holland and Amsterdam, but the experience undoubtedly contributed towards a new crispness of handling in his oil technique and a corresponding interest in marine subjects, suggesting that the works of the Flemish marine painters were of signal importance to him.

The year 1823 was a bad one for Joseph Stannard. He did not exhibit in either Norwich or London and, according to a letter written by him from London to the Norwich bookseller Mr Craske, he was in severe financial difficulty: 'I am truly sorry I was obliged to leave so clandestinely, but being disappointed of the situation that I had been in expectation of for the last five months and having very little to do for, I should have been in actual want several times had it not been for your kind self in advancing me money, and at the time I had every reason to suppose I could have repaid it in work...' (Reeve Collection, BM). It is possible that, like John Sell Cotman, he took up the etching needle in an effort to extricate himself from this plight (see p. 102). Certainly, for the remainder of the 1820s Stannard's reputation blossomed and on 3 January 1826 he was in a position to marry a fellow artist and exhibitor with the

Norwich Society, Emily Coppin.

Joseph Stannard and Emily Coppin were a well matched couple. Emily came from an artistic background, her father being Daniel Coppin (*c.* 1770-1822), a local collector, house-painter and amateur artist. It was Daniel Coppin who had received Joseph Farington R.A. on his brief visit to Norwich in 1812 and had impressed Farington so with his 'refinement of taste' and grief for his recently-deceased wife. Mrs Coppin (*c.* 1768-1812) had also been an artist of some note, best known as a copyist (one of her copies after Gainsborough, probably exhibited with the Norwich Society in 1808 (202), is in the collection at Norwich, NCM 72.94). Elizabeth Bentley wrote a tribute to the memory of Mrs Coppin recording that 'she was twice honoured with the larger medal presented by the Society for the Encouragement of Arts' (*Norfolk Chronicle*, 1 August 1812). One such honour had been 'the *greater silver Pallet...*for her magnificent drawing, in crayons, of Belisarius, after Salvator Rosa' (*Norwich Mercury*, 1 May 1802).

Emily Stannard, née **Coppin** (1803-85) followed her mother's inclinations, but far exceeded her example. In 1820 she received the large gold medal from the Society of Arts for an original painting of flowers and in August the same year had accompanied her father to Holland, just a year before her future husband made his trip. Her obituarist records in the *Norfolk Chronicle* for 7 January 1885 that whilst in The Hague and Amsterdam she obtained permission to copy paintings after Van Huysum and in 1821 'she was presented with the large gold medal of the Society of Arts, London for an original painting of fruit'. Throughout the period 1816-32 she exhibited annually with the Norwich Society. excepting the years of her marriage and her husband's death (see p. 105). She received a consistently good press locally and in 1828, as Mrs Joseph Stannard, she gained the (Isis) gold medal for an original painting of game.

Emily Stannard

During the last five years of his life, despite increasing illness, Joseph Stannard produced work which reveals him to be, after John Crome and John Sell Cotman, the most independent and distinguished colourist of the Norwich painters. His painting *Thorpe Water Frolic—afternoon* (1824-5) was his masterpiece, by which he ensured his renown (see p. 100). The only criticism that was levelled at him on more than one occasion concerned his tendency to adopt atmospheric tones which were 'a little too blue', a criticism which was similarly levelled, perhaps more justifiably, at Cotman—also in the late 1820s.

In October 1827, with the exhibition rooms at the new Corn Exchange still not complete, the Stannards organised a small exhibition of eighteen pictures at Joseph's painting room. Joseph and his wife were joined by his younger brother **Alfred Stannard** (1806-89). Alfred had exhibited one picture with the Norwich Society in 1820 and again in 1822, but had received his first real notice in 1825, when the *Norwich Mercury* commented that he had 'some very creditable proofs of industry and talent' (6 August 1825). His participation in his brother's show in 1827 brought him once again before the public eye and his work met with a measure of optimistic appreciation. The *Norfolk Chronicle* felt that he was a credit to his brother's instruction, evincing 'a studious application of ability' while at least one of his pictures, *Scene near Loddon* was felt to 'bespeak the rising genius of the Artist' (6 October). Alfred's work never fully justified this optimism and is usually more redolent of 'studious application'. This quality is also to be seen in his etched work, of which eight examples are recorded. Etchings dated 1828 and 1829 reveal him to have been a less successful pupil of his brother in this field than the Rev. E.T. Daniell. His drawing style similarly owes something to Joseph, although a series of watercolour studies of estate buildings, commissioned by Lord Harvey of Tasburgh and now in the Norwich Castle Museum, are no more than practical records.

Alfred Stannard

Having married a Miss Sparkes in 1827, Alfred spent the rest of his long career working as a Drawing Master and bringing up a large family, two of his children becoming artists in their own right. Alfred George Stannard (1828-85) and **Eloise Harriet Stannard** (1829-1915). Although there is less of the Norwich School—as opposed to Victorian tradition—in the work of Alfred George, Eloise Harriet remained a stalwart Stannard to the end of her long life. Like her aunt Emily she saw her task as an artist to paint as objectively as possible: 'I always suffered a good deal from depression; and I cannot describe what relief and companionship I found in trying to copy the minutest of natural effects. Frankly, I do not think this painstaking sort of work is done nowadays with anything like the success that it used to be. There is not so much finish about it. As with everything else, the tendency is all towards rush and hurry' (*Eastern Daily Press*, 14 October 1910).

Eloise Harriet Stannard

Unlike many of his contemporaries in Norwich, Joseph Stannard had not advertised as a drawing master. Nevertheless he evidently encouraged his brother Alfred, first in the field of painting and, in the

late 1820s, in etching. His other alumnus was Edward Thomas Daniell, although his teaching of Daniell seems to have been limited to the principles of etching techniques. It is likely that their respective essays into printmaking were something of a shared enterprise.

Both their earliest dated etchings are inscribed with the date February 1824 which, together with an apparent interchange of stylistic resemblances, suggests a working relationship that began at this time, with Stannard technically in advance of his younger contemporary. Daniell rapidly developed as a skilful etcher and Stannard's early death on 7 December 1830 robbed him of a mentor as much as a master. Daniell's work over the four years 1831–4 amply demonstrates the degree to which he extended Stannard's early example as an etcher.

Edward Thomas Daniell (1804–42) was born on 6 June 1804 in Fitzroy Square, London, the son of Sir Thomas Daniell Bart.—the former Attorney General of Dominica—and his second wife, Anne Drosier of Rudham Grange, Norfolk. Sir Thomas died two years later at Snettisham Lodge, Norfolk and 'the widow Daniell' moved to 68 St. Giles Street, Norwich. The following account of the career of E.T. Daniell is culled from the work published on this important figure by F.R. Beecheno (*E.T. Daniell—A Memoir*, 1891) and Jane Thistlethwaite ('The etchings of E.T. Daniell', *Norfolk Archaeology* vol. XXXVI, part I, 1974).

Edward Thomas Daniell

Daniell's artistic influences are not readily established. His early education was at the Norwich Grammar School, where John Crome was drawing master. If Crome had any influence upon Daniell it was probably that of enthusiasm rather than any debt of style, while Daniell's later watercolours reflect more the character of John Sell Cotman in their use of wash. In fact Daniell early established artistic contacts outside Norwich and although his education and subsequent ordination saddled him with the status of an amateur, he is—next to John Sell Cotman and James Stark—the Norwich painter most readily to imbibe the influences of a number of his metropolitan contemporaries. The difficulty in allying his style with any one of those contacts in particular is a measure of his originality. In February 1822 the collector Chambers Hall and his brother Thomas of Elmsfield Lodge, Milbrook, Southampton, wrote to John Linnell about 'our young friend Mr. Daniells who accompanied us to your house last week and who wishes to possess a drawing by Girtin'. Thus even before his eighteenth birthday Daniell was mixing with artists and collectors and had already befriended Linnell of whom he later became a patron. He matriculated at Balliol College, Oxford on 9 December 1823, where he spent the next five years reading classics.

During this period Daniell evinced considerable interest in the visual arts, learning much from Joseph Stannard about etching, but also visiting and corresponding with Linnell. He visited Linnell on 30 August 1825 and commissioned a picture from him and the following year proposed to help sell a set of William Blake's illustrations to the Book of Job which Linnell had commissioned. On 6 August 1826 he wrote to Linnell to acknowledge receipt of his picture. Writing from Fakenham, he commented: 'There are many very fine subjects in this neighbourhood, & I am today going to finish a coloured sketch of Walsingham Abbey begun on Friday. I shall see you in Oct! & probably shall trouble you for your criticism on some out of door performances.' He also remarked of Blake: 'I am sorry to hear poor Mr. Blake is unwell, but hope he may recover again to use his pencil & graver.' His development as an etcher at this time is to be seen in dated prints such as *Near Norwich, Whitlingham Staithe* and *Bure Bridge, Aylsham*, all of which are dated 1827. His watercolour study for *Bure Bridge, Aylsham*, dated 1826, is now in the collection at Norwich (NCM 780.235.951) and testifies to his fluid, sensitive use at this time of washes freely applied over light pencil.

Daniell also began to paint in oils at this time and received a few lessons from Linnell in August 1828. In October 1828 he wrote to Linnell to postpone both a drawing lesson and a sitting for his miniature because 'I find that the examinations for which I am preparing next month require a closer application to my literary studies than I had imagined & that I must not attempt to "serve two masters".' He gained his B.A. degree on 8 November 1828 and the following year embarked on a tour of the continent from which he returned late in 1830 (see p.110). It is uncertain whether he returned to Norwich in time to see his friend Joseph Stannard before his death, but he was back in Norwich by 2 January 1831, to judge by a letter written to Elizabeth Rigby that day. Elizabeth Rigby, later Lady Eastlake, was subsequently to credit Daniell for having taught her both to draw and to etch. In the summer of 1831 Daniell toured Scotland with Edmund Head, then a Fellow and Tutor of Merton College, Oxford, and G.A. Denison, another Oxford contemporary who later became an Archdeacon. This tour not only provided him with Scottish subject-matter but almost certainly encouraged him to adopt techniques associated with the

Scottish etchers (see p. 110). The following summer he exhibited for the first and only time with the Norwich Society, when his work was noted by the *Norwich Mercury*. Three of his four exhibits related specifically to his continental tour.

Daniell's Oxford friends and classical education must have played a major part in his decision to take holy orders. He was ordained as deacon by Bishop Bathurst at Norwich Cathedral on 2 October 1832 and three days later was licensed as a curate of Banham, near Attleborough, Norfolk. On 3 June 1833 he was ordained priest. It was during this period that he also produced his finest etchings (see pp. 109, 110). His departure for London early in 1835 followed that of his like-minded contemporary the Rev. James Bulwer, as well as John Sell Cotman and Miles Edmund Cotman. His removal to London facilitated the painting of his portrait by Linnell for whom he gave numerous sittings throughout the year until it was finished in March 1836, in time for the Royal Academy exhibition that year. The following year Linnell etched a portrait of Daniell's mother, finished in November.

When Daniell arrived in London he lodged at 77 Park Street, Grosvenor Square but moved in 1836 to 13 Green Street, Grosvenor Square where he remained until leaving England in 1840. He exhibited annually whilst in London, the majority of his subjects continuing to recall his continental travels. His oil sketches tended to be small in size, although for his exhibits at the Royal Academy in 1838 (251) *View of St. Malo* and 1839 (349) *Sketch for a picture of the Mountains of Savoy from Geneva* he adopted a long, low format, using canvases over a metre long (NCM 15 and 16.75.94). John Linnell, in his diary, records how 'Mr. Daniell brought his Picture of the Lake of Geneva, worked upon it for 3 hours' (9 April 1839). While it is not certain which painting this was, Linnell's comment is an indication of the seriousness with which Daniell regarded his work as a painter in oils. Daniell made no further etchings whilst in London, preferring to have his existing plates printed in Norwich by Henry Ninham. A letter from Daniell to Ninham in April 1835 survives in the Reeve Collection: Daniell requests half a dozen proofs of each of four plates and also the plates themselves 'as I want to touch them but should like specimens of your printing before I do' (BM). This suggests that Ninham was responsible for printing all his plates, although it is possible that Daniell could have pulled some early proofs under Stannard's guidance or in liaison with Ninham whose printing press was at Chapel Fields, not far from the homes of both Stannard and Daniell in St. Giles.

Daniell continued to be active as both artist and patron during his years in London. In addition to exhibiting at the Royal Academy and British Institution, he was also a Committee member of both the Society for the Encouragement of British Art during 1838 and the Selection Committee of the Art Union. He used the latter position in particular to further Linnell's cause, negotiating the purchase of his *The Disciples on the Road to Emmaus* (Ashmolean Museum, Oxford) as an Art Union prize for sixty guineas. He also commissioned Linnell's eldest daughter, Hannah Palmer (the wife of the artist Samuel Palmer), to make a copy of Raphael's Vatican fresco, *The 'Disputa'* while she was on her honeymoon in Rome. John Linnell wrote to inform his daughter of Daniell's request on 24 March 1839: 'Mr. D. says he considers that Fresco the finest piece of color in Rome.' He received the drawing on 4 December 1839.

The precise date when Daniell left England to tour the Holy Land and the Near East, is unrecorded. Linnell's last diary entry concerning Daniell is 3 June 1840, five days after they had examined together Francis Danby's celebrated painting, *The Deluge*. Daniell's artistic, classical and spiritual background combined with the example of David Roberts' recent return from the Near East, led him to seek the original sites of the Holy Land (see p. 111). His journey took him to Athens by December, from where he crossed to Egypt, passing up the Nile to Palestine, reaching 'Beyrout' by October 1841. In December he was due to return to England, but was persuaded to join the expedition of the surveying ship *Beacon* which was *en route* to Lycia to collect the antiquarian remains Sir Charles Fellows had discovered at Xanthus. Daniell was requested to join the expedition as an amateur artist by Lieutenant T.A.B. Spratt R.N., the geographer, and Professor Edward Forbes, F.R.S. of King's College, London, the naturalist to the survey. It is principally their subsequent account of the expedition which tells of the circumstances of Daniell's last months visiting the ancient cities of Lycia. On 24 September 1842, having contracted malaria, Daniell died in Adalia, having fallen 'a victim to his zeal and enterprise' (A.B. Spratt and E. Forbes, *Travels in Lycia*, 1847, vol. II, p. 36).

Joseph Stannard
Thorpe, Near Norwich c. 1820
oil on canvas
(45.8 × 66.2 cms)
R.J. Colman Bequest
1946 (1266.235.951)

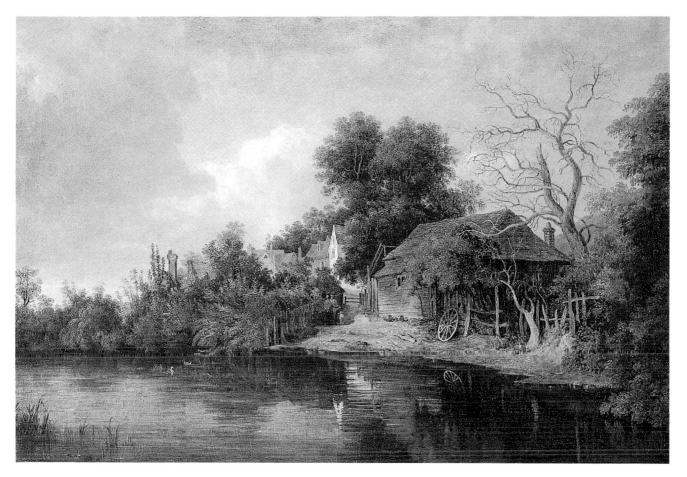

Joseph Stannard painted a number of views at Thorpe (see p.100), but this is one of the earliest and most intimate. The scene may well be that exhibited with the Norwich Society in 1820, (13) *Scene at Thorpe, looking towards Norwich,* a picture described as indicating 'talent, industry, and taste' (*Norwich Mercury,* 29 July 1820). The quiet intimacy of this composition, with its crisp handling of muted but clear tones of colour, renders this scene typical of the Norwich genre. Hemingway has pointed out that the composition may have been inspired by a similar view, *The Yare at Thorpe,* painted by John Crome, *c.* 1806 (see p. 23). Although Stannard's technique is very different, with his palette of soft greens and his creamier treatment of the trees, the subject-matter is typical not only of John Crome, but of all the Norwich painters.

Although Joseph Stannard is most closely associated with beach scenes, shipping and marine subjects, he was also attracted to quietly rural scenes. Seven of his eleven known etchings are of woodland scenes, often in the vicinity of Trowse, which in both technique and subject recall the etched work of John Crome. Horace Bolingbroke, in his manuscript catalogue of Norwich School prints (NCM), records one lithograph by Joseph Stannard entitled *Thorpe River looking towards Norwich.*

Joseph Stannard
*At Trowse — Boy fishing
from Staithe*
etching
(6.2 × 10.4 cms plate)
signed in plate, top right:
J Stannard
Purchased 1975 (8.424.975)

Joseph Stannard
Thorpe Water Frolic—afternoon
1824-25

oil on canvas
(108 × 172.8 cms)
J.J. Colman Gift
1894 (35.94)

Thorpe Water Frolic—afternoon, exhibited with the Norwich Society in 1825 (9),
proved to be Joseph Stannard's most ambitious work. The painting shows Stannard
responding to the example of both John Berney Crome, whose *Yarmouth Water*

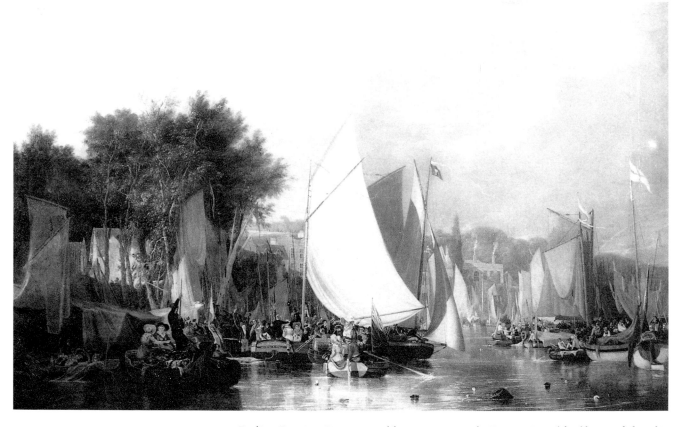

Frolic—Evening: Boats assembling previous to the Rowing Match had been exhibited in
1821 (38), and of George Vincent. The expansive yet busy composition, dominated by a
bright sky charged with a rolling cloud formation, owes much to Vincent's work of the
early 1820s. Stannard's preliminary oil sketch, formerly in the collection of Mr John
Norgate, showed a far less grandiose composition, transformed in the final version. The
Norfolk Chronicle commented that the artist had 'produced a composition intensely
interesting, masterly and elegant' (6 August 1825), acknowledging that Stannard was
here making a considerable contribution to the 'celebrity' of the Norwich School.

The *Norwich Mercury* remarked on the same day: 'we believe there are very few
artists now alive who could have produced a design where truth and fiction are so nicely
blended'. The essential fiction of the painting lies in the elegance of the artistic licence
employed by Stannard. The event depicted was organised by the leading manufacturer
John Harvey, who can be seen standing in his gondola surveying the festivities just to
the left of the centre of the composition. The frolic attracted an enormous crowd of
almost twenty thousand spectators at Thorpe in 1824, but Stannard evokes the scene
with an elegance which does justice to Thorpe's contemporary reputation as 'the
Richmond of Norfolk'. An excellent skater and oarsman, he has depicted himself stand-
ing in his boat to the extreme right of the composition.

Yarmouth Beach and Jetty represents one of the most perfect examples of Joseph

Stannard's mature powers as an artist, painted in 1828, a year in which he did not exhibit his work. His absence from the Norwich Society exhibition that summer was lamented by the *Norwich Mercury*, who noted that Stannard's 'fine talents have been stopped by illness of many months duration' (16 August). It is likely that this oil was worked up from sketches made whilst Joseph Stannard was recuperating at Yarmouth and may be the work exhibited the following summer as (84) *Fishermen, Yarmouth Beach*. A number of studies for this picture survive at the British Museum (Reeve Collection). A similar subject, also in the collection at Norwich, *Yarmouth Sands* (NCM 87.935), shows the same figure of the fisherman emptying his catch. Similarly painted on panel, this may also have been exhibited in 1829.

The local press responded well to Stannard's work that year. He already had a reputation for high finish and accuracy and the *Norwich Mercury* remarked that his 'elaborate marine pictures have all the delicate touch and high finish of Vandervelde, whilst at the same time they are perfectly original in their composition' (25 July 1829). The same critic was later moved by Stannard's pictures to make a comment that is as expressive of the attraction of the Norwich School as of Stannard in particular: 'Perhaps there is scarce any thing which gives more general pleasure than landscape, because it embodies so much of what all are daily seeing, daily enjoying' (8 August 1829).

Joseph Stannard
Yarmouth Beach and Jetty 1828
oil on mahogany panel
(52.2 × 74 cms)
signed, bottom left:
J. Stannard 1828
R.J. Colman Bequest
1946 (1267.235.951)

Joseph Stannard
Coast Scene

etching with drypoint
(6.1 × 10 cms plate)
signed with monogram, in
plate, bottom right: *JS*
Purchased 1975 (7.424.975)

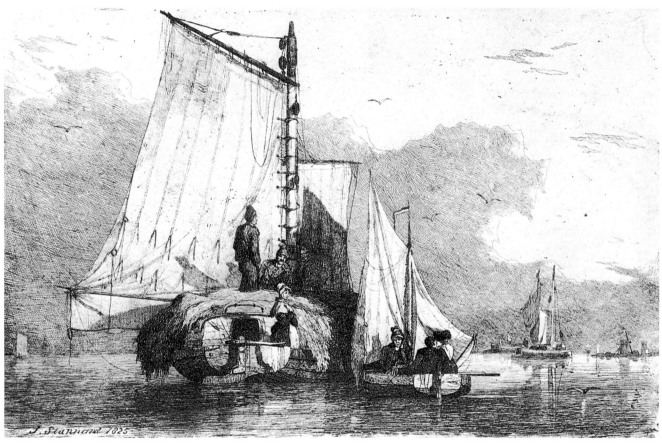

Joseph Stannard
Boats on Breydon 1825

etching
(13.8 × 21.2 cms)
signed on plate, bottom left:
J. Stannard 1825
Purchased 1971 (543.971)

Joseph Stannard holds a key position in the development of a tradition of etching amongst the Norwich painters. The rarity of his etched work has tended to obscure his achievement in this field, although Chambers was the first to comment, in 1829, specifically upon the 'very spirited' quality of Stannard's etchings. A corpus of eleven etchings and one lithograph is known, although it is likely that others await discovery. An unrecorded etching, entitled *Unloading Ships* and signed in pencil, is in the collection at Norwich (NCM 62.428.976).

Stannard signed eight of his plates and dated five, thus making it possible to date his use of the medium to the period 1824-27. His earliest dated etching is *Old Whitlingham Church*, inscribed *J.S. Febry 1824* while a second plate, *Gable End of Shed with Trees*, is also dated to this year. Two works dated to 1825 are *Boats on Breydon* and *Yarmouth Jetty* while the latest dated plate is *The Beach at Mundesley* (1827). Within this brief time span Stannard rapidly developed the example of John Crome, his compositions becoming more assured, his use of the etched line gathering momentum and freedom. His plates all bear that spontaneous immediacy one associates with the early states of Crome's etchings, before they were ruined by subsequent rebiting which Stannard never saw. The heritage of his brief example as an etcher may be seen in the silvery tones of the etchings of his pupil, the Rev. E.T. Daniell (see p. 000).

A number of Joseph Stannard's sketches in coloured chalks survive, often of shipping studies and beach scenes. Two examples of the latter in the British Museum are *Mundesley, Norfolk* (1902-5-14-465) and *Beach Scene, Mundesley* (1902-5-14-466), while a number of shipping studies are in the collection at Norwich. Such studies help to explain Stannard's proficiency in details of rigging which was praised by the visitors to the Stannard family Exhibition in 1827: 'every rope is right' (*Norfolk Chronicle*, 6 October 1827). The use of coloured chalks, often on coloured papers, was taken up by Joseph's brother Alfred and also Alfred's son, Alfred George Stannard. Their collective example may have been followed by Henry Bright, who made this medium his own.

Two similar sketches in coloured chalks on brown paper survive, also signed and dated April 1830 (Christie's, lot 91a, 14 June, and lot 148, 20 November 1979). Sketches such as these, dating from the last year of his life, find Joseph Stannard continuing to direct his keen draughtsmanship towards figure subjects as much as to landscape and marine subjects. His last exhibit with the Norwich Society that August was a portrait in oils of the Rev. William Gordon of Saxlingham, a patron whose only contemporary addition to his family's old master collection had been a beach scene by Joseph Stannard. The portrait was noted by the *Norfolk Chronicle* as 'a small sized portrait in oil, strong in likeness and remarkable for its high finish' (7 August 1830).

Joseph Stannard
Two studies of Gypsy Encampment
1830

coloured chalk on brown paper
(23.5 × 31.5 cms)
each sketch signed, bottom right:
J.S. 1830/April and *J. Stannard 1830*
Purchased 1935 (1.60.935)

Emily Stannard
née Emily Coppin
Flowers 1840s?

oil on canvas
(51 × 40.5 cms)
Miss Emily Stannard Bequest
1894 (72.94)

Anna Maria Stannard
Winter Scene

oil on millboard
(14 × 17.2 cms)
R.J. Colman Bequest
1946 (1250.235.951)

Emily Stannard's early flowerpieces demonstrate an overtly Dutch character which owes much to her studies of Van Huysum and also De Heem. Her 'glowing yet harmonious colouring', her 'judicious grouping' and 'exquisite finishing' (*Norwich Mercury*, 3 August 1822) was initially based upon these models. In 1823 she exhibited (92) *Picture in the manner of De Heem* and again this was praised over and above others which were felt to be 'more hard without being more effective' (*Norwich Mercury*, 2 August 1823). By 1824 her eminence in the field was established and the following year the *Norwich Mercury* was fulsome in its praise: 'Miss Coppin is an honour to art, an honour to the City, and an honour to her sex, by the taste, industry, and knowledge, her beautifully disposed and elaborately finished pictures display. Can we say more? Ought we to have said less?' (6 August 1825).

Flowers represents a later and less mannered composition, typical of Emily Stannard's work of the 1840s and 1850s. Her work should not be confused with that of her niece Anna Maria Stannard, the wife of Alfred G. Stannard. Anna Stannard also exhibited still lifes and bird paintings in the Norwich exhibitions between 1853-69. A daughter of David Hodgson, her work does not particularly resemble that of Emily Stannard. Anna's signature, 'A. Stannard' should not be confused with that of Alfred Stannard, her father-in-law.

Emily Stannard
née Emily Coppin
Still Life—Dead Ducks
and a Hare with Basket
and a Sprig of Holly
1853

oil on canvas
(91.8 × 70.8 cms)
R.J. Colman Bequest
1946 (1261.235.951)

Emily Stannard contributed to numerous exhibitions in Norwich throughout her life-time. Her debt to her studies of the Dutch Masters is evident, both in her highly finished technique and her choice of subject-matter. In her early days with the Norwich Society as Emily Coppin she was grouped with other Still Life painters such as Miss Crome, Miss Fitch and Miss M.A. Kittmer for their 'extremely tasteful and correct specimens in that class of painting' (*Norfolk Chronicle*, 29 July 1820). Emily Coppin soon out-stripped her contemporaries in this field, her only true rival being James Sillett, representing the older generation, and also his daughter Emma.

Emily Stannard first exhibited a picture of dead game with the Norwich Society in 1829 (6). This had been the picture for which she received the Isis Gold Medal the previous year (see p. 96) and she persisted with this new genre throughout her sub-sequent career. She submitted three paintings, all of dead game, in 1831—a year after her husband's untimely death. The *Norwich Mercury* praised both her 'really exquisite' work and her resolve in not succumbing to her recent loss (30 July). Dated examples reveal that both her technique and command of composition strengthened. The sprig of holly, the painted label with its inscribed date 1853, and the abundant display of the game shop, within sight of the church of St. Peter Mancroft, suggest that this particular composition was painted in the winter of that year.

Alfred Stannard
On the River Yare 1846

oil on canvas
(65 × 80 cms)
signed, bottom right:
A. Stannard 1846

R.J. Colman Bequest
1946 (1241.235.951)

Alfred was a pupil of his elder brother Joseph and followed him in most enterprises. Like his brother, he painted marine subjects, but also Broadland scenes and landscape views, some of which caused controversy over his claims that they were 'painted on the spot'. *The Literary Gazette,* when reviewing the British Institution Exhibition in the spring of 1828, could not help but balk at Alfred Stannard's statement that his oil of *Trowse Hall* had been painted in the open air, considering it to be an elaborately finished studio picture. Another of Alfred Stannard's early oils, *Marsh Mill, near Hardly Cross,* received a lengthy notice in the *Norfolk Chronicle* (14 March 1829) prior to its being sent to London for exhibition in Suffolk Street. The critic marvelled at the picture for being 'extremely picturesque as well as accurate...judiciously composed and highly finished...'

On the River Yare represents Alfred Stannard's continuing adherence to the Norwich School tradition in depicting picturesque local subject-matter, but in a format which is increasingly mannered. The exact location of this scene is not certain. Although it probably shows a brickworks, possibly Berney's Mill near Reedham, another version of the scene (private collection) omits the smoking chimney to the left of the composition. Alfred Stannard had a fondness for reproducing his own compositions as well as those of his brother.

Alfred George Stannard's landscapes are comparable with those of his father, Alfred

Alfred George Stannard
Peterborough c. 1849
oil on canvas
(48.3 × 66 cms)
R.J. Colman Bequest 1946
(1252.235.951)

Stannard. His technique is, however, broader and often lacks the neat definition which is to be seen in his father's earlier work. It was perhaps inevitable that Alfred George Stannard's work would move further away from the example of Joseph Stannard. He exhibited a number of pictures in London from 1851-64, his address being given as Castle Meadow, Norwich for the first time in 1856, although he is also recorded at 3 Chalk Hill Terrace, Thorpe that same year. It is likely that he and his wife Anna Maria moved to Castle Meadow that year. An oil by Anna, signed and dated 1856 (Christie's, 13 October 1978, lot 53), portrays a dead game composition inspired by Emily Stannard's example (see p. 105) and depicts an envelope inscribed 'Mr. A.G. Stannard Castle Meadow Norwich'.

The family had moved again by 1864, when the British Institution catalogue gives A.G. Stannard's address as St. Andrew's Hall Plain. *Peterborough* is one of his most accomplished compositions and is possibly the picture of the same title included in the second Exhibition of the Norfolk and Norwich Association for the Promotion of the Fine Arts in 1849 (319). James Reeve records that A.G. Stannard produced a number of pictures in imitation of John Crome, which he sold to dealers. There is little to substantiate this suggestion, based upon a traditional boast by Alfred Stannard that he had painted at least three hundred Cromes.

Eloise Harriet Stannard
*Fruit—Grapes, Peaches, Plums
and a Pineapple with a Carafe
of Red Wine* 1872

oil on canvas
(71.7 × 58.8 cms)
signed, bottom right:
E.H. Stannard 1872

R.J. Colman Bequest
1946 (1255.235.951)

Eloise Harriet, like her brother Alfred George, may be included among the painters of the Norwich School despite the fact that she never exhibited with the Norwich Society. Both brother and sister depended for their artistic training to such an extent upon a received family tradition that their talents represent the heritage of the Norwich Society as opposed to any wider aspect of contemporary Victorian painting. Eloise Harriet continued to reinterpret the still life genre in the spirit of both her sister-in-law Anna and aunt Emily. She specialised in flowers, fruit and baskets of fruits, demonstrating a singular and prolific ability.

Between 1852-73 Eloise Harriet exhibited regularly at the Royal Academy and the British Institution as well as at Suffolk Street, London. From 1852 she is recorded as living at King Street, Norwich, until she moved to Opie Street in 1864 and then St. Andrew's Hall Plain by 1866. Her last move was to her house in Chapel Field Road where she died. Just over four years previously, she gave a long and characterful interview to the *Eastern Daily Press* (14 October 1910) in which she described how, during the winter months, she would be loaned the City Corporation plate to incorporate into her abundant fruit compositions.

Edward Thomas Daniell
Whitlingham Lane by Trowse
c. 1833
etching, state I
(16.8 × 25 cms)
Purchased 1925 (50.61.925)

This etching reveals Daniell at his best, working with a delicacy which prefigures by some thirty years the work of etchers such as Legros, Whistler and Seymour Haden. Daniell is closely allied with the Norwich School both in his quiet, unostentatious depictions of the Norfolk landscape in his later etchings of *c.* 1831-34 and through his contact with some of the artists of the second generation. He excelled in the use of drypoint, the technique whereby the design is richly strengthened by drawing directly on the metal plate with a needle and thus causing a soft ride or 'burr' of metal to rise at the edge of the line—which in turn gathers the ink to print a richer, darker tone. Norwich artists such as Thomas Lound and Henry Ninham adopted this technique to a certain extent, suggesting a direct influence by Daniell upon their work. It is likely that Ninham was the channel for this influence, as it was he who printed Daniell's plates.

This is one of Daniell's last etchings, made whilst curate of Banham, Norfolk—a position he retained until the spring of 1834. In August that year he became embroiled in the opposition to the City Corporation's project for refacing the Keep of Norwich Castle. He united with Henry Ninham to make an etching of the Keep to record its condition before restoration, but the plate was never finished or published.

Edward Thomas Daniell
Grindelwald near Interlaken
c. 1831-2

etching, state III
(11.5 × 18.3 cms)
Purchased 1925 (74.61.925)

below

Edward Thomas Daniell
*Ruins of a Claudian Aqueduct
in the Campagna di Roma*
oil on millboard
(20.2 × 15.3 cms)
R.J. Colman Bequest
1946 (773.235.951)

Having gained his degree at Oxford in November 1828, Daniell went on a continental tour for some eighteen months from 1829-31. A number of his drawings and watercolours survive from this tour, together with etchings derived from them. Daniell was one of many English travellers who made similar tours of Switzerland, Germany, Italy and possibly Spain: J.M.W. Turner also visited sites such as Grindelwald and Constance

in 1829, an early coincidence which probably helped to foster his later friendship with Daniell. During this period Daniell established his free style of drawing, with light touches of pencil and broad washes of colour, which was to mark his talent, albeit amateur, in a league with that of John Sell Cotman and artist friends such as William Muller and David Roberts.

Grindelwald near Interlaken is developed from a watercolour drawing, in reverse, now in the collection at Norwich (NCM 785.235.951). An oil version is also recorded. The freedom of both line and composition shows him moving away from the example of Joseph Stannard, towards the tradition established by Andrew Geddes and the Scottish etchers whose work he almost certainly saw whilst on a walking tour of Scotland in the summer of 1831. Daniell's continental tour resulted in a series of oil studies in which he developed a freedom akin to his sketching technique. While in Italy Daniell visited the painter Thomas Uwins in Naples before going north to Rome and the Campagna, provoking Uwins to write to Joseph Severn 'What a shoal of amateur artists we have got here! There is a Daniel too come to Judgement! a second Daniel! Verily—I have gotten more substantial criticism from this young man than anyone since Havell was my messmate...If gentlemen all take to painting for themselves, what is to become of us poor professional brushmen?' (May 1830).

In January 1835 Daniell moved to London as curate of St. Mark's Church, North Audley Street. During the next four years he befriended many of the most distinguished artists of the period, including David Roberts, William Dyce, William Mulready, Clarkson Stanfield, John Linnell, the Eastlakes and Edwin Landseer, as well as Turner, whom he greatly admired. During this period Daniell came to share the current enthusiasm for the Near East. His imagination was fired by the drawings of Roberts who returned from Egypt and the Holy Land in 1839. John Linnell records how, on 10 February 1840, he went 'to Mr. Daniell to see Roberts' drawings of Egypt and Palestine'. Daniell's interest had grown to such an extent that within the year he resigned his curacy at St. Mark's and left England for the Middle East, reaching Corfu in September.

Daniell's topographical and romantic watercolours record his journey, making it possible to follow his path—at times day by day. The majority of these watercolours reveal a vision that emulates that of David Roberts and exceeds that of Edward Lear, who followed him nine years later. In December 1840 he was in Athens, in January 1841 at Alexandria and by June had reached Mount Sinai. The Convent of St. Catherine was required visiting for any traveller en route between Palestine and Egypt. Daniell's composition closely recalls that of Roberts, whose view was subsequently published in the latter's *Views in the Holy Land* (1842-9).

Edward Thomas Daniell
Interior of Convent, Mount Sinai
1841

pen, watercolour and body colour
(33.1 × 49.2 cms)
inscribed:
Interior of Convent at Sinai
June 19th 2pm 1841
R.J. Colman Bequest
1946 (913.235.951)

GREAT YARMOUTH & THE JOY BROTHERS

The last five years of John Sell Cotman's residence at Southtown, Great Yarmouth, spent under the aegis of the Yarmouth banker, patron and polymath Dawson Turner, coincidentally saw a parallel act of artistic patronage at Yarmouth. The period during which Cotman, at the behest of his patron, embarked upon his major Normandy series was that in which the artistic talents of the brothers William and John Cantiloe Joy were discovered and fostered by the Norfolk eccentric, Captain George William Manby (1765-1854), renowned for his inventions for life-saving at sea. Manby himself owed much to Dawson Turner in that throughout his career Turner sustained him both financially and as a friend.

The town of Great Yarmouth and its immediate vicinity vaunted a number of picture collections owned by gentlemen whose taste was not exclusively dependent upon inherited old masters, but who actively purchased contemporary art. These included the Rev. John Homfray M.A. who numbered amongst his collection not only old masters such as *The Embarkation of St Ursula* ascribed to Tintoretto (formerly owned by Thomas Harvey of Catton) but, by 1826, three pictures by William Joy and four watercolours by John Cantiloe Joy. Mr Yetts of Chapel Street added two sea pieces by William Joy to his collection of otherwise old master pictures, and he also commissioned two family portraits from Joseph Clover. Sir Edmund Knowles Lacon, whose residence was at nearby Ormesby House added six drawings by the Joy brothers to his family collection. Sir Edmund's only other response to contemporary art was to add two paintings by John Crome to his collection, *A View of Norwich from Heigham* and *A View on Norwich River*, of which John Henry Druery remarked 'It would not be an easy matter to produce two superior pictures of this highly esteemed artist' (*Notices of Great Yarmouth*, 1826). R. Cory, Jun., Esq., F.A.S., whose library was of considerable local historical, architectural and antiquarian interest extended his collecting to the purchase of 'two excellent pictures, by Joy', besides a battlepiece attributed to Hughtenburgh. A gauge of William Joy's relatively rapid rise to local renown may be seen in Druery's arbitrary comment in the course of describing the hall of the Rev. George Anguish's home near Yarmouth, Somerleyton Hall: 'May the writer of this account be excused for observing, that this would be an excellent and appropriate situation for a series of marine paintings, by that eminent artist, William Joy, of Yarmouth, in which should be exhibited the ever memorable exploits of the hospitable proprietor's gallant ancestor, the famous Admiral Sir Thomas Allen?' As far as Dawson Turner's collection was concerned, the Joy brothers may be allied with John Sell Cotman in that Turner's patronage did not extend to purchasing their work. Although Turner gave freely of both finance and advice to the artists he supported, it was only John Crome's work which he purchased with any seriousness.

In the light of Druery's championing of the Joy brothers it is somewhat puzzling that he omits to mention the collection of Captain Manby from his *Notices of Great Yarmouth*. A measure of Manby's patronage lies in the group of pictures by the Joys as well as by Nicholas Pocock, Francis Sartorius and F.L.T. Francia which he donated to Norwich Castle Museum in 1841 (see p. 116). The eccentric behaviour for which Manby was renowned may be inferred from his publicaton in 1803 of *An Englishman's Reflections on the author of the present Disturbances*, a pamphlet in which he advocated the assassination of Napoleon, with himself the assassin. Manby's jingoistic pamphlet actually aided his appointment as Barrack Master in Yarmouth that same year. C.J. Palmer described Manby as a man of 'excessive vanity and egotism [which] frequently exposed him to ridicule' (*Perlustration of Great Yarmouth with Gorleston & South Town*, vol. III, 1856, p. 211), but this is to ignore that side of his personality which led him to take under his wing two young local artists whose careers and reputation, with his help, were to extend well beyond the immediate seafaring community.

In 1818 Manby was able to furnish the young Joy brothers with a studio in the Royal Barracks. We owe most of our knowledge of the Joy brothers' early years to Chambers' *Norfolk Tour* of 1829: 'William Joy was born in 1803 and his brother John Cantiloe (his mother's maiden name) in 1806, the sons of a respectable character...guard of the Yarmouth to Ipswich Mail Coach.' Mr John Joy (*c*. 1772-1826) 'was also highly susceptible of the sublime and beautiful in nature and it was from his criticism on the effect of light and shade, as relative to the picturesque at sea' that led him to mention to Manby that 'he had two sons who were beginning to paint from nature'. The earliest examples of this youthful talent to survive are six 'select views in the Grounds of Mr. Wright's Academy Southtown Gt. Yarmouth', engraved as

vignettes by J. Lambert after William Joy in 1820. William Joy had first exhibited with the Norwich Society the previous year when he showed five works at the early age of sixteen. These youthful efforts were apparently highly derivative and were spotted as such by the critic for the *Norfolk Chronicle*, who commented that two, *Sea Storm* and *Sea Piece*, were almost certainly 'from Woollett'—presumably the engraver William Woollett (1735-85) whose speciality 'in the tender transparency of water, when seen in motion' (S. Redgrave, *A Dictionary of Artists of the English School*, 1878) would have appealed to William Joy.

The Joy brothers gained their first real fillip in 1820 when, in honour of the Sovereign's birthday, Captain Manby organised a special exhibition of their work in one of the apartments of the Royal Barracks (see p. 117). His encouragement evidently bore immediate fruits. John Cantiloe exhibited with the Norwich Society for the first time in 1823 along with his brother. They both exhibited in Norwich again the following year, eliciting praise from the *Norwich Mercury* not only for themselves but also for Captain Manby 'who has brought his diligent and ingenious pupils to a point of excellence which now fits them for studying the technical means under some eminent professor. They are ripe for the best instruction' (14 August 1824). The *Norfolk Chronicle*, on the same day, more specifically praised William: 'Mr. Joy appears quite *au fait* in the rigging of his vessels...In the management of his skies there seems much room for improvement both as to the forms and handling of clouds...' Both brothers exhibited three works the following year, when the *Norwich Mercury* commented 'Messrs. Joy, who have been studying the sea in all its appearances at Yarmouth, have several meritorious pictures—we think the water-colours will be most esteemed' (6 August).

During the 1820s Captain Manby remained a key influence upon his protégés. Even when he was away from Yarmouth he wrote to Dawson Turner to enlist his help. The Dawson Turner correspondence now in the care of Trinity College Library, Cambridge, contains a number of letters from Manby. On 28 March 1821 Manby wrote from Liverpool, prior to a whaling expedition to Greenland to test his prototype harpoon gun and detonating shell: 'I have taken the deepest interest in the welfare and advancement of talent in the two sons of Mr. Joy. You and Mrs. Turner would do me a great kindness if you would occasionally visit them in the room they work in at the Barracks and make such remarks on their studies, which you both are so fully enabled to do, as it will tend to their improvement, as I really feel they will do honour to my name.' A curious result of this trip was the series of four grey wash drawings of the Greenland Whale Fishery by William Joy, presumably derived from Manby's own sketches, which were subsequently engraved as illustrations to his *Journal of a voyage to Greenland* (1822). Another letter from Manby finds him writing to Dawson Turner from France on 23 March 1827 requesting him to visit William Joy to 'impress upon his mind' the importance of his latest commission, 'it being the storm exactly as it happened, the day previous to the founding of the Royal Institute' (later the R.N.L.I., founded 1824).

In the autumn of 1829 William Joy went to London at Manby's instigation, to seek potential patrons. He gained an introduction to Admiral Sir Charles Cunningham (1755-1834) and Captain Edward Pelham Brenton (1774-1839) and won commissions from both. Manby wrote at length to Dawson Turner on 16 November 1829, commenting: 'The Admiral has been most kind to Joy and told me he would exert himself for his advancement and benefit in any way in his power...Joy is now well on the road to fame and fortune, and will do honour not only to his native town but also to his country.' Two days later Manby wrote again: he had been with William Joy to 'a gallery in Pall Mall near the British Institute', where Manby gave Joy a brief counsel upon the principles to be learned from the work of William van de Velde: 'There were only a few pictures of merit, but two of W. Van de Velde, certainly not of his best, yet they answered my purpose. I was able not only to point out sufficient merits, but also to impress upon Joy's mind what was defective in his painting—namely a hardness of pencilling, and to show Van de Velde exhibited no determined line, but softened it as is seen, in an attentive observance to nature.' Joy had that afternoon visited the National Gallery, returning to Manby that evening, commenting 'There is more to be collected by studying from Claude than from any other pictures about.'

By November 1830 John Cantiloe had joined his brother in London and a letter of 29 November from Manby to Dawson Turner marks both the summit and the end of his guidance in the furthering of their career: 'They are both fully employed particularly the eldest who will have at least four historical pictures for the exhibition. The youngest has a wonderful demand for his small water-colour drawings.' The subsequent history of their movements is not easily chronicled. Much of their time was spent in London, and also Chichester. In 1838 the Killarney steamer crew were saved by the Manby Apparatus

(see p. 115), an event which occasioned two of William Joy's most evocative shipwreck scenes in watercolour, now in the collections of the British Museum and Norwich Castle Museum. William Joy's last recorded exhibit in London is in 1845 at the British Institution when his address is North Street, Chichester, although White's Directory published that year refers to the Joys as being in London at that time. The date of their respective deaths has also remained a mystery. However, a number of works survive dated in the 1850s, while no work is known dated later than 1859, the year before their work was included in the Exhibition of the Works of Deceased Local Artists, organised by the Norfolk and Norwich Fine Arts Association in 1860.

John Cantiloe Joy
Yarmouth Beach 1820s?

pencil and watercolour
(19.2 × 27.3 cms)
R.J. Colman Bequest
1946 (999.235.951)

John Cantiloe Joy appears to have learnt much from his elder brother William, to the extent that not only is their subject-matter invariably identical, but his technical mastery of such details as a ship's rigging is equal to that of William. The chief distinction between the brothers was first noted by Druery in 1826 in his *Notices of Great Yarmouth:* 'John Joy—A junior brother of the above [William], who pursues the same line of painting, but in water colours—many of his pieces deserve the highest commendation.' Although William painted in both oil and watercolours, there is no known oil which may with any certainty be attributed to John Cantiloe. The tradition that both artists worked together on single canvases is without foundation. Equally, the common attribution of individual watercolours to both artists is more often an indication of the difficulty in distinguishing between them, rather than a serious suggestion that both artists have clear idiosyncrasies of style identifiable in the same work.

It is possible to discern certain characteristics in the watercolours of John Cantiloe which help to identify his work. While the colour ranges of both artists are similar, John Cantiloe tends towards a lower colour key. His method of painting the roll of cresting waves is perhaps his most obvious trademark, which is almost a translation into watercolours of William Joy's technique in oil. William, by contrast, adopts a more linear style when painting in watercolours, with a curious seaweed-green tonality for

his 'water in motion'. It remains possible that they would have worked together on some watercolours.

John Cantiloe Joy
Rescue of a crew at Gorleston
1830s?

pencil and watercolour
(31.8 × 42.9 cms)
R.J. Colman Bequest
1946 (1002.235.951)

Captain Manby had experienced a shipwreck at first hand when aboard the *Bordelais* which foundered on the Asklow Bank whilst heading for Ireland in 1802. The experience left a lasting impression upon him and when in February 1807 the gun brig *Snipe* and other ships were wrecked in the Yarmouth Roads, with a death toll of 144 by drowning, Manby began experiments which resulted by the end of the year in his Life Saving Apparatus. This apparatus enabled a lifeline to be fired from the beach to a ship aground up to a distance of four hundred yards, making it possible to draw people ashore from the sinking craft. A modified version of this principle is still in use, having first been successfully proved on 12 February 1808.

In 1837 Captain Manby sent four prints of his Apparatus in action to Queen Victoria on her accession, in the hopes of receiving a knighthood. Based upon drawings by John Cantiloe and printed in London by A. Friedel, these lithographs depict the different stages in giving assistance to a stranded vessel with the aid of the Manby Apparatus. Ever the self-publicist, Manby had used similar drawings by the Joy brothers to illustrate a lecture on 'Saving Lives from Shipwreck' which he delivered in London on 28 May 1830. Manby never did receive the knighthood he hoped for, despite a long letter outlining his 'services to the state' which he wrote to the Prime Minister, Sir Robert Peel, in 1841.

John Cantiloe Joy
*Effecting Communication
with a Stranded Ship*

lithograph
(11.4 × 17.3 cms subject)
inscribed in plate
bottom margin, as title
and: *DRAWN BY J. JOY*
Provenance unknown 1840

William Joy
*Boat going to a Vessel
in Distress* ? early 1820s

oil on canvas
(65.7 × 91.6 cms)
Presented by Captain G.W. Manby
1841

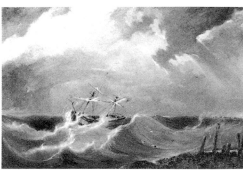

Francois Louis Thomas Francia
Saving the Crew of the brig
Leipzig *wrecked on Yarmouth*
1815

oil on canvas
(49.2 × 71.1 cms)
signed, bottom centre
with monogram: *LF*
Presented by Captain G.W. Manby 1841

In his *Norfolk Tour* (1829) Chambers describes how Captain Manby first offered the Joy brothers 'the use of the productions of Pocock, Powell, Sartorius and Francia in his possession.' *Boat going to a Vessel in Distress* owes much to the example of the only known pair of oils by F.L.T. Francia (1772-1839), *Saving a Crew at Winterton* and *Saving the Crew of the brig 'Leipzig' wrecked on Yarmouth, 1815*. These had both been commissioned by Manby to illustrate his invention for life-saving (see p. 115) and were exhibited at the Royal Academy in 1816. Throughout his career Manby remained concerned to publicise the benefits of his life-saving apparatus and was happy to commission a picture of a shipwreck in a hopeless situation to promote his cause.

Chambers records how Manby, on being introduced to William Joy, 'was particularly struck with the manner with which this young man viewed the compositions placed before him, and also with his criticisms, which evinced more of the experienced artist than the young amateur.' With Manby's help, William Joy had by 1826 established a firm reputation as 'a painter of considerable genius...whose marine views are highly and justly admired. Water in motion is his forte, and in this particular department of the art, so difficult to painters in general, he has, it will be allowed, few superiors' (J.H. Druery, *Notices of Great Yarmouth*, 1826).

William Joy first exhibited with the Norwich Society in 1819, showing a total of five sea pieces. The *Norfolk Chronicle* commented that these early works were derivative, but did exhibit a 'highly finished character, delicate handling, and soft colouring' (14 August). The following year both William and his brother John Cantiloe were firmly under the wing of Captain Manby (see pp. 112-113). At his instigation the Joy brothers held an exhibition of their work in one of the apartments of the Royal Barracks. The exhibition consisted 'principally of Marine subjects—all indicating no inconsiderable ability and skill' (*Norwich Mercury,* 29 April 1820). John Cantiloe was aged fourteen in 1820 and it is likely that most of the works on show were by William. The *Norwich Mercury* concluded: 'In all the Sea Pieces the vessels are painted in a style combining freedom of execution with neatness of finishing, and the figures augur well...'

Captain Manby was particularly anxious that his protégés should have every opportunity to study from Nature as much as from the works of contemporary marine painters 'in order to acquire a correct style.' With this in mind he saw to it that their room at the Royal Barracks had 'an expansive view of the ocean, and from which might be seen all the variety of the sublime changes of its appearance, the hues produced on it by reflected clouds, with the ever varying character of the vessels which ploughed its surface' (Chambers, *Norfolk Tour* 1829).

William Joy
Shipping. Brig anchored off-shore c. 1820s
pencil and watercolour
(27.6 × 40.3 cms)
R.J. Colman Bequest
1946 (1003.235.951)

SECOND GENERATION ARTISTS

All but one of the artists considered in this chapter were sons of John Crome and his contemporaries. The names Crome, Ladbrooke and Hodgson have already occurred in this book in connection with the founding spirits of the Norwich Society. Although the second generation of these families were inevitably influenced by their fathers, it is appropriate to separate them from the artistic activity in Norwich at the beginning of the nineteenth century. Their influence upon the art scene in Norwich lies in the middle years of the century, while they also represent a gradual shift towards a stylistic affinity with the mid Victorians as opposed to the relatively innovatory work of the earlier generation.

Henry Ninham

Henry Ninham (1793-1874) was born on 15 October 1793, the son of John and Elizabeth Ninham (see pp. 47, 50). Although John Ninham had no especial connection with the Norwich Society, his son Henry began exhibiting in 1816. His development as an artist was modest, attracting only occasional notice in the local press. His first exhibit (88) *Dutch Boor* was probably a copy, possibly an engraving. He almost certainly gained his early artistic education from his father, whose heraldic and printing business he and his brother Thomas continued after their father's death in 1817. In 1818 and 1819 he also advertised himself in the catalogues for the Norwich Society exhibitions as 'Teacher of Perspective', rather than as a Drawing Master.

A concern for accuracy and neat precision in execution characterizes his work in all media throughout his career, qualities perhaps most to be expected of a printmaker and teacher of perspective. He exhibited relatively few pictures with the Norwich Society, attracting praise mainly for his 'neat delineations' (*Norwich Mercury*, 14 August 1824), whilst being associated with the architectural work of the Norwich architect John Thomas Patience (*c.* 1773-1843) and the London draughtsman William John Donthorne (1799-1859). By 1830 he was advertising as an instructor in 'every Department of Drawing and Painting', adding 'Attendance in the evening as heretofore for Architecture and Perspective' (*Norwich Mercury*, 17 July 1830). Ninham exhibited with the Society for the last time in 1831 when his work was inadvertently attributed in the catalogue to Robert Mendham (1792-1875) of Suffolk. The mistake was compounded by the *Norwich Mercury* reviewer, who commented of Ninham's work: 'Mr. Mendham displays the same fidelity, but hardly we think so much talent as in the sketches of heads, etc. which he formerly exhibited. We say this not to disparage his abilities but to show the diversity of his studies' (30 July 1831).

Henry Ninham became more established within the artistic confraternity of Norwich during the 1830s. He had never joined the Norwich Society, although his name was included amongst those who attended the Inaugural Artists' Conversaziones of 1829. He came to the notice of John Sell Cotman as a result of the heraldic work in which he was employed at Attleborough, Norfolk. Cotman wrote to the Rev. William Gunn at Smallburgh on 25 February 1833: 'I went on Saturday with the Rev. Mr. Daniell to Attleburgh to see a very fine and curious screen showing the Arms of all the Bishoprics &c. I will see it is not marred in repairing, and will send the person employed—a very clever painter—Mr. Ninham, over to Worstead to see yours' (Cotman Family Collection).

It was during this time that Ninham gradually gained a reputation amongst the Norwich etchers for his able printing of their plates. Partly as a result of this increasing reputation and partly due to his own scrupulous interest in the buildings of Norwich, he became involved in the controversy surrounding the decision of the Norfolk magistrates to reface the Castle Keep. It is likely that it was Ninham who provided E.T. Daniell with the drawing upon which Daniell based his etching of the Castle. In a letter to Dawson Turner Daniell commented of the Castle Keep: 'I have had a very beautiful drawing made of it...I can only say that if my etching be half as much like the Castle or half as good as the drawing it will be more like than anything yet done of that very beautiful relic' (6 September 1834). Once Daniell had moved to London he relied upon Ninham for news of the refacing: 'Show me by a plan, how high they have got pulling down, and enable me to judge whether even now in the eleventh hour any good can be done; and I in return will just inform you how I stand with regard to my plate. It stands precisely as it did when I left Norwich' (7 April 1835). The plate was never finished, but Ninham himself made a lithograph as did M.E. Cotman, David Hodgson and J.H. Hakewill. Ninham's was lithographed by L. Haghe and published by Charles Muskett of Norwich. A letter from M.E. Cotman to John Joseph Cotman

reveals that Ninham had been chosen by Muskett in place of David Hodgson: 'Muskett finds fault with Hodgson's drawing of the Castle and employs Ninham' (2 November 1834).

Ninham was also employed by Dawson Turner to help prepare the plates of John Crome for their posthumous publication in 1834. Most of the etchings were ruined by this misguided attempt to 'improve' them, a fact of which Ninham himself was painfully aware. Twenty years later he attempted to clear his name. On 4 December 1858 the *Norwich Mercury* made a statement on his behalf: 'Mr. Ninham wishes us to state that the plate of Mousehold Heath, etched by Crome...was only rebitten, not retouched, by him, in the foreground...Mr. Ninham's work on Crome's plates was confined to the most scrupulous re-biting of Crome's lines, where they had been left weak' (see p. 28).

The history of Henry Ninham's career during the 1840s and thereafter is very much that of his published work. In 1841 *An Interior view of the Hall of the Polytechnic Exhibition* was engraved and published by Mr. Dallinger after Ninham early in the year, which was followed by the publication in London of James Grigor's *The Eastern Arboretum*, a register of remarkable trees, seats, gardens, etc. in the county of Norfolk, illustrated with fifty etchings of trees by Ninham. 1842 saw the publication of Ninham's *Picturesque antiquities of the City of Norwich* (see p. 123) and the following year the Rev. J.H. Bloom's *The Castle and Priory at Castle Acre* was published, with nine etchings by Ninham after Charles Wright. In 1845 W.C. Ewing wrote the text for the *Remnants of Antiquities in Norwich* drawn and lithographed by Ninham (privately printed). In 1848 J.T. Barrett published *Memorials of Attleborough Church*, with eight illustrations by or after Ninham. In 1850 Charles Muskett published *Notices and Illustrations of the...pageantry formerly displayed by the Corporation of Norwich*, with two etchings by Ninham after his drawings. Ninham's last major publication was *Views of the Ancient Gates of Norwich* (Norwich, 1864) based upon the drawings of John Kirkpatrick, with twenty-three etchings of the interior and exterior of eleven city gates and the interior of Heigham Gate. This is not the sum of his published work, however, as he produced many single etchings for *Norfolk Archaeology* (vols. I-VII, 1847-72) and *Suffolk Archaeology* (vol. III, 1863) as well as individual proofs of Norfolk subjects (see also p. 122). Henry Ninham's last commission before he died was a large painting of the Arms of all the Deans of Norwich for the Very Rev. Dr. Goulburn, Dean of Norwich. Ninham completed this just before his death on 23 October 1874. His obituary published in both the *Norfolk News* and the *Norfolk Chronicle* on 31 October was written by James Reeve. Ninham had outlived his wife Frances (died 1845) by almost thirty years and his daughter, Frances Elizabeth, by almost twenty years.

David Hodgson

A contemporary of Henry Ninham and also a painter of architectural subjects, was **David Hodgson** (1798-1864), the son of Charles Hodgson (see pp. 47, 51). Unlike Ninham, David Hodgson exhibited in London and other provincial centres such as Manchester, Liverpool and Birmingham. He also travelled to other parts of Britain, particularly Chester and was, in common with John Berney Crome, one of the more literary and articulate of the Norwich artists. When he succeeded the Norwich architect Philip Barnes (1792-1874) as Secretary to the Norwich Society in 1822, he held the position through a difficult period, playing an important part in soliciting support for the Society whilst its old exhibition rooms were exchanged for a better-appointed gallery in the new Corn Exchange. Samuel Woodward (1790-1838), the geologist and antiquary, was just one of a number of potential patrons who received a persuasive letter from Hodgson in 1827, seeking his support and patronage.

A measure of David Hodgson's literary aspirations is to be found in a poem written in heroic couplets and printed for private circulation in 1860. Entitled *A Reverie, or Thoughts suggested by a visit to the Gallery of the Works of Deceased Norfolk and Norwich Artists by David Hodgson. August 20th, 1860*, the poem is best remembered for its sentiment rather than its content. In the preface Hodgson pays specific tribute to John Crome, Robert Ladbrooke, George Vincent, James Stark and John Berney Crome and concludes 'Distinct in their subjects from the above-mentioned, may be classed John Sell Cotman and Charles Hodgson, both excellent as architectural draughtsmen; both men of no common stamp...' The continuing claim of the Hodgson family to local public attention was advanced by an essay appended to the poem by Hodgson's son, F.H.S. Hodgson, then living at Rackheath. This ponderous monologue was archly entitled *Art Musings, Respectfully Dedicated, Without Permission, to the Committee of the Fine Arts Association, by one of Themselves*. David Hodgson was one of the most consistent advocates of art and artists in Norwich, his output including an unpublished memoir of his father and a letter of 4 August 1858 published in the *Norwich Mercury* concerning the collection of civic portraits. He is amongst the earliest to record that sense of corporate identity which the Norwich artists felt. Although he is an early protagonist of much of the mythology connected with the School, his key

position in the original Society during its last ten years lends credence to his writings.

David Hodgson first exhibited with the Norwich Society in 1813, showing two pictures, and contributed consistently thereafter. In 1818 he advertised in the exhibition catalogue as a drawing master. The *Norfolk Chronicle* responded to his work specifically for the first time that year: 'The architectural interiors by Mr. Hodgson junr. are very promising: these subjects, to be executed even with tolerable success, require a skill which lies far below the surface—indeed an architectural designer must dive to the bottom of his art, if he means to rise to the top of it' (8 August 1818). Hodgson's work at this time was much in the vein of that of his father, a fact noted by the *Norwich Mercury* two years later: 'Mr. D. Hodgson has taken up that department which his father has left and with abundant promise of inheriting the delicate accuracy of his manner' (29 July 1820). Hodgson continued to specialise in architectural views throughout his career, and his drawings in particular demonstrate a lasting concern with the problems of perspective. An early indication of the importance of perspective in his teaching may be seen in his announcement that he 'has prepared a concise and comprehensive series of Lessons on Perspective...' (*Norwich Mercury*, 20 July 1822). On 1 January 1823 he married Frances Stone at St. George's, Tombland, their son being born on 2 December that year. Their daughter Anna Maria was born 31 August 1828, while a second daughter died in infancy in 1830.

Two albums of sketches and watercolour studies by Hodgson, many of them dated to a specific day, are in the collection at Norwich (NCM 41.98). These studies were the raw material from which Hodgson was later to derive and often repeat his oil compositions and their quality sometimes justifies the enthusiasm of the contemporary reviewers for his work. They demonstrate a range of subject-matter which includes landscape and tree studies as well as architectural and street scenes. His use of watercolour often recalls that of James Stark. His exhibited titles during the early 1820s demonstrate that Hodgson exhibited a number of landscapes as well as architectural views. While his expertise in matters of perspective was never in doubt, his colouring did receive some criticism. In 1824 the *Norfolk Chronicle* commented that 'however accurate in his design, he has made in our apprehension rather too great a sacrifice of fidelity, as to local colouring for the obvious (and we admit the fully attained) purpose of enhancing the picturesque effect' (14 August). Hodgson never did succeed in improving upon his oil technique which has been variously described as 'treacly' and 'clotted', with its 'preponderance of yellows and browns' (Miklos Rajnai).

During the late 1820s David Hodgson met with glowing approval in the local press, being consistently praised for his increasing powers both as a recorder of 'many of the relics of our ancient structures, both domestic and ecclesiastical' and as a landscape painter in watercolour as well as oils. In 1825 he was appointed Painter of Domestic Architecture to H.R.H. the Duke of Sussex, in the same year that his father was appointed Architectural Draughtsman to the Duke. David Hodgson was well patronised locally and collectors of his work included William Herring, Thomas Bignold, S. Colman, Francis Stone and Mr. Yarrington. In 1823 he sent his work to Newcastle, and later to Manchester (1827, 1829), Liverpool (1827), Leeds (1828, 1830) and Birmingham (1829). His work was purchased by W. Roberts of Birmingham (two landscapes), Rev. J. Hollingworth of Newcastle and William Gate of Carlisle and he sold work in Liverpool and Manchester as well as London, where he exhibited regularly at the British Institution from 1822 until the year of his death.

Hodgson continued to exhibit in Norwich throughout his lifetime, submitting work to the exhibitions organised by the leading art organisations of the City, successively the Norfolk and Norwich Art Union (1839), the Norwich Polytechnic Exhibition (1840) and the Norfolk and Norwich Association for the Promotion of the Fine Arts (1848-49, 1852-53, 1855-56, 1860). His work for the first exhibition of the East of England Art Union (1842) was notable for being exclusively landscapes, an aspect of his work which has been consistently neglected (see p. 125).

In 1843 or shortly afterwards he completed his series of etchings entitled *Antiquarian Remains, principally confined to Norwich and Norfolk*. A total of twenty etchings and one vignette, these were often based upon sketches much earlier in date. His compositions have a considerable charm and antiquarian flavour and also owe much to the example of John Sell Cotman's etchings. An example is Hodgson's etching *Broomholme Priory Bacton*, inscribed with the date 1843, but based partly upon his knowledge of John Sell Cotman's etching of this subject first published in 1812 (republished as plate 16 in Cotman's *Architectural Antiquities of Norfolk*, 1818) and his own pencil and watercolour drawing of 13 September 1819 (NCM 14.41.98). A Cotmanesque flavour is particularly evident in his etched skies, but also in touches such as the addition of discarded planks resting against the wall in his interior view of

Castle Rising Castle, Norfolk. These were not in his original drawing, dated 1828 (NCM 326.41.98). Another influence upon his etched work is also possible in the etchings of George Cuitt the Younger (1779-1854) of Chester, with whose work Hodgson must have been familiar.

The record of David Hodgson's later career is essentially that of his exhibited work in Norwich and with the British Institution. He had lived most of his life in Tombland but by 1856 had moved to Grey Friars Priory Lane, King Street, Norwich. He died at his home on 22 April 1864 and was buried in the Heigham Cemetery four days later, just eight months to the day after his wife Frances.

John Berney Ladbrooke (1803-79) was born in Norwich on 31 October 1803 and received his early artistic training from his father, Robert Ladbrooke. He exhibited his first sketch at Norwich with the seceding Society at the age of thirteen and thereafter exhibited regularly both in Norwich and London. Although he traditionally received some training from John Crome, his work does not suggest any real influence from him. When, in 1821, Robert Ladbrooke embarked upon his monumental project to publish a complete series of lithographs of Norfolk churches, it fell to John Berney to help with the production. Dated examples range from 1821 to 1832 and it was probably in order to assist his father that John Berney established a lithographic press at his father's house in Scole's Green, Norwich. He advertised lessons in the art of lithography at two guineas for four lessons as early as 1822, although his early efforts at this time were mediocre. In 1832 he published a set of four *Select Views of Norwich and its Environs* which demonstrate considerable improvement in his technique. The *Views of the Churches of Norfolk* was finally published a year after his father's death, in 1843.

John Berney Ladbrooke

J.B. Ladbrooke established himself as a drawing master and although based in Norwich was prepared to travel as far as Bungay, Loddon, Long Stratton, Bawburgh and Buxton, and 'to attend Private Families or Schools contiguous to the line of road through which he passes' (*Norwich Mercury*, 23 January 1836). He became a popular teacher and his pupils included his niece, the still-life painter Maria Margitson (1832-96), and also William Philip Barnes Freeman (1813-97) and John Middleton (see pp. 132, 142-5). In a letter to J. French (11 February 1850) Ladbrooke mentions that he had travelled in Holland and France, but only one continental subject appears amongst his exhibited works. By contrast, his travels in Scotland, Wales and the Lake District provided him with much material. In 1859 he had a house and studio built on Mousehold, Norwich, which he named Kett's Castle Villa. Much of his work in oils in the collections at Norwich dates from his later years and it was at Kett's Castle Villa that he died of 'senile decay' on 11 July 1879. He is buried in the nearby Rosary Cemetery.

J.B. Ladbrooke's elder brother, Henry, was also an artist, as was his younger brother Frederick Ladbrooke (1810-65). **Henry Ladbrooke** (1800-69) moved out of Norwich, living first at North Walsham and then King's Lynn, from where he, too, maintained a practice as a Drawing Master. Whilst at North Walsham he advertised his willingness to attend pupils in the surrounding area, including Stalham, Dilham, Cromer, Holt, Dereham, Weasenham and Castle Acre. He subsequently moved to Valenger's Road, King's Lynn, where he was helped in his teaching by his daughter Fanny. He later returned to Norwich where he died at his residence in Colegate Street on 18 November 1869. His younger brother Frederick, a portrait and landscape painter, had died four years previously, at his home in Bury St. Edmunds, on 7 October 1865.

Henry Ladbrooke

Other second generation artists who deserve mention are the children of John Crome. In addition to John Berney Crome, **Frederick James Crome** (1796-1832) also became an artist (see p. 31), although his early death prevented him from achieving any real distinction. His last exhibit in Norwich was *View near the Back of the new Mills* in 1821 (66) which the *Norwich Mercury* considered 'a picture of promise' (18 August). He is mainly remembered for his etchings, of which nine are recorded. John Crome's youngest son, Joseph (born 1810), also exhibited some sketches with the Norwich Society from 1822-25, but it was his third son **William Henry Crome** (1806-67) who continued the family tradition after the death of John Berney Crome, albeit in a mould increasingly removed from that of his father (see p. 124). William's son Vivian also became an artist, who studied at the Royal Academy before moving with his mother to Birmingham shortly after the death of his father. John Crome's eldest daughter to survive infancy also became a painter. **Emily Crome** (1801-40) specialised in still-life paintings and exhibited annually at Norwich from 1816, her work often being compared in the local press with that of Emily Coppin, as well as Miss Fitch and Mary Ann Kittmer, two pupils of James Sillet. The final artist to be considered here is **Samuel David Colkett** (c. 1808-63) who, though not related to James Stark by any family connection is, next to Stark's own son, Arthur James (see p. 33), the chief disseminator of Stark's style into the Victorian period.

William Henry Crome

Henry Ninham
St. James Fyebridge and
Whitefriars, Norwich c. 1830s

pencil and watercolour
(23.9 × 29.8 cms)
R.J. Colman Bequest
1946 (1190.B6.235.951)

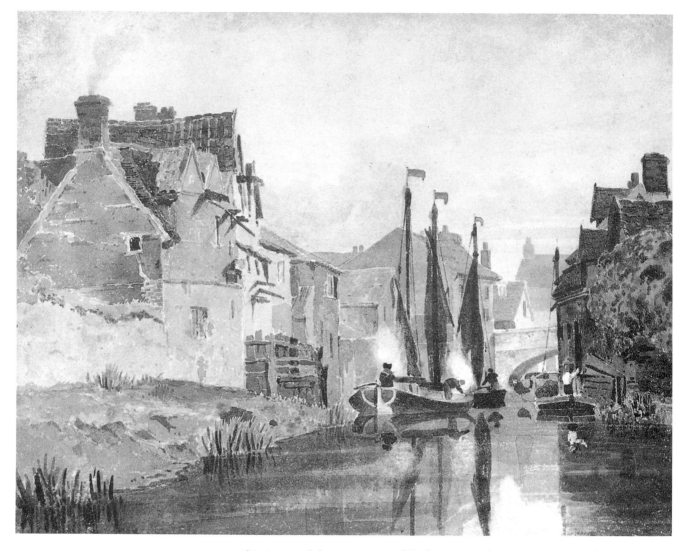

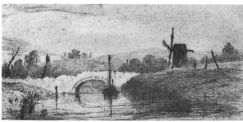

Henry Ninham
Bridge and Mill, Composition

etching with drypoint
(4.3 × 8.8 cms plate)
Purchased 1969 (73.557.969)

This is one of the most successful of Henry Ninham's many views of contemporary Norwich. The delicate use of wash and subtle tones reveal Ninham responding to the example of John Crome in this medium and perhaps also John Thirtle. Although Henry Ninham's reputaton is for neat and precise delineations of architectural subjects, his riverside scenes in both watercolour and oils reveal an assured sense of composition. His delicate palette owes most to the example of John Crome, particularly in his use of greys and blues. Another version of this subject, in brown wash, survives in the National Gallery of Canada, Ottawa (No. 2858). Norwich Castle Museum has two other versions, one in watercolour (NCM 1190.B46.235.951) and one in oil (NCM 428.961).

While much of Ninham's work as a printer was reproductive, he achieved a considerable output of original etchings. The most original and intimate of these were not published in his own lifetime, although he did distribute a few impressions amongst friends. The set of fifteen etched *Views of Norwich and Norfolk* was published with a brief Memoir in 1875. Most of these had been executed by Ninham during the 1830s and all except four were original compositions. The set shows Ninham experimenting with the techniques of softground and drypoint, sometimes emulating the effects achieved by the Dutch Masters—particularly Rembrandt—and at other times following the example of Joseph Stannard and E.T. Daniell.

Henry Ninham's small portraits of the courtyards, back streets and waterways of Norwich mark him as the leading recorder of the city after the death of John Thirtle. His compositions often occur in both oil and watercolour versions which he would some-times repeat over considerable time spans. His work of the 1860s is not noticeably more advanced than his work of, for example, the 1840s. His oils often lack the defin-ition of his watercolour drawings, being painted in a sketchy technique which comple-ments the picturesque charm of his subject-matter. Although his self-appointed task as recorder of Norwich complements that of his contemporary David Hodgson, his tech-nique as an oil painter achieves more finesse.

The scene of St. Stephen's Back Street incorporates a distant view of the east end of the Church of St. Peter Mancroft on the left, with the church and tower of St. Stephen's Church on the right. A similar but later oil version of this view, with some changes of proportion and detail, was with Mandell's Gallery, Norwich, in 1982. The version reproduced here is inscribed with the date 1843 on the reverse. The previous autumn Ninham had published his *Picturesque antiquities of the City of Norwich,* praised by the *Norfolk Chronicle* for its 'unequivocal merit' (10 September 1842). Issued under two or three different title covers, this consisted of nine india proof etchings on large folio sheets 'highly creditable to the accuracy and industry of this native and resident artist.'

Henry Ninham
*St. Stephen's Back Street,
Norwich* 1843
oil on millboard
(17.7. × 22.8 cms)
R.J. Colman Bequest
1946 (1189.235.951)

William Henry Crome was born on 22 October 1806, the third son of John Crome. He exhibited landscapes with the Norwich Society from 1822-33 and also in London from 1826-48. One of his exhibits at Norwich, and also at Birmingham, in 1829 was (39)

William Henry Crome
Landscape (with Bridge and Man Fishing) 1843

oil on mahogany panel
(68 × 94.3 cms)
signed, bottom right:
W.H. Crome 1843

R.J. Colman Bequest
1946 (768.235.951)

Composition from the 'Spirit of Solitude' after Shelley. The *Norwich Mercury* commented that his picture indicated 'a very poetical imagination. He has dared to deviate from the Norwich School with an aspiration which is harbinger of a style of painting we shall rejoice to see...' (8 August 1829). He also exhibited at Edinburgh in 1846 and Manchester from 1839-48.

W.H. Crome was increasingly recognised for his pictures 'of imagination' (*Norwich Mercury*, 31 October 1829) and it is in this sense that he 'deviates' from the example of his father to ally himself with the Victorian landscape tradition. His palette is idiosyncratic, with a heady use of green. He was on the Committee of the Artists' Conversaziones, the first of which was held on 16 December 1830, but left Norwich soon after 1832. On 1 February 1834 John Sell Cotman wrote in a letter to Dawson Turner 'William has already left Norwich, for no one to no where, in wretchedness and, I am afraid, insane—and so considered by his family' (Barker Collection). The catalogues for the exhibitions of modern artists at the Royal Manchester Institution record his changing addresses in the 1840s. In 1839 he was living at 3 Dudley Street, Liverpool. In 1844 his address was in London, and in 1846-47 at 18 Leopold Place, Edinburgh. By 1848 he had moved to 12 Croome's Hill Grove, Greenwich. He died in a Union Workhouse at Greenwich on 23 October 1867.

David Hodgson
Norwich Fishmarket
1849

oil on canvas
(76.5 × 63.5 cms)
signed, bottom right:
D. Hodgson 1849
Mrs. Anna E. Butcher
Bequest 1923 (62.923)

David Hodgson
*Stratton Strawless,
Norfolk* 1822

pencil and watercolour
(17.9 × 27.7 cms)
inscribed, bottom right:
Stratton Strawless / Sept. 1822
R.J. Colman Bequest
1946 (991.235.951)

David Hodgson first exhibited a view of Norwich Fishmarket with the Norwich Society in 1822 (58), his first year as Secretary. The *Norfolk Chronicle* found the painting 'extremely well designed, and from our knowledge of the locality of the subject, we can speak to the correct delineation of that bustling scene' (3 August 1822). The *Norwich Mercury* commented on the fact that the composition was 'taken from above, as we can see by the top of the awning' (3 August). Although the reviewer regretted the absence 'of those beautifully correct delineations of Cathedral Architecture, which used to do him so much honour', the composition was Hodgson's first to receive real critical attention. This was probably the version he sent for exhibition at Newcastle in 1823 (19).

Hodgson exhibited a second version in Norwich in 1825 (81), entitled *Street Scene, Norwich—afternoon*. The *Norfolk Chronicle* this time commented that it was 'a powerful and well coloured picture, full of bold execution, and in perspective beautifully correct. This gentleman has indeed made a prodigious advance...since we last saw from his hand the same subject' (6 August). Hodgson exhibited the subject again in 1828 (80), possibly the compositon *Old Fishmarket, Norwich* (NCM 987.235.951), a pencil version of which was lithographed by Louis Haghe (Norwich 1833 No. 201). Hodgson repeated such compositions throughout his lifetime. Although best known for his oils, he was also a competent draughtsman and landscapist, particularly in watercolour.

Henry Ladbrooke
Bolton Abbey 1841

oil on canvas
(91.5 × 129.5 cms)
signed, bottom left:
H. Ladbrooke 1841

R.J. Colman Bequest
1946 (1008.235.951)

Henry Ladbrooke was the second son of Robert Ladbrooke, born on 20 April 1800. He is traditionally said to have wished to enter the church but to have become a landscape painter having studied under John Crome. He exhibited with the seceding society in 1818 and then with the Norwich Society in 1821, three years before his father returned to the fold. In this year he advertised as Drawing Master, operating from Scoles Green, but within two years had moved to Calvert Street, when he advertised as 'Drawing and Writing Master'. An example of Henry Ladbrooke's writings, which he called his 'Dottings', was published in series in the *Eastern Daily Press* on 22, 25, 27 April 1921. The 'Dottings' contain numerous anecdotes about Robert Ladbrooke, John Crome and the Norwich painters and an appraisal of John Sell Cotman whose 'genius was of a much higher cast—infinitely more elegant and classical'.

Henry Ladbrooke's own work tends towards a mannered classicism, with a taste for distant vistas framed by trees in the foreground. His colouring and lighting effects are sometimes invested with a quality identified in 1823 as 'a lurid air' (*Norwich Mercury*, 2 August), although his last exhibit with the Norwich Society was deemed 'one of the best landscapes in the exhibition, sober and harmonious in its colouring...' (*Norwich Mercury*, 10 August 1833). The greatest influence upon him as a painter appears to have been the work of his father.

John Berney Ladbrooke
Lane Scene 1874

oil on canvas
(61 × 91.8 cms)
signed, bottom right:
J.B. Ladbrooke 1874
Sir Peter Eade Bequest
1916 (67.16)

Although throughout his career John Berney Ladbrooke painted a number of still life subjects of flowers and sometimes fruit, he became best known for his rustic scenes inspired by his native Norfolk. As early as 1823 the *Norfolk Chronicle* noted of his exhibits with the Norwich Society that (73) *View of the City of Norwich from the Back of the Barracks* 'deserves observation: it is painted on a large scale, and embraces much that is of local interest' (2 August), while the following year the *Norwich Mercury* found his 'colouring is also exceedingly good' (14 August). When in 1830 he chose to exhibit just one *Composition* (158) which was classical in design he was commended by the *Norfolk Chronicle* for his 'boldness in the attempt' and for his 'effects of aerial perspective' (7 August).

However, in 1831 the *Norwich Mercury* concluded that 'His largest picture is a composition, and we fear it must be pronounced a failure' (30 July). His best work remains that founded upon direct observation, often painted with an eye for detail, but a combination of bombastic lighting effects and a strangely lurid colouring which allows for both summer and autumnal tints to his trees within one scene, makes for an increasingly theatrical effect in his late work. The prime legacy of his teaching as an oil painter may be seen in the oils of his pupil John Middleton.

S.D. Colkett was both a pupil of James Stark and a copyist of his work. He first exhibited in Norwich with the seceding society in 1818 at just twelve years of age. It is not certain when he became Stark's pupil, but he had moved from Norwich to London by 1828. He exhibited regularly at the British Institution from 1825 and the exhibition catalogues record his numerous changes of address. By 1833 he had returned to Norwich, where he lived first at Rigby's Court, St. Giles, and later Princes Street, from where he

Samuel David Colkett
Landscape, River and Mill
to Left, Sheep in Foreground

oil on canvas
(61.2 × 86.5 cms)
signed, bottom left:
S.D. Colkett 18?7
R.J. Colman Bequest
1946 (31.235.951)

carried out a picture restoration service as well as a teaching practice. On 1 June 1839 he advertised his business by appealing directly to the 'Nobility and Gentry' for custom, proudly proclaiming his experience as 'Late Pupil of Mr. James Stark'. He also advertised 'a Vacancy for a Pupil' (*Norfolk Chronicle*).

Colkett later moved to Great Yarmouth in 1844, selling his collection of paintings, engravings and etchings through Mr. Ives on 5 June 1844. He continued to do business at 9 Regent Street, Great Yarmouth, and to solicit the support of the gentry, teaching both 'in Private and in classes'. He diversified as much as possible, becoming a dealer in Old Master paintings. He also proclaimed his abilities as a restorer 'on an entirely new principle. Valuable prints bleached, and the mildew stains removed by a new and safe method.' (*Norfolk Chronicle,* 23 August 1849.) As a painter in oils Colkett tends to prettify his subject-matter, transforming the rural scenes of his masters into rustic idylls in tune with the sentiment of the Victorian age. Six unpublished lithographs and etchings by Colkett are recorded by Bolingbroke (NCM Art Department MS), four of which were after paintings in the collection of William Yetts of Yarmouth. By 1854 Colkett had moved once again, this time to Cambridge, where he died at his home in 54 Trumpington Street on 24 January 1863 'after a long and severe affliction' (*Norfolk News,* 31 January 1863).

THE YOUNGER ARTISTS

Of the numerous artists who continued the tradition of the Norwich School into the middle years of the nineteenth century, five stand out for their individual talents, while still working in accordance with principles established by the early practitioners. Robert Leman, Thomas Lound, Alfred Priest, Henry Bright and, most notably, John Middleton, may be said to represent the final phase of the Norwich School. This is not to suggest that artistic activity ceased in Norwich with, for example, the untimely death of John Middleton at the age of only twenty-nine in 1856. It is the case, however, that artistic endeavour in Norwich during the period from 1840 until the 1890s was increasingly institutionalised. The clamour to set up a Government School of Design in Norwich, followed by the Norwich School of Practical Art, in line with the principles of the South Kensington System of art teaching (established by Henry Cole) is the dominant factor in the Norwich art world during these years. In this respect Norwich conforms to the national pattern, leaving individual artists such as Frederick Barwell (1830-1922) and Frederick Sandys (1829-1904) to turn away from Norwich for their artistic identity, albeit retaining a hold upon local patrons and subject-matter. While Barwell became a successful genre painter and friend of Millais, Leighton and Alma Tadema, Sandys allied himself with the Pre-Raphaelite Brotherhood.

Robert Leman

Within this context of increasing professionalism it is perhaps surprising that both Robert Leman and Thomas Lound were essentially amateurs. **Robert Leman** (1799-1863) first exhibited in Norwich in 1819 and his early exhibited works appear to have lacked any real sense of direction. During the 1820s and early 1830s he exhibited only intermittently, his subjects being mainly architectural, including in 1820 (8) *St. John's Church Devizes* and (18) *St. Lawrence's Church, King's-street*, in 1821 (154) *Crowland Bridge*, in 1822 (168) *Louth Cathedral* and in 1831 (26) *Fish Market, Rome*. His work was noticed by the press in 1833 (see p. 135) but he did not exhibit again until 1839 when he was Honorary Secretary of the newly-formed Norfolk and Norwich Art Union. He later became a member, together with Thomas Lound and John Middleton, of the Committee of the Norfolk and Norwich Association (1848-52) and also of the Government School of Design. During this period he was a clerk and later the manager of the Norwich Union Fire Insurance Company. His professional work does not appear to have impeded his love of sketching. His death on 18 March 1863 necessitated a sale of over fourteen hundred accumulated sketches and drawings which was held by Messrs Spelman of Norwich on 23 April. He had outlived his friend Lound by just over two years. Lound's own collection sale (6 March 1861) had included twenty two sketches by Leman produced for the Norwich Amateur Club. Leman died at his home off the Newmarket Road and was interred in the Rosary Cemetery.

Thomas Lound

Leman's friend and fellow amateur, **Thomas Lound** (1802-61), was a brewer by trade but led an active life as both artist and collector. His first exhibit with the Norwich Society was a view of St. Benet's Abbey, a subject to which he returned in both oil and watercolour. His work has sometimes been confused with that of his friend Leman and also that of John Thirtle, whose work he especially admired, collecting some seventy-five examples during his lifetime. He also imbibed the example of earlier Norwich artists, copying the work of both John Crome (NCM 96.356.957, see p. 25) and Robert Dixon (NCM 98.356.957) as well as that of his contemporary, John Sell Cotman (see p. 133). His own work is, however, rarely signed or dated, although at least three sketch-books have survived which record his later sketching tours of 1845, 1853 and 1854 (private collections).

Lound was evidently well liked by his contemporaries and letters from John Sell Cotman to his son John Joseph record evenings spent with Dixon, Lound and also Geldart. Lound became an established figure among the local artists and, together with Leman, helped to form the first Norfolk and Norwich Art Union and to revive the Artists' Conversaziones, which had petered out with the demise of the Norwich Society. Lound was appointed President of the Art Union Committee and together with Leman later became a Committee member of the School of Design. The Artists' Conversaziones met with considerable success: 'The interchange of thought was as natural as it was vivid and agreeable' (*Norwich Mercury*, 28 September 1839). The report continues: 'It remains for us only to state, that the tables were most liberally supplied, by the kindness of their owners, with folios, drawings, and books of prints— some of them evincing ability both in intellect and art of a high description.' As was usually the case, it is possible that this puff was in fact written by the editor of the *Norwich Mercury*, R.M. Bacon who,

together with Lound and Leman, had been a member of the original Artists' Conversaziones established by John Sell Cotman and John Berney Crome in 1830 (see p. 124). Lound and Leman also became active members, along with David Hodgson, William Freeman, John Barwell and Charles Muskett, of the Norwich Amateur Club.

Lound exhibited in the main Norwich exhibitions of 1842, 1848-49, 1852-53, 1855-56 and 1860 and also regularly at the British Institution and the Royal Academy in London during the same period. In 1847 one of his pictures, *Old Houses on the banks of the River at Norwich* was selected by a prizeholder, F. Pellatt, the winner of a fifteen pound prize awarded by the London Art Union (information from Dr. Michael Pidgley). It was during this period that he embarked upon a number of sketching tours of North Wales and Yorkshire. When he died at his home in King Street 'from an apoplectic fit', Thomas Lound 'had for some time previously suffered from ill-health, which was aggravated by the loss, not long since, of his wife and son' (*Norfolk Chronicle*, 26 January 1861). His wife Harriet had died in 1859, and his son Henry Edwin not long afterwards.

Alfred Priest

Another of the younger artists, most usually rememebered as a pupil of James Stark, was **Alfred Priest** (1810-50). Born on 12 December 1810, he was the son of John Fox Priest, a chemist of 1 St. Giles Street, Norwich. Traditionally he is said to have been to sea before being apprenticed to a surgeon in Downham Market. He was subsequently placed with Henry Ninham back in Norwich and it was from Ninham that he received his early artistic training.

Priest's earliest surviving dated works are among his etchings executed first under the aegis of Henry Ninham and later the artist, etcher and engraver E.W. Cooke. He first exhibited with the Norwich Society in 1831 and again in 1832, but his address at this time is not recorded. His first dated original etching is inscribed with the title *Sketch of the opening the Harbour at Lowestoft on the 9th of August 1831. By A Priest* and is a relatively naïve rendering of the scene. Of some fifty-nine etchings (BM) some are after other artists such as John Sell Cotman and Ruysdael, while ten are after E.W. Cooke. The earliest of these is *Great Yarmouth* which is inscribed *By A Priest 1830 1st under tuition.* It is not clear whether Priest had left Norwich for London as early as 1830, his first recorded London address being 14 Crawford Row in 1833, the year of his first exhibit at the Royal Academy. E.W. Cooke records in his diary meeting Priest on at least three occasions, the first being 4 December 1833 at a Conversazione where the company included James Stark and David Roberts. Cooke records on 25 September 1834: 'Mr. Priest called to see my pictures' and again on 10 February 1836 he mentions showing Priest his drawings at James Stark's house. A number of Priest's early seascapes reflect this contact with one of the leading marine painters and engravers of the day. His etched work, usually on a small scale, deserves to be better known, although his two surviving attempts at lithography are desultory by comparison.

Priest also became acquainted with E.T. Daniell and the Cotman family, whose correspondence contains a number of references to him. John Joseph appears to have commented favourably on Priest's work, to judge by Miles Edmund's comment to him 'I am glad to hear Priest's picture *is* a good one' (3 April 1834). On 9 November 1834 Miles Edmund asked after news of Priest, who at this time was actively engaged in portraiture.

In March 1836 Priest advised Miles Edmund on the retouching of one of his two entries for the exhibition of the Society of British Artists at Suffolk Street and that summer they visited Reading together (see p. 136-7). One other occasion when Priest figures in the Cotman family letters is in Ann Cotman's letter to her brother John Joseph (11 May 1837) concerning Daniell's reported admiration for Priest's exhibit that Spring at the Royal Academy, (56) *Landscape—painted on the spot.* It is evident both from his London contacts and his surviving work that Priest was not simply a pupil of James Stark alone, but in addition to Ninham's early teaching absorbed influences from some of his more outward-looking contemporaries. His greatest debt to Stark lies in the freedom of Stark's later style, itself influenced by contemporary metropolitan painters. The cause of Alfred Priest's early death is not certain, but he returned to Norwich in 1848, only to die just three days short of his fortieth birthday, on 9 December 1850. His body was buried at Cringleford.

The most professional of the younger artists of the Norwich School was **Henry Bright** (1810-73), whose London years and metropolitan friends, patrons and exhibition successes gave him a distinguished reputation. He established himself as a private teacher of the upper classes and aristocracy and as early as 1836 styled himself in the catalogue of the Liverpool Academy exhibition as 'Draughtsman in crayons to her Royal Highness the Langravine of Hesse Hamberg'. He also published 'A LIST of a few of the distinguished Pupils Mr. H. Bright had the honour to instruct in Painting and Water Colour Draw-

ing during twenty years of his Practice in London.' It is possible that his early success caused some resentment with his Norwich contemporaries: on one occasion he felt the need to write to Alfred Stannard to complain of being ignored by him and his daughters when out walking with Thomas Lound near Bracondale: 'I touched my hat to you, you *must* have *known* me but did not condescend to *notice me*...I must say I derived much of the pleasure of my earlier years with you, and I am *truly sorry* that from some cause you have not had the good feeling to give an old acquaintance a look nevertheless I *may* have the power to serve you. I know, and have as *intimate friends* many of the most wealthy collectors in England' (Reeve Collection, BM). The following account of Henry Bright's career is based upon Marjorie Allthorpe-Guyton's admirable study of the artist, first published in 1973 (see Bibliography).

Henry Bright

Henry Bright was born in Saxmundham, Suffolk, the exact date now being uncertain. He was the son of Jerome Bright, a noted clockmaker of the town, and Susannah Denny, of Alburgh, Norfolk. At little more than twelve years of age his parents sent him to work for Paul Squires, the Norwich chemist and soda water manufacturer. Bright is traditionally said to have taken lessons from John Berney Crome and he evidently became apprenticed for a period to Alfred Stannard. It was probably from Alfred Stannard and the example of Joseph Stannard that Bright was first prompted to use coloured papers, often with black and coloured chalks as, indeed, was Alfred's son, Alfred George Stannard (see p. 103). Bright was only in Norwich for a short period and there is no recorded address for him at this time. This suggests that he took lodgings in Norwich, while the evidence of manuscript letters from 1850 to 1870 reveals that he developed close friendships with Lound and also William Philip Barnes Freeman (1813-97). According to Bright's biographers he went on sketching tours with Leman. These later documented friendships may well have had their source in his early days in Norwich, perhaps as a guest of the Artists' Conversaziones. By 1833 he had returned to Saxmundham, for it was there that he married Eliza Brightly on 8 May 1833. In 1836 Bright moved to London to 12 Spring Terrace, Paddington.

Bright remained in the London area for some twenty years, submitting work to the main London exhibitions throughout the period. Although his obituarist in *The Art Journal* (November 1873) states that Bright did not exhibit oils until the Royal Academy exhibition of 1845 this is by no means certain. Nevertheless his ability as a watercolourist enabled him to become a member of the New Society of Painters in Watercolours in 1839 where he exhibited until 1844. His work was well received by *The Art Journal*: 'There is no one of the many works contributed by Mr. Bright that will not do him credit' (15 April 1840). During this period he developed friendships with a number of leading artists, including Samuel Prout (see p. 138) and James Duffield Harding. It was perhaps in emulation of Harding that Bright issued a series of drawing books in the 1840s. The earliest known is dated 1843, *Rudimental drawing book,—for Beginners in Landscape Complete in six numbers* and was published by Ackerman & Co., London. The following year another publication was advertised in *The Art Union*: 'BRIGHT'S DRAWING BOOK ON LANDSCAPE. First published, in Eight Numbers, at 1s. each, or in boards, price 9s. BRIGHT'S DRAWING BOOK ON LANDSCAPE in a series of Thirty Two Plates. Published by S and J. Fuller, 34 Rathbone-place' (1 August 1844). In addition, two other drawing books by Bright are recorded, published by George Rowney & Co., but no copies are now known. Henry Bright also associated his name with the manufacture of coloured crayons which were advertised in *The Art Union* along with his drawing books published from Rathbone Place '...where is also made and sold Bright's superior Coloured CRAYONS for Landscape Painting, so justly admired in his beautiful crayon Drawings.' Bright's name was also coupled with those of David Roberts, John Constable and his friends E.W. Cooke and Henry Jutsum as 'Among the many Artists of eminence who have expressed their approbation by written testimonials' for 'Winsor & Newton's Moist Water Colours' (*The Art Journal*, May 1849).

Henry Bright appears to have established for himself in London an extremely profitable career. In addition to his drawing books and landscape crayons, his reputation grew as a teacher of the titled and well-to-do. These included the wife and daughter of Sir Robert Peel, whom Bright considered 'a great lover of pictures and collector of modern Masters' and whose collection included a 'Crome' (Bright to Mrs. Sherrington, 4 July 1850, NCM). Many of his pupils were almost certainly patrons as well. As early as 1844 Bright's *Entrance to an Old Prussian Town* was purchased from the New Society of Painters in Watercolours by Queen Victoria. His work was equally appreciated by his professional colleagues: in 1845 his exhibit at the Royal Academy (335) *On the River Yare, Norfolk Morning* was praised by *The Art Union* as '...a small sketch, laid in with consummate skill and effect...The handling, as usual, is broad and free, with a sharp touch here and there to define form. It is a gem of the purest water' (1 June 1845). The

picture was purchased by the artist, Clarkson Stanfield. Indeed, Bright's professional success extended to producing works jointly with other artists, including John Frederick Herring, William Shayer, Marcus Stone, Charles Baxter, Thomas Earl, Isaac Henzell and James John Hill, Bright's contribution being invariably the landscape background. Such collaborations suggest a practical head for business, in recognition of the current popularity of genre and animal subjects.

Although he continued to live in London until 1858, Bright seems to have renewed his contact with Norwich around 1847. In 1848 he exhibited for the last time with the British Institution, submitting work that year for the first time to the Norfolk and Norwich Association for the Promotion of the Fine Arts at the School of Design in Norwich, when his work was well received by the *Norwich Mercury* (9 September). Together with Lound, Freeman and Leman, Bright also contributed drawings to the Artists' Conversazione prompted by the exhibition. There is a close affinity between the drawings of Bright and Robert Leman, particularly in their similar use of chalk and stump on buff paper. This is also true of the sketches of Lound and it seems likely that the similarities owe something to the drawing books of J.D. Harding. Bright's oil technique also reflects the influence of Harding, who possessed a comparable facility in his dashing and sometimes mannered use of paint. Illness caused Bright to leave London in 1858, moving first to Saxmundham, then Surrey and possibly later to Maidstone. His final move was to Ipswich where he died on 21 September 1873. According to his obituaries in the *Norfolk Chronicle* and the *Norwich Mercury* he had been living in Ipswich since 1868.

John Middleton

The youngest of the artists to be considered here, **John Middleton** (1827-56), was also one of the most gifted of the Norwich artists. Little is known of Middleton's early life, although he is credited with two teachers, J.B. Ladbrooke and also Henry Bright. The influence of Ladbrooke is most evident in his oil technique, particularly during his early twenties. Ladbrooke specifically refers to 'my pupil John Middleton' in a letter to Josiah French of 11 February 1850 (NCM). Similarly, Bright includes Middleton in his list of 'distinguished pupils', published *c.* 1856. The exact nature of the stylistic interdependence of Bright and Middleton is discussed below (pp. 141-2). Their relationship does not appear to have been without its hiccoughs: in a letter to Thomas Lound's son Henry, Bright comments, 'J. Middleton dined here tonight. he was *wondrous polite*. Tell your good papa that my *Lecture* did him good...' (22 February 1850, NCM).

John Middleton was born on 9 January 1827, the son of John Middleton, a painter and decorator who had taken over Daniel Coppin's business in St. Stephen's Street. His mother, Ann, was probably the 'Mrs. J. Middleton' who exhibited with the Norwich Society in 1828 and 1829. It is interesting to note that her exhibits were botanical studies, that of 1828 being (191) *Caetus Speciocissimus, flowered in the greenhouse of Mr. C. Middleton, April 1828*. While his mother's art could not have directly influenced John Middleton (she died in 1830) he may well have retained the family interest in botany. E.W. Cooke records in his diary for 20 June 1855: 'Mr. Middleton of Norwich called, a fern fancier.' No higher compliment could have been paid, as Cooke was himself a fellow 'fern fancier'. Middleton's artistic talents developed with a phenomenal precocity, reaching full maturity when he was twenty years of age (see pp. 142-5). A brief spell in London was cut short by the death of his father necessitating his return to the family business in 1848. He nevertheless continued to exhibit annually in London and the praise for his work in *The Art Journal* was consistently high. The last of a number of sketching tours for Middleton was a visit to Scotland in 1853. He became 'the victim of an insidious disease from which there was no escape', dying of consumption at the tragically early age of twenty-nine on 11 November 1856, at his home in Surrey Street. His work remains as a distinguished coda to the spirit not only of his immediate contemporaries, but also to that of the leading artists of the first generation in Norwich, John Sell Cotman and John Crome. It is John Middleton's no mean achievement during his brief life to have won contemporary recognition in both Norwich and London, to have published a slim volume of etchings which are imbued with the qualities of John Crome's original essays in that medium and to have produced a body of wash drawings that reveal him to be one of the finest exponents of the English water-colour tradition.

Thomas Lound
*View of Norwich (Mill
in Foreground) c. 1840s?*

pencil, watercolour and ink
(14.5 × 22.7 cms.)

Purchased 1941 (36.941)

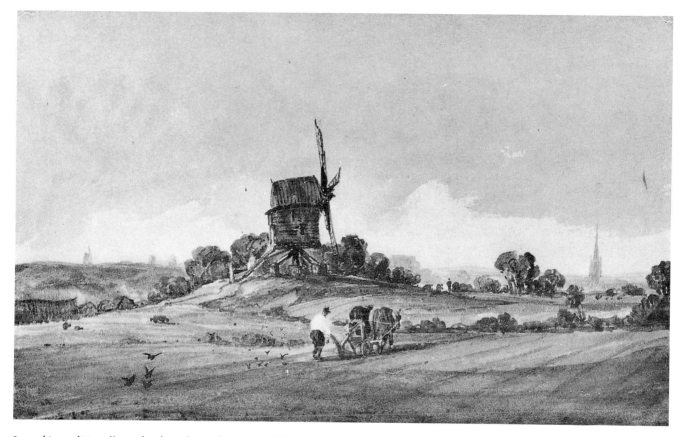

Lound is traditionally said to have been the pupil of John Sell Cotman and a number of his copies of Cotman's compositions survive to demonstrate his close study of Cotman's work. These include *Cader Idris from Barmouth Estuary* (NCM 13.155.938) and *Near Durham* (NCM 11.155.938) which relates to plate 36 of Cotman's *Liber Studiorum*. It is possible that Lound was one of the many subscribers to Cotman's Circulating Library of Drawing Copies, but he also copied other artists such as David Cox. Thomas Lound's *Harvest Field* (NCM 535.972), signed and dated 1836, is one such copy after Cox with whom he was also acquainted. He also copied oils, notably *Yarmouth Beach and Jetty* by John Crome (NCM 1.4.99), his own version (NCM 2.134.934) being a painstaking reconstruction which has little to do either with Crome's technique or his own broad handling of oils.

Thomas Lound
*Mill on Mousehold at
evening, man and sheep
in foreground*

watercolour
(7.7 × 11.5 cms)

Bequeathed by
Miss F.C. Thirkettle
1957 (15.356.957)

View of Norwich (Mill in Foreground) is one of the most perfect of Lound's original compositions which belies his reputation for broad free brushwork. An album of eighty-three small watercolours by Lound bequeathed to Norwich Castle Museum in 1957 by Miss Florence Thirkettle, granddaughter of the artist, is further testimony to his abilities as a watercolourist. Many of these are records of his larger compositions and those of others such as M.E. Cotman (NCM 42.356.957), but they are all characterised by a sensitive exploration of the subtlest atmospheric effects attainable in miniature.

Thomas Lound
Low Tide (Gorleston Pier)
c. 1840s?

pencil and watercolour
(13.5 × 22.7 cms)
R.J. Colman Bequest
1946 (1067.235.951)

Low Tide (Gorleston Pier) is a notable example of Lound's broad use of wash and explor-

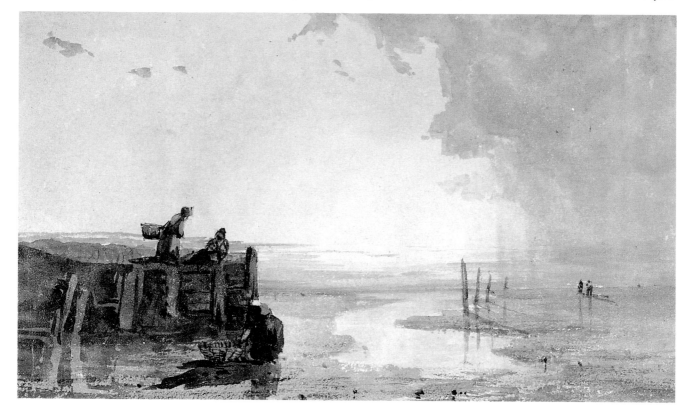

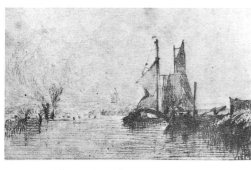

Thomas Lound
At Reedham

etching
(6.1 × 9.4 cms plate)
Purchased 1925 (29.61.925)

ation of atmospheric effect. Lound had received scant attention in the local press when exhibiting with the Norwich Society (1820-33) gaining his most significant praise only in 1839, when he exhibited ten works with the Norfolk and Norwich Art Union: 'Amongst the amateurs the president, Mr. Lound, puts in many and solid claims to the honourable place and distinction his fellows have ordained him. Whether in oil or watercolours he shows great power, and justifies a belief which no one can fail to entertain who looks carefully into this exhibition, that the amateurs tread closely on the heels of the profession' (*Norwich Mercury*, 17 August).

Lound's output as an artist was prolific, and he was also an avid collector, most notably of the work of John Thirtle. Like Thirtle, he concentrated almost entirely upon local subject-matter until he embarked upon summer sketching tours of Wales and Yorkshire in the 1850s. Although his best work was in watercolour, he also produced a large number of drawings in monochrome as well as in chalk on coloured papers, in common with Henry Bright. The chalk drawings also demonstrate some affinities with Miles Edmund Cotman and his brother, John Joseph. Twenty small etchings of local scenes by Lound are recorded and these sometimes recall the etched work of Miles Edmund Cotman, but are more usually essays in Rembrandtesque effects, often achieved by a subtle use of drypoint.

Robert Leman
*Mountain Scene, Snowdon from
Capel Curig c.* 1852?
watercolour and pencil
(32.5 × 50.4 cms.)
R.J. Colman Bequest
1946 (1027.235.951)

Robert Leman first exhibited subjects from North Wales in 1852, with the Norfolk and Norwich Association for the Promotion of the Fine Arts. This suggests that he had recently been on a sketching tour of the area, probably in the company of Thomas Lound, who similarly exhibited a number of Welsh subjects that year. A watercolour of

the same subject attributed to Lound is recorded in a private collection. The strong sense of design which characterises this watercolour is reminiscent of the work of John Sell Cotman, whose drawings Leman sometimes copied. Cotman's Greta period drawings were a particular inspiration to Leman and a group of Yorkshire drawings of 1861 are testimony to his longstanding appreciation of Cotman's example. His technique is, however, very different from that of Cotman, resembling that of his friend Thomas Lound in his use of wash and following Henry Bright in his use of pencil. His broad, unmodulated washes of colour may sometimes oversimplify— a tendency which is in marked contrast to the meticulous finish of his pencil, charcoal and chalk studies of rocks and trees. A feature of his drawings is his idiosyncratic use of the stump of the pencil to resemble charcoal in its effect.

Robert Leman
Brignall Bank, Greta River
1861
pencil
(37.6 × 54.8 cms)
inscribed, bottom left:
Brignall Bk / Greta River / 1861.
R.J. Colman Bequest
1946 (1045.235.951)

Leman's work was well received by the Norwich public but he does not appear to have exhibited his work elsewhere. His sketches submitted to the last exhibition of the Norwich Society in 1833 were pronounced 'natural and good' (*Norwich Mercury*, 10 August), while his work exhibited in 1839 with the Norfolk and Norwich Art Union was described as 'very *very* clever' (*Norwich Mercury*, 17 August). As Honorary Secretary of the Art Union and later Committee member of the Norwich School of Design, Leman played a positive role in the artistic life of the city during the middle years of the century.

Alfred Priest
Scene at Taverham, Norfolk
1839

oil on canvas
(87.1 × 133.4 cms)
signed (on boat):
A.P. 1839
Miss M.A.W. Hipperson Bequest
1969 (302.969)

Scene at Taverham, Norfolk is a relatively early example of Alfred Priest's mature style of painting in oils and was one of two exhibits submitted by Priest to the Royal Academy in 1839 (2). The picture shows one of the oldest paper mills, in existence in 1701. Priest painted a number of similar subjects, having exhibited (171) *Water Mill, Maple Durham, near Reading* with the Society of British Artists in London in 1837. He showed the same subject at the Royal Academy in 1843 (487), a scene also painted by his friend Miles Edmund Cotman (NCM 624.235.951). The following year he exhibited (112) *Iffley Mill, near Oxford* at the Society of British Artists. He also painted a variety of ford and river scenes, all subjects calculated to demonstrate his talent in the fluid depiction of transparent effects of water, often flecked with white to represent its turbulence.

Priest's work in watercolour in the mid-1830s resembles that of his friend M.E. Cotman. A letter from Francis Walter Cotman to his brother John Joseph (12 July 1836) records a visit to the Reading area by Miles Edmund in the company of Priest, and common subject-matter in both oils and watercolour suggest a close working relationship at this time. During the 1840s Priest's oil technique developed a facility which increasingly separated his work from the more meticulous approach of Miles Edmund Cotman.

Alfred Priest
*Bridge at Godstowe,
near Oxford* 1844

oil on canvas
(76.5 × 55 cms)
signed, bottom right:
A. Priest 1844

R.J. Colman Bequest
1946 (1196.235.951)

Bridge at Godstowe, near Oxford was exhibited at the Royal Academy in 1844 (318) and represents Alfred Priest's technique at its most accomplished. A picture entitled *Godstowe Bridge, Oxford*, exhibited with the Society of British Artists in Suffolk Street, London in 1845 (524) was possibly the same painting. A sense of bravura dominates both composition and technique inviting comparison with the work of Henry Bright in its adroit handling. Priest lived at 30 Pembroke Square, London from 1834 and his exhibited titles reveal that much of his subject-matter derived from trips to Berkshire and Oxfordshire. His exhibits in London find him painting subjects in the vicinity of Reading for the first time in 1836, Pangbourne in 1841, Derbyshire in 1842, Oxford in 1844 and on the Wye in 1847. Norfolk subjects also figure throughout his career.

A number of oils survive dating from the last two years of Priest's life and these reveal that he was then painting with an increasingly loaded brush with a correspondingly more clotted appearance to his paint surface. His idiosyncratic use of flecks of white to suggest clouds or water spume becomes more laboured as, for example, in his *Beach Scene* dated 1849 (NCM 1199.235.951). In his last years he returned to depicting seascapes, subjects which had figured in his work in the early 1830s and were recalled as 'beautiful sea pieces' by the art critic of the *Gentleman's Magazine* when reviewing the Suffolk Street Exhibition in 1838 (*Norfolk Chronicle*, 9 June 1838).

Henry Bright
*Remains of St. Benedict's Abbey
on the Norfolk Marshes—
Thunderstorm clearing off* 1847

oil on canvas
(80.3 × 132.9 cms)
Gift of F.J. Nettlefold
1947 (172.947)

The ruined gatehouse of St. Benet's Abbey stands close to the north bank of the river Bure, some three miles east of Horning, Norfolk. This Romantic subject, made the more picturesque by the eighteenth-century brick tower draining mill built within it, was a

favourite subject for artists of the Norwich School. Bright exhibited this painting at the Royal Academy in 1847 (621) and again with the Norwich Fine Art Association in 1869 (181). The picture prompted a mixed reaction at its London showing, *The Athenaeum* commenting that it was a 'highly conventional rendering...Dexterity and flippancy of execution, pushed to the extreme—as seen in the handling of the clouds with the palette knife— are not the methods by which the most renowned of landscape painters have achieved their fame' (5 June 1847). *The Art Union*, however, was more appreciative, finding it 'a picture of uncommon power' and 'a truly beautiful production—especially beautiful in those qualities in which the works of this artist maintain a high reputation—that is, in their *chiaro' scuro* and colour' (1 June 1847).

The dramatic silhouette, lighting effects and cloud formations recall the tradition of seventeenth-century Dutch landscape painting, but are also typical of Bright's sense of drama and romance conjured up by the wind-swept Norfolk landscape. Another treatment of the subject by Bright, in black chalk and pastel on grey paper, presents the abbey silhouetted against a romantic moonlit sky. This was once owned by Samuel Prout and according to Prout's son the drawing 'so much delighted my father,....that he gave the Artist, then a young man, one of his drawings in exchange for it' (Christie's, 1 March 1977, lot 64).

Bright appears to have drawn with chalks for most of his career, developing his exploration of effects particularly during the 1850s. His use of crayons or coloured chalks was well known and recognised by *The Art Union* as having an effect upon his work in other media: 'It is sufficiently evident that whatever peculiarity may distinguish its

style, that peculiarity is traceable to long practice in crayon drawings, and especially obvious in the broad touches and occasional sharp outlines. And not less is colour influenced by earlier practice, as appears in the sky, which is not like Nature' (1 June 1846). Henry Bright was closely linked with a range of 'superior coloured CRAYONS for Landscape Painting', which he used himself, and which were sold under his name (see p. 131).

Rocky Coast with Wrecks dates from late in Bright's *oeuvre*, at a time when he was emulating the effect of oils in his heavily-worked drawings. Their bombastic lighting effects recall the mannerism of his Victorian contemporaries such as the landscape painters Edmund J. Niemann (1813-76) and James Webb (c. 1825-95). His late chalk drawings are almost invariably large in scale and *Rocky Coast with Wrecks* is unusual for its small size, whilst still retaining an awe-inspiring atmosphere in the best Romantic tradition. The rugged coastline is probably inspired by that of the north east of England or possibly Scotland but specific locale takes second place to painterly imagination. His exhibited titles indicate that he had been to Wales and Sussex by 1838, Devon, Cornwall and Monmouthshire by 1844, Yorkshire by 1846 and Oxfordshire by 1847. A letter of 13 May 1860 refers to 'My absence in Scotland with a client...' (Reeve Collection, BM).

Henry Bright
Rocky Coast with Wrecks
c. 1860s

black, white and coloured chalk
on brown paper
(26.5 × 36.4 cms)
signed, bottom left:
H Bright
Gift of H. Bliss through
the NACF 1948 (65.948)

Henry Bright
Windmill at Sheringham
late 1840s?

oil on canvas
(80.5 × 133 cms)
W. Cadge Bequest 1903 (53.03)

Windmill at Sheringham is one of the finest of several mill subjects by Henry Bright and yet it is not certain that it was exhibited during his lifetime. Although the scene almost certainly represents Upper Sheringham post mill, with a distant view of Lower Sheringham or Beeston comparable to that depicted by Robert Dixon in 1809 (see p. 58), there is no record of a Sheringham subject exhibited by Bright. Henry Bright's numerous mill subjects are often quite accurate depictions, usually either post mills or tower mills which are also occasionally of a continental type, but they are not always topographically precise. Marjorie Allthorpe-Guyton has pointed out that many are simply variations on a theme, one composition often being a mirror image of another. A similar, though smaller oil in which the compositional elements are effectively in reverse of *Windmill at Sheringham* is Bright's *The Mill* (NCM 65 .948).

Such mill subjects were almost certainly influenced by *The Mill* attributed to Rembrandt. This had been in the collection of William Smith, M.P. for Norwich, at the beginning of the nineteenth century and was copied by numerous artists during the first half of the century. Such an influence need not have been direct and John Linnell's *The Windmill* (Tate Gallery, No. 439) exhibited at the Royal Academy in 1847, the same year as Bright's *Remains of St. Benedict's Abbey...* is one probable source.

Henry Bright
Old Barn Kent 1847
pencil and watercolour
(42.4 × 58.8 cms)
signed, bottom right:
Henry Bright 1847
R.J. Colman Bequest
1946 (14.235.951)

A number of studies related to this subject include a pencil study, *An Old Barn*, also in the collection at Norwich and similarly dated 1847 (NCM 73.75.94). A report of a meeting of The Graphic Society in the winter of 1847 reveals that Henry Bright had spent part of the summer in Kent: 'Mr. Bright's studies made during the past summer in Kent and Sussex were impressive for their sense of truth to Nature — more so than any oil pictures that we have seen from his hands. In landscapes of a more select class such studies would only serve as the constituents for combination; here, as they form the main subject of the pictures, they will no doubt induce the painter to be less garish and keep more to the "modesty of Nature" for the future' (*The Athenaeum*, 11 December 1847).

Henry Bright
An Old Barn 1847
pencil and stump
(35.6 × 50.6 cms)
signed, bottom right:
Henry Bright Sepr / 1847
Presented by the
East Anglian Art Society
1894 (73.75.94)

It seems almost certain that Bright was accompanied on his visit to Kent by John Middleton as the following year Middleton exhibited in Norwich two studies (370, 376) entitled *A Sketch from Nature, in Kent* and in London with the British Institution, (406) *Scene near Tunbridge Wells, Kent*. Although Middleton was Bright's pupil, the contiguity between their wonderful control of washes of colour during this period suggests one of the most harmonious moments in the history of English watercolour painting.

It is possible that *Bullingstone, Kent* is one of the two studies entitled *A Sketch from Nature, in Kent* exhibited by Middleton in Norwich in 1848 (370, 376). John Middleton's visit to Kent in the summer of 1847 took him to a number of spots in the area of Tonbridge and Tunbridge Wells. Two similar watercolours in the collection at Norwich are *Tunbridge Wells* (NCM 1139.235.951) and *Tonbridge Kent* (NCM 1144.235.951), both

John Middleton
Bullingstone, Kent 1847
watercolour
(33 × 48.2 cms)
inscribed, bottom left, with
title, monogram and date
R.J. Colman Bequest
1946 (1143.235.951)

of which have the immediacy of on-the-spot studies. The use of wash in these and in other similar works of the period 1847-48 show a marked improvement in the control of his washes when compared to works dated to the previous year. One example of his work of 1846 is *Richmond* (NCM 1138.235.951), a watercolour which also suggests that he was working on-the-spot, although with looser washes, reminiscent of the watercolour studies of Joseph Clover (see p. 64).

On 11 December 1847 the *Norfolk Chronicle* commented of Middleton that he was 'one of the most rising young artists of the day', praising the 'brilliancy of colouring, and a charming alternation of light and shade, with admirable drawing and grouping' of two of his compositions. These were to be included in a forthcoming sale of modern pictures from the collection of Henry Wallis, the engraver. It has been thought that his travelling companion for the Kent trip, Henry Bright, must have been responsible for the improvement of his young pupil's style. Although their work is remarkably similar at this time, it is evident that Middleton's rapid development was also a signal influence upon the work of his own teacher. His obituarist commented: 'Had it pleased providence to have permitted this young but highly-gifted gentleman to have survived to a greater age, it is beyond doubt he would have risen to a very high position among the artists of this country.' (*Norwich Mercury*, 15 November 1856.)

John Middleton
Alby, Norfolk 1847
pencil and watercolour
(31.7 × 48.3 cms)
inscribed with title, signed
with monogram and dated,
bottom left
R.J. Colman Bequest
1946 (1141.235.951)

John Middleton's debt to John Sell Cotman has often been commented upon, not least in relation to *Alby, Norfolk*. While the subject and pure use of wash recall Cotman's *Drop Gate, Duncombe Park* of c. 1806, now in the British Museum (1902-5-14-14), Cotman's treatment in compositional terms is a very much more formal one. Yet Middleton's eye for motif, whether man-made or natural, is strongly reminiscent of that of Cotman. Although Middleton's own early Greta subjects are derived from James Duffield Harding (eg NCM 1151.235.951), his excursions throughout Norfolk and the British Isles find him selecting subject-matter and motifs which echo those of Cotman.

The quality of Middleton's vision may be seen in a group of his photographs in the collections at Norwich Castle Museum. In common with Leman and Lound, who both owned photographic equipment, Middleton was a keen amateur photographer. A fellow associate of the Norfolk and Norwich Association for the Promotion of the Fine Arts was W.J. Bolding (1815-99), a shipowner and farmer of Weybourne, Norfolk who took early photographs of Weybourne and also of the workers on his estate. Middleton's photographic skills, however, were directed towards the wooded land-scapes, rocks, streams and felled timber which he encountered on a visit to Wales, and were equally inspired by the majestic silhouettes of the Welsh castles and Telford's great suspension bridge across the Menai Strait.

John Middleton
View in Wales
photograph
Presented by
Mr. F.A.G. Canham
1932 (91.932)

John Middleton
Blofield 1847

watercolour
(33 × 48.2 cms)
inscribed, bottom left, with
title, date and monogram
R.J. Colman Bequest
1946 (1142.235.951)

John Middleton
Gunton

etching
(11.2 × 16.2 cms plate)
Purchased 1925 (3.62.925)

Blofield is closely comparable in style to *Alby, Norfolk* (p. 143) and also Middleton's work in Kent of the same year. Another Norfolk subject of *c.* 1847 which is in the collection at Norwich is a watercolour of similar style entitled *Lane Scene* (NCM 1140.235.951). This may be identified as *Cantley Beck, near Ketteringham*, the title of an oil version also in the Colman Collection (NCM 1129.235.951). Middleton exhibited a picture of this title at Norwich in 1848, of which the *Norwich Mercury* commented: 'Mr. Middleton, as a landscape painter, takes a high rank in the English School; and the present is a fair specimen of his talents. The colouring is chaste and natural; the lights and shades well observed; and there is a softness, a repose, over the whole, that is highly pleasing' (7 October 1848).

1847 proved to be the *annus mirabilis* of Middleton's life and career. It was in this year that he moved to London and first exhibited at the Royal Academy. Following the death of his father the following year, Middleton returned to Norwich to continue the family painting and decorating business, at 63 St. Stephen's Street. The relative lack of watercolours positively dated by the artist from the 1850s makes it difficult to be certain of his subsequent development. It appears that Middleton produced watercolours which were more heavily finished, in common with his oils of this period, never quite retaining the clarity of his vision when just twenty years of age.

Landscape with Pollards is unusual in Middleton's *oeuvre* in that its unfinished quality renders it quite different from his other work in oils. Middleton exhibited a good number of oils, both in London, at the Royal Academy and at the British Institution from 1847-55, and with the Norfolk and Norwich Association for the Promotion of the Fine Arts, and his work in this medium was well-received. He appears to have been respond-

John Middleton
Landscape with Pollards
c. 1847

oil on canvas
(51.4 × 61.6 cms)
Purchased 1938 (67.938)

ing to the growing fashion for more finished paintings, a trend which his friend Henry Bright identified in a letter to W.P.B. Freeman as the norm by 1861: 'The days of "suggestive art" *only*, are past, elaborate finish is looked for' (10 February 1861, Reeve Collection, BM). Middleton's oils have in general an over-elaborate concern for detail which is reminiscent of the work of his first teacher, J.B. Ladbrooke. *Landscape with Pollards*, by comparison, possesses the more 'suggestive' air of his watercolours, enhanced by the romantic profusion of butterbur in the foreground.

John Middleton was also a skilful etcher. In 1852 he published a set of nine etchings which in substance are reproductions of some of his most successful compositions. These are not, however, simply replicas, but reproduce the spirit of his compositions often in reverse and with changes in detail. One example in the collection at Norwich is *Gunton Park* painted in 1849 (NCM 1130.235.951) which is reproduced in etched form as *View at Gunton:* the heavy finish of the oil version is transformed by a subtlety of line which reveals Middleton as a worthy heir to John Crome in the medium of etching. In common with Crome, John Middleton's work depicts quiet corners of the countryside with an intimacy of vision and sensitivity of line, wash or brushstroke charged with a freshness of vision 'now probably to be the more closely studied and the more valued'. (*Norwich Mercury*, 15 November 1856.)

SELECT BIBLIOGRAPHY

Allthorpe-Guyton, Marjorie, *Henry Bright 1810-1873*, A Catalogue of Paintings and Drawings in the Collection of Norwich Castle Museum, Norfolk Museums Service, 1973.

Allthorpe-Guyton, Marjorie, *John Thirtle 1777-1839, Drawings in Norwich Castle Museum*, Norfolk Museums Service, 1977.

Allthorpe-Guyton, Marjorie, *John Sell Cotman 1782-1842, The Great Years— Early Life and Works*, Norfolk Museums Service Information Sheet, 1979.

Allthorpe-Guyton, Marjorie, *The Norwich School*, Norfolk Museums Service Information Sheet, 1979.

Allthorpe-Guyton, Marjorie, with Stevens, John, *A Happy Eye. A School of Art in Norwich 1845-1982*, Jarrold & Sons Ltd., Norwich, 1982.

Beecheno, F.R., *E.T. Daniell. A Memoir*, privately printed, Norwich, 1889.

Binyon, Laurence, *John Crome and John Sell Cotman*, Seeley & Co. Ltd., London, 1897.

Binyon, Laurence, 'Life and Work of John Sell Cotman', Masters of English Landscape Painting, J.S. Cotman, David Cox, Peter de Wint, *The Studio* Special Number, 1903.

Burlington Magazine, Cotman Number, July 1942.

Chambers, John, *A General History of the County of Norfolk, intended to convey all the information of a Norfolk Tour*, 2 vols., Norwich & London, 1829.

Clifford, Derek, *Watercolours of the Norwich School*, Cory, Adams & Mackay, London, 1965.

Clifford, Derek and Timothy, *John Crome*, Faber & Faber, London, 1968.

Collins Baker, C.H., *Crome*, Methuen & Co. Ltd., London, 1921.

Cotman, Alec and Hawcroft, Francis, *Old Norwich*, Jarrold & Sons Ltd., Norwich, 1961.

Cundall, H.M., 'The Norwich School', *The Studio* Special Number, 1920.

Day, Harold A.E., *The Life and Works of Joseph Stannard*, Eastbourne Fine Art, 1965.

Day, Harold A.E., *East Anglian Painters*, 3 vols., Eastbourne Fine Art, 1967-1969.

Dickes, W.F., *The Norwich School of Painting*, Jarrold & Sons Ltd., Norwich and London, 1905.

Fawcett, Trevor, 'Patriotic Transparencies in Norwich, 1798-1814', *Norfolk Archaeology*, XXXIV, part III, 1968.

Fawcett, Trevor, *The Rise of English Provincial Art, Artists, Patrons and Institutions outside London 1780-1830*, Oxford Studies in the History of Art and Architecture, Clarendon Press, Oxford, 1974.

Fawcett, Trevor, 'Thorpe Water Frolic', *Norfolk Archaeology*, XXXVI, part IV, 1977.

Fawcett, Trevor, 'Eighteenth-century art in Norwich', *Walpole Society*, XLV I, 1976-8.

Fawcett, Trevor, 'Measuring the Provincial Enlightenment: The Case of Norwich', *Eighteenth Century Life*, VIII, n.s., 1, College of William and Mary, Williamsburg, 1982.

Gage, John, *A Decade of English Naturalism 1810-1820*, exhibition catalogue, Norwich Castle Museum and Victoria and Albert Museum, University of East Anglia, Norwich, 1969.

Hardie, Martin, *Watercolour Painting in Britain*, vol. II, 'The Romantic Period', Batsford, London, 1967.

Hawcroft, Francis W., 'John Middleton. A Sketch of his Life and Work', *The Saturday Book*, No. 16, Hutchinson & Co., London, 1956.

Hawcroft, Francis, 'Crome and his Patron: Thomas Harvey of Catton', *The Connoisseur*, CXLIV, December 1959.

Hawcroft, Francis, *John Crome 1768-1821*, bicentenary exhibition catalogue, Norwich Castle Museum and Tate Gallery, Arts Council, 1968.

Hemingway, Andrew, *The Norwich School of Painters, 1803-1833*, Phaidon, Oxford, 1979.

Holcomb, Adele M., *John Sell Cotman*, British Museum Prints & Drawings Series, British Museum Publications Ltd., London, 1978.

Holcomb, Adele M., and Ashcroft, M.Y., *John Sell Cotman in the Cholmeley Archive*, North Yorkshire County Record Office Publications No. 22, August 1980.

Isherwood Kay, H., 'John Sell Cotman's Letters from Normandy 1817-1820', Parts I and II, *Walpole Society*, XIV and XV, 1926 & 27.'

Jewson, C.B., *The Jacobin City. A Portrait of Norwich 1788-1802*, Blackie, Glasgow & London, 1975.

Kaines Smith, S.C., *John Crome*, British Artists Series, Philip Allan & Co., London, 1923.

Kaines Smith, S.C., *Cotman*, British Artists Series, Philip Allan & Co., London, 1926.

Kitson, Sydney D., *The Life of John Sell Cotman*, Faber & Faber, London, 1937, reprinted Rodart Reproductions, London, 1982.

Mallalieu, Huon, *The Norwich School, Crome, Cotman and their Followers*, Academy Editions, London, 1974.

Miller, Charlotte, 'Painting's Elusive Joys. Two Norfolk Marine-Artist Brothers', *Country Life*, 6 October 1977.

Moore, Andrew W., *John Sell Cotman 1782-1842*, bicentenary exhibition catalogue, Norfolk Museums Service, 1982.

Mottram, R.H., *John Crome of Norwich*, Bodley Head, London, 1931.

O'Looney, Betty, *Frederick Sandys 1829-1904*, exhibition catalogue, Brighton Museum & Art Gallery, 1974.

Oppé, A.P., 'The Watercolour Drawings of John Sell Cotman', *The Studio* Special Number, 1923.

Parris, Leslie, and Shields, Conal, *Landscape in Britain c. 1750-1850*, exhibition catalogue, Tate Gallery, London, 1974.

Popham, A.E., 'The Etchings of John Sell Cotman', *The Print Collectors Quarterly*, October 1922.

Rajnai, Miklos, *The Norwich School of Painters*, Jarrolds Art Series, Norwich, 1978.

Rajnai, Miklos, ed., *John Sell Cotman 1782-1842*, Arts Council Bicentenary Exhibition Catalogue, The Herbert Press, London, 1982, with hardback edition containing additional supplement of pictures from Norwich Castle Museum.

Rajnai, Miklos, assisted by Allthorpe-Guyton, Marjorie, *John Sell Cotman 1782-1842, Drawings of Normandy in Norwich Castle Museum*, Norfolk Museums Service, 1975.

Rajnai, Miklos, and Allthorpe-Guyton, Marjorie, *John Sell Cotman 1782-1842, Early Drawings (1798-1812) in Norwich Castle Museum*, Norfolk Museums Service, 1979.

Rajnai, Miklos, assisted by Stevens, Mary, *The Norwich Society of Artists 1805-1833*, A dictionary of Contributors and their Work, published for the Paul Mellon Centre for Studies in British Art by the Norfolk Museums Service, 1976.

Redgrave, Richard and Samuel, *A Century of British Painters*, Phaidon Press Ltd., London, 1947.

Reeve, James *Memoir of John Sell Cotman*, Jarrold & Sons Ltd., Norwich and London, 1911.

Rienaecker, Victor, *John Sell Cotman 1782-1842*, F. Lewis Ltd., Leigh-on-Sea, 1953.

Snelgrove, Dudley; Stirling, Angus and Thistlethwaite, Jane, *Norwich School Prints, Paintings and Drawings by the Rev. E.T. Daniell 1804-1842*, exhibition catalogue, Aldeburgh, Paul Mellon Foundation for British Art, 1968.

Theobald, Henry Studdy, *Crome's Etchings, A Catalogue and An Appreciation with some Account of his Paintings*, Macmillan & Co., London, 1906.

Thistlethwaite, Jane, 'The Etchings of Edward Thomas Daniell 1804-1842', *Norfolk Archaeology*, XXXVI, part I, 1974.

Turner, Dawson, *Outlines in Lithography, from a small Collection of Pictures*, privately printed, Yarmouth, 1840.

Watt, Norma, 'The Struggle of John Joseph Cotman', *Norfolk Fair*, December 1978.

Watt, Norma, 'Centenary of John Berney Ladbrooke 1803-1879', *Norfolk Fair*, December 1979.

White, William, *History, Gazetteer, and Directory of Norfolk...*, Sheffield, 1845, reprinted Augustus M. Kelley, New York, 1969.

PORTRAITS OF THE ARTISTS

All the portraits are in the collection of Norwich Castle Museum unless otherwise stated.

Henry Bright *131*
1810-1873
Photograph
Private Collection

Rev. James Bulwer *81*
1794-1879
by Frederick Sandys
1829-1904
Oil on panel
75.6 × 55.3 cms
The National Gallery of Canada, Ottawa

George Clint *49*
1770-1854
Self Portrait
Oil on canvas
76.2 × 63.5 cms
National Portrait Gallery, London (2064)

John Joseph Cotman *80*
1814-1878
Self Portrait
Black and white chalk on buff paper
40.5 × 33.5 cms
Provenance unknown

John Sell Cotman *67*
1782-1842
by Mrs. Dawson Turner
1774-1850, after J.P. Davis
1784-1862
Etching
29.9 × 22.5 cms
Presented by Lady Grace Woodward 1970 (17.483.970)

Miles Edmund Cotman *79*
1810-1858
by Lucy C. Sothern
active 1835
Black and white chalk on buff paper
34 × 24 cms
Inscribed, bottom left:
M.E. Cotman/sketched by Lucy C. Sothern
R.J. Colman Bequest
1946 (1235.235.951)

John Crome *19*
1768-1821
by John Opie
1761-1807
Oil on canvas
55.8 × 43.2 cms
J.J. Colman Bequest
1899 (15.4.99)

John Berney Crome *31*
1794-1842
by Horace Beevor Love
1800-1838
Watercolour and pastel
24.7 × 20.1 cms
Presented by the East Anglian Art Society 1894 (59.75.94)

William Henry Crome *121*
1806-1867
by George Clint
1770-1854
Oil on millboard
30.5 × 25.4 cms
R.J. Colman Bequest
1946 (1392.235.951)

Rev. Edward Thomas Daniell *97*
1804-1842
by John Linnell
1792-1882
Pencil
oval 22.7 × 19.9 cms
Signed, bottom right: *J. Linnell* and inscribed, bottom left: *E.T. Daniel* (sic)
Purchased 1971 (213.971)

Joseph Geldart *81*
1808-1882
Self Portrait
Chalk
44.5 × 35.6 cms
Fitzwilliam Museum, Cambridge

David Hodgson *119*
1798-1864
by Horace Beevor Love
1800-1838
Watercolour and pastel
29.8 × 24 cms
Signed (on back of chair):
H B Love 1831 and inscribed, bottom left:
David Hodgson/Artist
Bequeathed by James Reeve
1921 (10.21.21)

Henry Ladbrooke *121*
1800-1869
Photograph from *Eastern Daily Press*
1921

John Berney Ladbrooke *121*
1803-1879
Photograph

Robert Ladbrooke *47*
1770-1842
by Thomas Charles Wageman
1787-1863
Pencil and watercolour
27.2 × 21.7 cms
Presented by J.B. Ladbrooke
1875 (30.75)

Robert Leman *129*
1799-1863
by Joseph Geldart
1808-1882
Black chalk heightened with white
on buff paper:
42.7 × 35.2 cms
Purchased by the Friends of the Norwich Museums
with a grant from the Victoria & Albert Museum
1981 (65.981)

Thomas Lound *129*
1802-1861
Self Portrait
Pencil and watercolour
14.1 × 12.5 cms
Presented by the Executors of R.E. Banham
1965 (588.965)

John Middleton *132*
1827-1856
Photograph

Henry Ninham *118*
1793-1874
by Anthony Sandys
1806-1883
Chalk on buff paper
22.8 × 17.8 cms
R.J. Colman Bequest
1946 (1206.235.951)

John Ninham *47*
1754-1817
by unknown artist
Oil on panel
40.5 × 37 cms
Presented by J.L. Gunn
1947 (149.947)

Alfred Priest *130*
1810-1850
by Miles Edmund Cotman
1810-1858
Black and white chalk and grey wash
on grey paper 36 × 28.8 cms
Signed, bottom right: *MEC/1836*
Cotman Family Collection

James Sillett *48*
1764-1840
Self Portrait
Oil on canvas
33.1 × 25.6 cms
Signed and inscribed
on stretcher:
J. Sillett. 1803
painted by himself.
Provenance unknown

Alfred Stannard *96*
1806-1889
by William Beechey
1753-1839

Oil on canvas laid on panel
41.6 × 35.4 cms
R.J. Colman Bequest
1946 (1383.235.951)

Eloise Harriet Stannard *96*
1829-1915, aged 18
by unknown artist
Black and white chalk on buff paper
54.4 × 41.8 cms
Purchased 1979 (225.979)

Emily Stannard (née Coppin) *96*
1803-1885
by Julian Cedric Brewer
active 1852; died 1903
Chalk on grey-green paper
37.3 × 34.5 cms
Signed, bottom right:
J C Brewer, delint./1885
Presented by the East Anglian Art Society
1894 (75.75.94)

Joseph Stannard *95*
1797-1830
by William Beechey
1753-1839
Oil on panel
56 × 43 cms
Signed, bottom left: *W B 1824*
R.J. Colman Bequest
1946 (1384.235.951)

James Stark *32*
1794-1859
by Joseph Clover
1779-1853
Oil on canvas
76.5 × 57 cms
Presented by H.C., E.M. and L.G. Bolingbroke
and Mrs. L. Prior 1921 (16.21)

John Thirtle *78*
1777-1839
Self Portrait
Pencil and watercolour
24.6 × 19.8 cms
Presented by L. O'Malley in memory
of his mother 1932 (70.932)

George Vincent *33*
1796-1832
by Joseph Clover
1779-1853, with landscape
background by Vincent
Oil on canvas
77 × 63.5 cms
J.J. Colman Bequest
1899 (16.4.99)

INDEX OF DONORS

General Index